THE
JEFFERSON MEMORIAL
THROUGH TIME

AMY WATERS YARSINSKE

AMERICA
THROUGH TIME®
ADDING COLOR TO AMERICAN HISTORY

America Through Time is an imprint of Fonthill Media LLC
www.through-time.com
office@through-time.com

Published by Arcadia Publishing by arrangement with Fonthill Media LLC
For all general information, please contact Arcadia Publishing:

Telephone: 843-853-2070
Fax: 843-853-0044
E-mail: sales@arcadiapublishing.com
For customer service and orders:
Toll-Free 1-888-313-2665
Visit us on the internet at www.arcadiapublishing.com

First published 2017

Copyright © Amy Waters Yarsinske 2017

ISBN 978-1-63500-049-8

Typeset in Mrs Eaves XL Serif Narrow
Printed and bound by CPI Group (UK) Ltd, Croydon, CR0 4YY

CONTENTS

Introduction

The Thomas Jefferson Memorial was conceived of and built to commemorate Thomas Jefferson (1743–1826), architect, principal author of the Declaration of Independence, and third president of the United States. Esteemed as an advocate for national independence and personal spiritual freedom, Jefferson's philosophy is perhaps best expressed in the Declaration of Independence, in which he wrote: "All men are created equal, that they are endowed by their creator with certain inalienable rights, among these are life, liberty and the pursuit of happiness." The memorial to his honor, with the classical serenity of its architecture reflected in the Tidal Basin and framed by ornamental Japanese cherry trees, remains one of the most familiar and popular images of the nation's capital.

The land on which the memorial is located was created by landfill dredged from the Potomac River in the late nineteenth century, and for many years this stretch of shoreline along the Tidal Basin served as one of Washington's most popular bathing beaches. The first proposal for a memorial on this important site, on axis with the White House and the Washington Monument, was made by the Senate Park Commission, popularly known as the McMillan Commission after its chairman, Michigan senator James McMillan.

According to the National Park Service history, as the city approached its centennial, there was a call to develop a comprehensive park system for the city. As early as 1898, a committee was formed to meet with President William McKinley to propose the erection of a monument to commemorate the centennial of the city. A joint committee formed by the United States Congress held its first meeting in February 1900 with Senator McMillan as chairman, and Charles Moore as secretary. At the same time, plans were put forward for the development of a national mall that would include the newly reclaimed Potomac Flats. As the bureaucracy planned for the centennial, the American Institute of Architects (AIA) joined the discussion, at times contentious and rife with differing ideas. AIA leaders envisioned the nation's capital as the perfect place for the group to express the ideals of the City Beautiful movement promoted by the 1893 World's Columbian Exposition in Chicago. The architect of this pivotal fair designed Beaux Arts Classical architecture in a grand and ordered civic space. When the Senate Commission officially formed in 1901 to explore and

plan the design of the city, the project then encompassed the historic core. The committee had also grown to include Daniel Burnham, a visionary of the World's Columbian Exposition, as well as landscape architect Frederick Law Olmsted Jr., architect Charles F. McKim, and sculptor Augustus Saint Gaudens.

Foremost in the minds of committee members was the amazing foresight and genius of Major Pierre Charles L'Enfant (1755–1825), the French artist and designer who had forged a lasting friendship with George Washington during his service in the Revolutionary War, and who subsequently devised the first plan for the new nation's capital city. The committee lamented the fragmented National Mall (hereafter also "the Mall") marred by a railroad station and focused upon restoring it to the uninterrupted greensward envisioned by L'Enfant. In total, the forward-looking plans made by the McMillan Commission called for re-landscaping the ceremonial core, consisting of the Capitol Grounds and Mall, including new extensions west and south of the Washington Monument; consolidating city railways and alleviating at-grade crossings; clearing slums; designing a coordinated municipal office complex in the triangle formed by Pennsylvanian Avenue, Fifteenth Street, and the Mall, and establishing a comprehensive recreation and park system that would preserve the ring of Civil War fortifications around the city.

In its 1901 plan, the McMillan Commission proposed a round, domed, Pantheon-like structure in which were to be grouped "the statues of the illustrious men of the nation, or whether the memory of some individual shall be honored by a monument of the first rank may be left to the future." Flanking this building were to be six large rectangular buildings containing baths, a theater, gymnasium, and athletic facilities. No immediate action was taken by Congress and, in fact, the site remained undeveloped for nearly four decades.

In 1925, a design competition was held for a memorial to Theodore Roosevelt to be located on the Tidal Basin site. The winning entry, by prominent New York architect John Russell Pope, consisted of two quarter-circle colonnades flanking a large circular basin, which was to contain a central island with an arrangement of sculpture and a fountain. But, again, no money was appropriated just then by Congress for construction, and the project was set aside. Then, on January 7, 1926, the Sixty-Ninth Congress in the House of Representatives introduced a resolution to authorize the erection of a memorial to Thomas Jefferson, the third president of the United States. Eight years later, on June 26, 1934, the Seventy-Third Congress passed a joint resolution establishing:

> The Thomas Jefferson Memorial Commission, for the purpose of considering and formulating plans for designing and constructing a permanent memorial in the city of Washington, District of Columbia. Said Commission shall be composed of twelve commissioners as follows: Three persons to be appointed by the President of the United States, three Senators by the President of the Senate, three members of the House of Representatives, and three members of the Thomas Jefferson Memorial Foundation, Incorporated, to be selected by such foundation.

The original bill, according to the National Park Service narrative, went so far as to state the exact location of the memorial which was destined for the intersection of Constitution and

Pennsylvania Avenues, east of the front of the National Archives Building. Later that year, at the urging of powerful New York congressman John J. Boylan, Congress created the Thomas Jefferson Memorial Commission. Boylan was subsequently chosen as the commission's first chairman. Two years later, in 1936, Congress appropriated $3 million for the construction of a memorial to Jefferson and further granted the memorial commission complete authority to decide upon the location of the memorial. The original site near the National Archives was deemed too small by President Franklin Delano Roosevelt, who greatly admired and revered Thomas Jefferson, for such an important monument. The president subsequently contacted the United States Commission of Fine Arts about the possibility of erecting a statue of Jefferson as part of the Federal Triangle project, then under construction.

At the beginning of the siting process, six locations beyond the National Archives location suggested by Congress were considered by the memorial commission, as described in a report by Gilmore Clarke and William Partridge, consultants to the commission, on April 9, 1937. The most favored of these involved the creation of an island for the memorial, located in the middle of the Tidal Basin. Although this scheme was not chosen, it did establish the importance of having the memorial on axis with the White House and other cardinal points as designated in the L'Enfant Plan and as expressed in the McMillan Plan of 1901. Frederick Law Olmsted Jr., himself a member of the memorial commission just then, wrote a report in 1935 outlining his opinion about the choice of sites. Concerning the south axis site, he stressed the importance of the visual relationship with the other axial compositions, namely the east-west connection between the Lincoln Memorial and the Capitol, and the north-south axis between the White House and the Washington Monument grounds.

The Thomas Jefferson Memorial Commission selected John Russell Pope (1874–1937), of New York City, as the project architect, also in 1935. Pope had been a member of the Commission of Fine Arts from 1912 to 1922, serving as vice chairman from 1921 to 1922. He also served on the Board of Architectural Consultants for the Federal Triangle complex in Washington, D.C. Notably, Pope had been the losing competitor in the 1911 competition to design the Lincoln Memorial, though he subsequently designed a number of important buildings in the nation's capital, to include the National Archives and the National Gallery of Art. Under the commission's direction, Pope prepared four separate schemes for a memorial to Jefferson, each on a different site: one at that end of East Capitol Street at the Anacostia River; one at Lincoln Park; one on the south side of the Mall across from the National Archives, and one at the Tidal Basin site, directly south of the White House. From the start, the latter site was the commission's preferred location for the Jefferson Memorial, for two reasons: first, it was the most prominent of the sites, and two, because it would complete the missing corner of the so-called "kite" plan configuration of important Washington buildings defined as the White House, the Capitol, the Washington Monument, and the Lincoln Memorial originally proposed by the McMillan Commission. For this site, Pope designed an enormous Pantheon-like building that was twenty-one feet taller than the Lincoln Memorial, its architecture evocative of both Jefferson's use of classicism in his own architectural renderings and structures, as well as Jefferson's use of domes at Monticello and at the University of Virginia Rotunda. Pope's homage to Jefferson was to

sit on a large square platform, flanked by two smaller, rectangular, colonnaded buildings, with the Tidal Basin in front formalized and made rectangular.

Pope's memorial design was widely debated. A number of prominent Washingtonians, to include respected landscape architect Henry V. Hubbard, of Olmsted Brothers, opposed the Tidal Basin site. Hubbard stressed the proposal's inevitable high cost, the interference with the flushing activities of the basin, the loss of land and vegetation from East Potomac Park, and the overbearing scale of the proposed development. Some opposed Pope's plan because construction would involve the destruction of a large number of elm and treasured Japanese cherry trees. Others believed that the vista south from the White House should be kept unencumbered, as shown in L'Enfant's original 1791 plan for Washington. Still, others—like Hubbard—decried Pope's structure as too grandiose for a man of Jefferson's simple agrarian background. Beyond the Washington elite, prominent architects criticized both the traditional style of Pope's design as well as the uncompetitive manner in which Pope had been chosen by the commission. Frederick Law Olmsted Jr. urged the commission to abandon this particular scheme in a telegram to Harlean James, of the American Planning and Civic Association, dated of April 22, 1937:

> The Jefferson Memorial with its terraces as now designed would be so stupendous in appearance that in my opinion an adequate setting could probably never be created in the Tidal Basin location hemmed in by [the] Bureau of Engraving and Printing and by railroad and highway embankments and bridges. Other vitally important problems as yet unsolved and possibly insoluble are involved in its relations to surroundings including Washington and Lincoln Memorials. Unless and until successful solutions for these unsolved problems are found and embodied in feasible and approved plans for the reconstruction of the surrounding park any precipitate commitment to building the latter as now designed would be a leap in the dark with failure more likely than success.[1]

After consultation with both the Commission of Fine Arts and the National Capital Park and Planning Commission,[2] the memorial commission adopted a resolution that modified the plan with regard to the proposed location of the memorial. The Thomas Jefferson Memorial Commission report to the Seventy-Fifth Congress, third session, House of Representatives, dated May 31, 1938, informed lawmakers of the site for the new memorial:

> It places the memorial on the south bank of the Tidal Basin, diminishing the expense of the memorial and its setting, preserving and improving the present traffic approach to the Highway Bridge. The site on the south bank of the Tidal Basin, on a line south through the White House, has been regarded ever since 1901 as the proper site for a memorial of major importance. In relation to the Washington Monument, it gives the Jefferson Memorial a position in the south similar to the position of the Lincoln Memorial on the west, and completes the great central plan of the city, in which the Capitol and the White House occupy the other two cardinal points on the east and north of the Monument. From the Washington Monument grounds the Jefferson Memorial will be seen across the Tidal Basin, which will retain its irregular outline and natural beauty and in which the memorial and the cherry trees flanking it will be mirrored.

Pope was in the sunset years of his architectural career when he took on the Jefferson Memorial project. After he died on August 27, 1937, the commission moved the following year, largely in response to prior and continuing criticism of Pope's drawings from the Commission of Fine Arts, to propose a smaller-scale version of Pope's earlier Theodore Roosevelt Memorial. Use of this scheme, interestingly, died on the vine quickly after the architect's widow, Sadie Jones Pope, prohibited it. Pope had bequeathed his entire estate, including control over his architectural portfolio, to his wife. Unable to revert to the Roosevelt plans, the commission returned to the Pantheon proposal. The Jefferson Memorial was never approved by the Commission of Fine Arts, which in 1939 issued a pamphlet opposing both its design and location.

Despite the fine arts commission's rancor over the project, the memorial's supporters were able to overcome the opposition just then, due largely to both the powerful congressional connections of the memorial commission and the personal interest of President Roosevelt in the project. Completion of the building's design was assumed by Pope's surviving partners, Otto Reinhold Eggers (1882–1964) and Daniel Paul Higgins (1886–1953). Ground was broken on December 15, 1938, for the construction of a scaled-down version of Pope's Pantheon scheme.

The cornerstone of the memorial was laid on November 15, 1939. Stuart G. Gibboney, then chairman of the Thomas Jefferson Memorial Commission, introduced President Franklin D. Roosevelt, whose keynote address revealed the thirty-second president's warm affection and admiration of Jefferson and his ideals. "This is the second occasion on which I have had the privilege of coming in an official capacity to this site," he told the crowd gathered to hear him speak, "and I hope that by January in 1941, I shall be able to come to the final dedication of the Memorial itself." Roosevelt was up for reelection in 1940, and could only speculate if he might return, just then, to the memorial in "an official capacity" to oversee the dedication. But on the occasion of the cornerstone laying, Roosevelt spoke of the selection of and development of the nation's capital: "In the earliest days of this Republic of ours, the Republic under the Constitution the representatives of the several states of the Union were in substantial agreement that a national capital should be founded in a federal district set apart from the jurisdiction of any individual state. That purpose was in a true sense a symbol of a realization of national unity; and the final location of the national capital in this place proclaimed a proper compromise between the interest of the North, the South, the seaboard and the interior, as they existed at that time," Roosevelt told the crowd gathered along the banks of the Tidal Basin. "In all of the hundred and fifty years of our (existence) life as a constitutional nation many memorials to its civil and military chiefs have been set up (here) in the National Capital. But it has been reserved to two of those leaders to receive special tribute in the nation's capital by the erection of national shrines perpetuating their memories over and above the appreciation and the regard tendered to other great citizens of the Republic. And, today we lay the cornerstone of a third shrine—adding the name of Thomas Jefferson to the names of George Washington and Abraham Lincoln," he continued. "I have spoken of the national character of the District of Columbia itself, a capital that represents today the vitality, not of the thirteen Atlantic

seaboard states, but of forty-eight states that encompass the whole width of the continent." Shifting to the enshrinement of Washington, Lincoln and Jefferson, Roosevelt declared that it was fitting that among hundreds of monuments to famous Americans "the three great shrines are dedicated to men of many-sided qualities." Of Washington, Roosevelt observed that "[he] represented abilities recognized in every part of the young nation and, indeed, in every part of the civilized world of his day, for he was not only a great military leader, not only a great moderator in bringing together discordant elements in the formation of a constitutional nation, not only a great executive of that nation in its troublesome early years, but also a man of vision and accomplishments in private civil fields—talented engineer and surveyor, planner of highways and canals, patron of husbandry, friend of scientists and fellow of political thinkers." Of Lincoln, too, Roosevelt described him as "a many-sided man. Pioneer of the wilderness, counsel for the underprivileged, soldier in an Indian war, master of the English tongue, rallying point for a torn nation, emancipator, not of slaves alone, but of those of heavy heart everywhere, foe of malice, and teacher of goodwill."

Circling back to Jefferson, the president heaped great praise: "To those we add today another American of many parts—not Jefferson the founder of a party, but the Jefferson whose influence is felt today in many of the current activities of mankind. When in the year of 1939 America speaks of its Bill of Rights," he iterated, "we think of the author of the statute for religious liberty in Virginia. When today Americans celebrate the anniversary of the Fourth of July 1776, our minds revert to Jefferson, author of the Declaration of Independence. And when each spring we take part in the commencement exercises of schools and universities, then we go back to the days of Jefferson, founder of the University of Virginia." In a series of pointed historical anecdotes, he reminded the crowd: "When we think of his older contemporary Benjamin Franklin as the experimenter in physics and of science, we remember that Jefferson was an inventor of numerous small devices to make human life simpler and happier and that he, too, experimented in the biology of livestock and of agriculture. In the current era in the erection of noble buildings in all parts of the country," he continued, "we recognize the enormous influence of Jefferson in the American application of classic art to homes and public buildings—and influence that makes itself felt today in the selection of the design for this very shrine for which we are laying the cornerstone. But it was in the field of political philosophy that Jefferson's significance is transcendent."

Roosevelt opined that Jefferson lived "as we live in the midst of a struggle between rule by the self-chosen individual or the self-appointed few, and, on the other hand, rule by the franchise and the approval of the many. He believed as we do that the average opinion of mankind is in the long run superior to the dictates of the self-chosen. During all the years that have followed Thomas Jefferson," he declared, "the United States has expanded his philosophy into a greater achievement of security of the nation, security of the individual and national unity, than in any other part of the whole round world." In conclusion, Roosevelt observed: "It may be that the conflict between two forms of philosophy will continue for centuries to come, but we in the United States are more than ever satisfied that the republican form of government based on regularly recurring opportunities to our

citizens to choose their leaders for themselves. And, therefore, in memory of the many-sided Thomas Jefferson and in honor of the ever-present vitality of his type of Americanism, we lay the cornerstone of this shrine." Roosevelt's praise was far from misplaced. The memorial embodies the ideals of beauty, science, learning, culture, and liberty. Jefferson truly was a Renaissance man. He was fluent in six languages: Latin, Greek, French, Spanish, Italian, and Anglo-Saxon. He spent much time studying the natural sciences, ethnology, archaeology, agriculture, and meteorology. Jefferson was also a gifted architect, America's first, according to some scholars. As American minister to France, he developed a love for the beauties of classical architecture, as evidenced by two of his famous creations, Monticello and the University of Virginia. He almost single-handedly introduced the neoclassical style to the United States. It is entirely appropriate that the memorial built in his honor should be based on the Pantheon in Rome, which he loved.[3]

The Jefferson Memorial was largely completed by the end of 1942 absent a statue of Jefferson. In 1939, the memorial commission held a competition to select a sculptor, receiving 101 entries. Six finalists were asked to submit models. Three finalists—Lee Lawrie, Rudulph Evans and Adolph A. Weinman—were asked to submit additional models. Evans was chosen as the sculptor of Jefferson for the interior chamber of the memorial, and Weinman was selected to sculpt the pediment relief at the entrance portico.

The Jefferson Memorial was formally dedicated by President Roosevelt on April 13, 1943, the two hundredth anniversary of Jefferson's birth. Due to the shortage of materials during the Second World War, Evans was prevented from casting his statue in bronze. For the dedication, a plaster cast of Evans' statue, painted to resemble bronze, was temporarily installed, where it remained until 1947, when it was replaced by the permanent bronze cast by the Roman Bronze Works, of Corona, New York, located in the Long Island borough of Queens. Evans complained that the lighting of the statue was not what it should be, prompting changes after installation. When he died in 1960, Evans was still unhappy with the statue's lighting.

As completed, the Jefferson Memorial takes the form of a colonnaded, circular Roman Ionic temple with a portico on the north side. Raised about twenty-five feet above grade on substantial reinforced concrete foundation, the building is surrounded by two concentric terraces. The outer terrace, nearly 422 feet in diameter, is defined by a three-foot-high granite retaining wall. A ten-foot-high marble retaining wall encloses the 294-foot-diameter inner terrace. A combination of marble steps and terraces on the north side leads visitors to the temple entrance. The temple itself rests on a 184-foot-diameter platform, surrounded by three stylobate steps, each five-feet, four inches wide. All exterior stone is Vermont Danby marble. There are thirty-eight forty-one-foot-tall exterior columns, twelve at the portico and twenty-six at the temple colonnade. The pediment above the building entrance contains Weinman's relief of the five members of the committee appointed by the Continental Congress to write the Declaration of Independence: Benjamin Franklin, John Adams, Thomas Jefferson, Roger Sherman, and Robert Livingston.

The interior of the Jefferson Memorial consists of the round, domed memorial chamber, which is eighty-two-feet in diameter, surrounded by the colonnaded ambulatory. The floor of the memorial chamber is a pink Tennessee marble and the interior walls are sheathed

in Georgia marble. The interior dome, rising to a height of ninety-one-feet, eight inches above the floor, and the portico vault are built of Indiana limestone. The memorial chamber has four openings at each of the four compass points. Each of the openings is flanked by four thirty-nine-foot, two-inch interior columns, of the same order of the exterior columns, but proportionally smaller. On each of the four chamber walls is a quotation from Jefferson's writing, cast in applied bronze letters. The quote panels are excerpted from the Declaration of Independence (southwest), the Virginia Statute for Religious Freedom (also called "A Bill for Establishing Religious Freedom") and a 1789 letter to James Madison (northwest), the "Notes on the State of Virginia" and a 1786 letter to George Washington (northeast), and an 1816 letter to Samuel Kercheval (southeast). Inscribed in the frieze is another Jefferson quotation: "I have sworn upon the altar of God eternal hostility against every form of tyranny over the mind of man." While there are misquotations made on the panels—typos, if you will—they do not diminish the message of Jefferson's writings and those of his contemporaries, which also appear on the walls of the memorial.

At the center of the memorial chamber, the focal point of the spatial axes created by the openings, is Evans' statue of Jefferson. The nineteen-foot-tall bronze statue stands on a six-foot-tall pedestal of Minnesota granite surrounded at its base by Missouri marble. The statue portrays Jefferson addressing the Continental Congress, capturing both his strength of character and his vitality of spirit. In his left hand he holds a scroll, perhaps the Declaration of Independence. At his feet are two column capitals, on which are sculpted corn and tobacco.

The weight of the roof and the dome is carried to the foundations by the columns and the massive masonry bearing walls of the main level. The dome itself is a double shell, with the interior dome self-supporting. The exterior dome, rising to a height of nearly one hundred and twenty feet above grade, is supported by an elaborate steel framework, encased in concrete.

Although the subject of extensive criticism at the time it was designed and built, the Jefferson Memorial has since assumed an integral role in the iconic image of monumental Washington. The memorial is particularly resplendent during the blossoming of the cherry trees in spring, and has become one of the most popular destinations for millions of visitors to the nation's capital. "Esteemed today as the last great American Beaux-Arts monument, it is appreciated as the appropriate commemoration of a man whose ideas and actions have assumed a transcendent importance for the American people," according to the National Park Service, which oversees the memorial. As a National Memorial, the Thomas Jefferson Memorial was administratively listed on the National Register of Historic Places on October 15, 1966, followed by an individual nomination in 1981. The areas of significance noted in the 1981 nomination were architecture, politics/government, and landscape architecture.

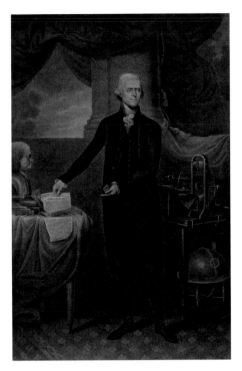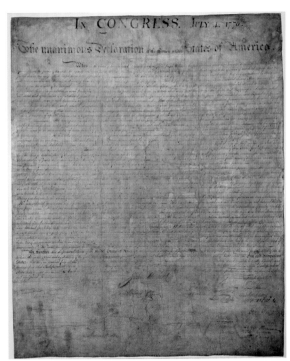

Above left: This Cornelius Tiebout (1777–1832) engraving, published in 1801, shows Thomas Jefferson, full-length portrait, facing slightly right, standing beside a table from which he is lifting the Declaration of Independence with his right hand and pointing to it with his left hand. There is a bust of Benjamin Franklin on the table, as well as several books. On a small table to the right is a single-disc electrostatic generator and beneath that, resting on the floor, is a globe. The original portrait from which Tiebout produced the engraving was the work of Rembrandt Peale (1778–1860). *Library of Congress*

Above right: On July 4, 1776, the Second Continental Congress adopted the Declaration of Independence ("the Declaration") in which the American colonies set forth a list of grievances against the British Crown and declared they were breaking from England's rule to form free and independent states. Just over two weeks later, on July 19, 1776, Congress resolved that the Declaration passed on the fourth be fairly engrossed on parchment with the title and style "The unanimous declaration of the thirteen United States of America" and that the same, when engrossed, be signed by every member of Congress. The engrossing was most likely done by Timothy Matlack, an assistant to Charles Thomson, secretary of the Congress. Although it bears the date "July 4, 1776," the engrossed Declaration was signed on August 2, 1776, by members of the Continental Congress who were present that day and later by other members of Congress. A total of fifty-six delegates eventually signed the document. Fast forward to World War II, just over two week after the Japanese attack on Pearl Harbor, on December 23, 1941, the Declaration, Constitution, Magna Carta, and Articles of Confederation were removed from public display, carefully wrapped in acid-free paper, placed in a bronze container sealed with lead and secured with padlocks, thus preparing the nation's most important founding documents for safekeeping outside of Washington, D.C. Chief assistant librarian Verner W. Clapp and armed Secret Service agents accompanied the documents to a Baltimore and Ohio Railroad Pullman car bound for Louisville, Kentucky, that departed the city on December 26, 1941. When it reached Louisville, the train was met by soldiers of the 13th Armored Division cavalry troop, which escorted the box containing the documents to Fort Knox. The Declaration was ultimately—and permanently—returned to Washington, D.C., in 1944, after there was no further threat that it might be damaged or destroyed. *National Archives*

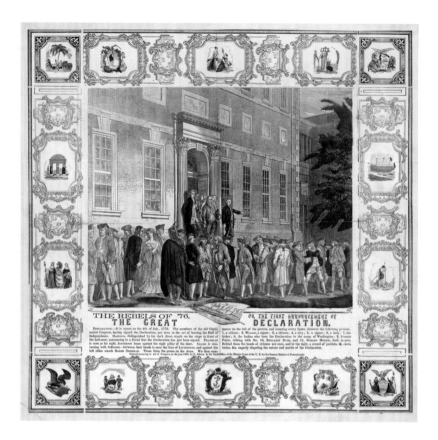

Above: "The rebels of '76—or the first announcement of the great declaration" is the subject of this hand-colored engraving published in 1860 of the signers of the Declaration of Independence leaving Independence Hall in Philadelphia, Pennsylvania. *Library of Congress*

Left: This print reproduction of Thomas Jefferson (1743–1826) was derived from Gilbert Stuart's original portrait. *New York Public Library*

Among the paintings on the walls of the United States Capitol is this one of Thomas Jefferson as secretary of state. Theodor Horydczak (1890–1971) took this picture in or about 1950. *Library of Congress*

Joseph Ferdinand Keppler (1838–1894) produced this chromolithograph, published on April 25, 1883. The illustration shows Thomas F. Bayard carrying a banner that shows a portrait of Thomas Jefferson and is labeled "Jeffersonian Principles," with a streamer at the top that states "A Government of the People, by the People, for the People." Attached to the corners of the banner are ribbons that are being pulled in different directions, tearing the banner in the process. At the upper left, a ribbon labeled "Civil Service Reform" is pulled by George H. Pendleton, holding a notice that states "Civil Service Reform will Save the Country" and at bottom left, a ribbon labeled "High Tariff"" is pulled by Samuel J. Randall, who holds a notice that states "High Tariff benefits the Laborer." At the center is Bayard with a notice in his pocket that reads "Let us dodge every question" and on the bottom right, a ribbon labeled "To the Victors belong the Spoils" is held by John Kelly, along with a notice that states "The Spoils Policy is the Safest Policy." Finally, at the top right, a ribbon labeled "Free Trade" is pulled by Abram S. Hewitt, who holds a notice that states "Free Trade benefits the Laborer." *Library of Congress*

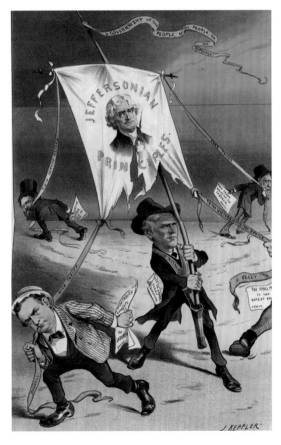

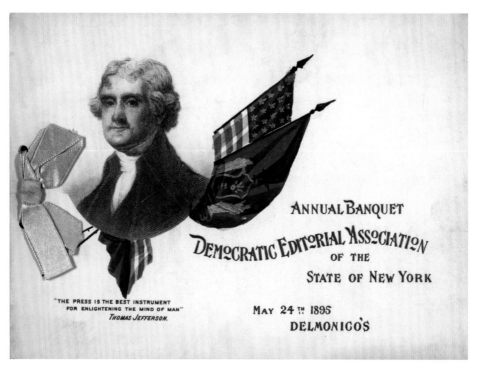

This menu published for the annual banquet of the Democratic Editorial Association of the State of New York held on May 24, 1895, at Delmonico's featured the portrait of Thomas Jefferson and this quote from the nation's third president: "The press is the best instrument for enlightening the mind of man." *New York Public Library*

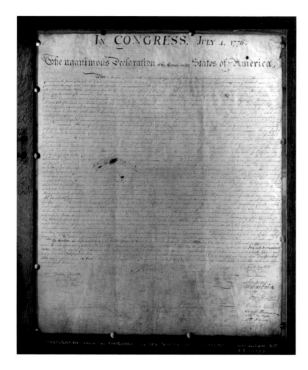

The Declaration of Independence (shown here) was photographed by Levin Corbin Handy (1855–1932) on April 23, 1903, on display just then in the United States Department of State. *Library of Congress*

The Declaration of Independence, displayed in a dimly lit hall at the National Archives reserved for the original Charters of Freedom, a term used to describe three documents in early American history that are considered instrumental to the nation's founding and philosophy. These documents are the Declaration of Independence, the Constitution, and the Bill of Rights. Carol M. Highsmith took this contemporary photograph of the Declaration on display. *Library of Congress*

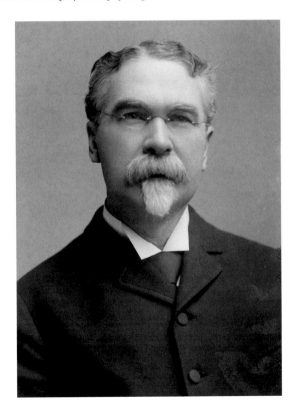

Senator James McMillan, pictured between 1873 and 1890, was photographed by C. M. Bell, a Washington, D.C. studio. *Library of Congress*

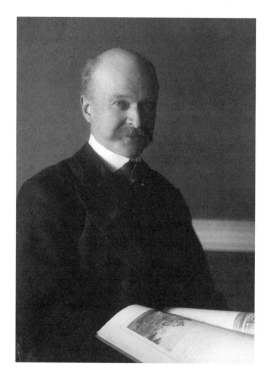

Frances Benjamin Johnston (1864–1952) took this half-length portrait of architect Charles Follen McKim (1847–1909) during the height of his involvement with the McMillan Commission. *Library of Congress*

Artist Kenyon Cox (1856–1919) finished this painting of sculptor Augustus Saint Gaudens (1848–1907) in 1908, a year after the artist's death. *Library of Congress*

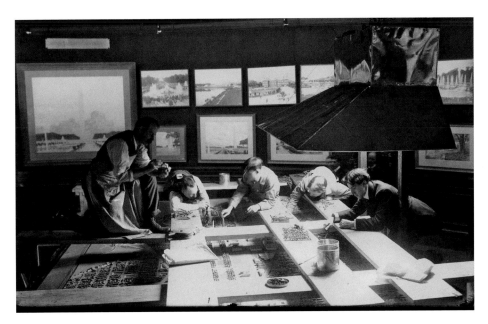

The building of the McMillan Commission model was photographed by Frances Benjamin Johnston in 1902. The photograph shows men working on the model for the redesign of the National Mall and other areas of Washington, D.C. *Library of Congress*

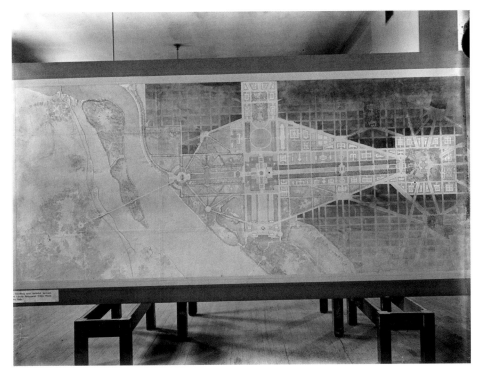

The McMillan Commission's future plan of Washington, D.C., dated 1901, was photographed by the Detroit Publishing Company. The map shows the area between the Capitol and Lincoln Memorial, White House and Potomac Park. *Library of Congress*

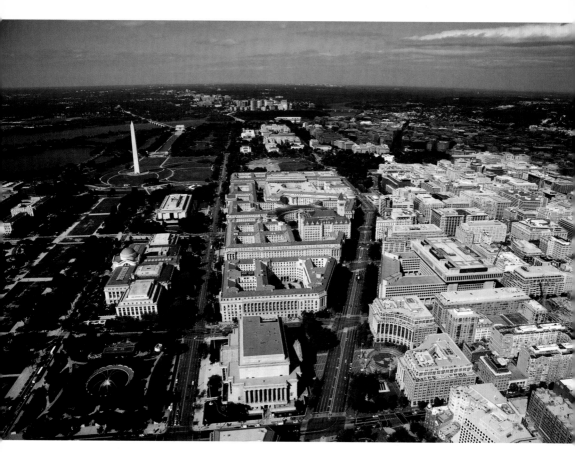

The Federal Triangle is the triangular area in Washington, D.C. formed by Fifteenth Street, Constitution Avenue, and Pennsylvania Avenue. It is the site of many United States federal government buildings, among them the Internal Revenue Service (IRS) fronting Constitution Avenue, and the Old Post Office Building. The French Renaissance-style Internal Revenue Service headquarters building was the first of these buildings of monumental scope to be erected in the 1920s and 1930s in the Federal Triangle area of the nation's capital, bounded by Pennsylvania and Constitution Avenues and Fifteenth Street and shown here (center). Like headquarters buildings of other departments and agencies in the Federal Triangle, it consolidated in a single location IRS functions and employees from disparate, often leased sites throughout the District of Columbia to a superblock between Tenth and Twelfth Streets, beside and behind the Old Post Office Building. The Internal Revenue Service Building and other Triangle structures that followed represented the largest public building project to that point in American history. The IRS building opened sixteen months ahead of schedule on June 1, 1930. An L-shaped northeast extension was added to the IRS building between 1934 and 1935, in part to accommodate the space needed for the Division of Distilled Spirits that had been created near the end of Prohibition in 1933. The extension completed the symmetry of the façade of the building along Tenth Street. The north side of the original IRS building and the western ends of its extension corridors were faced with unadorned red brick, rather than the Indiana limestone, anticipating demolition of the Old Post Office Building and completion of Department of Treasury supervising architect Louis Simon's plan. Demolition of the Old Post Office Building—thankfully—did not happen. The Triangle project was still under construction when President Franklin D. Roosevelt first proposed in 1934 the possibility of erecting a statue to Thomas Jefferson within the Triangle boundary. This September 20, 2006 photograph of the Federal Triangle was taken by Carol M. Highsmith. The Jefferson Memorial is out of frame to the left of the Washington Monument. *Library of Congress*

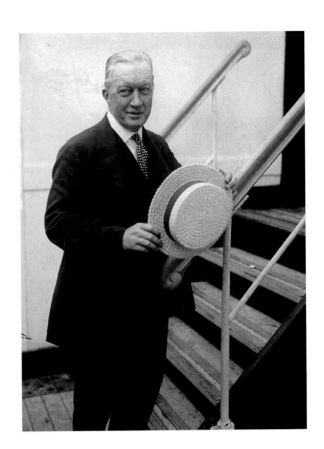

John Russell Pope, architect of the Jefferson Memorial, is shown in this undated photograph. *Library of Congress*

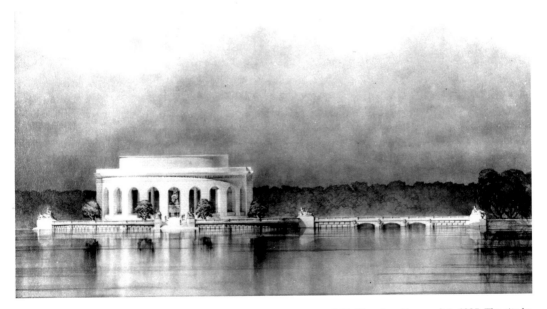

Architect John Russell Pope proposed this structure as a memorial to Theodore Roosevelt in 1925. The site he chose on the Tidal Basin was eventually allocated to Thomas Jefferson instead. *National Park Service*

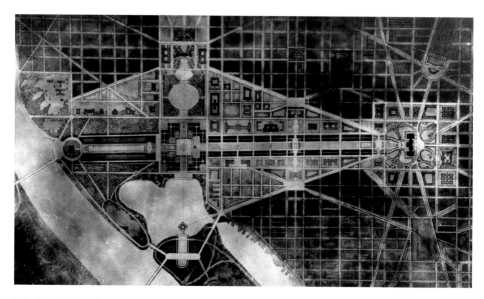

John Russell Pope's proposed site for the Theodore Roosevelt (subsequently taken by the Thomas Jefferson Memorial) fit into the McMillan Commission's plan for Washington, D.C.'s monumental core. *National Park Service*

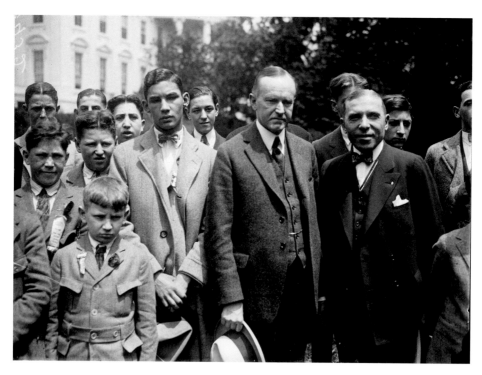

The "boy mayor of New York City" made the pilgrimage to the White House with members of the Thomas Jefferson Memorial Association in 1924. (Left to right, center of the picture): Maurice Worth (1907–1981, "the boy mayor"), President John Calvin Coolidge Jr. (hat in hand), and New York representative Sol Bloom (1870–1949), who began his career as an entertainment impresario and sheet music publisher in Chicago. *Library of Congress*

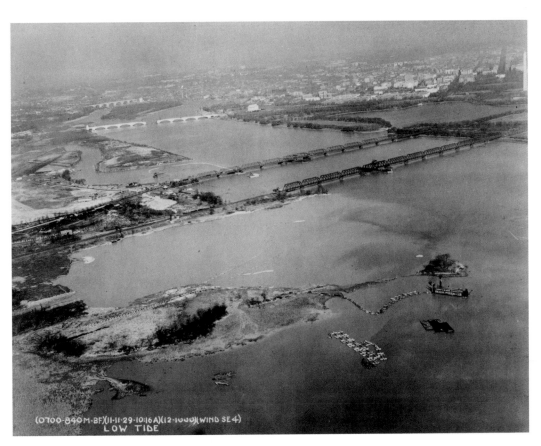

(0700-840M-BF)(11-11-29-10:16A)(12-1000)(WIND SE 4)
LOW TIDE

Dredging operations in the Potomac River were underway on November 11, 1929, when this photograph was taken at low tide. The future site of the Jefferson Memorial is upper right on the Tidal Basin below the Washington Monument. The double-bridge in the center is the Highway Bridge (later replaced, and today known as the Fourteenth Street Bridge). Boot-shaped Columbia Island, Arlington Memorial Bridge, Theodore Roosevelt Island (also called Analostan Island), and Francis Scott Key Bridge are visible upstream (to the left and top of the image). Note the pontoons between Columbia Island the north span of Highway Bridge, middle left. They indicate the area to be filled with dredged material from the Potomac River to create what will eventually be called the Pentagon Lagoon, and to narrow the outlet from Boundary Channel to the Potomac River. This will also allow the Mount Vernon Memorial Parkway (later named the George Washington Memorial Parkway) to be built along the axis of Columbia Island, cross the outlet channel, and proceed south below the soon-to-be-replaced Highway Bridge. Note the parallel pontoons in the lagoon south of Highway Bridge, which indicate where dredged material from the Potomac River will be placed to allow the parkway to continue south. The lagoon is the wide mouth of Roaches Run, a creek in Virginia. A large dredge can be seen tied up at the pier near the spit of land extending into the Potomac River. Several barges (to hold the material dredged up) are also nearby. *Library of Congress*

Before there was a Thomas Jefferson Memorial, the third president's birthday was commemorated at a host of other venues. Retired United States Army Reserve lieutenant colonel Francis Scott Key-Smith, the great-great-grandson of the author of "The Star-Spangled Banner," was photographed on April 13, 1932, placing a wreath on the statue of Thomas Jefferson at the Capitol Building in Washington, D.C., following a ceremony conducted under the auspices of the Society for the National Capital Memorial of Thomas Jefferson. A Harris and Ewing photographer took the photograph. *Library of Congress*

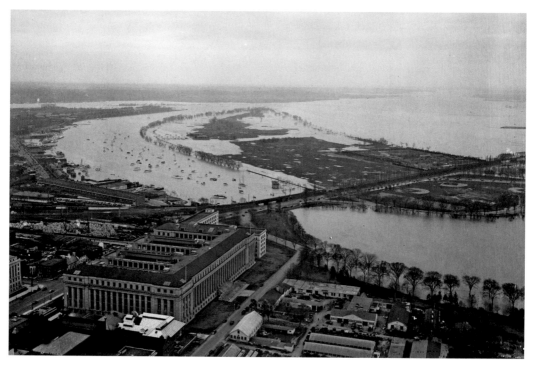

The future site of the Thomas Jefferson Memorial ("the Jefferson Memorial") (center right) was partly underwater when this picture was taken of flooding by a Harris and Ewing photographer on March 19, 1936. East Potomac Park above it (center) was almost completely submerged. *Library of Congress*

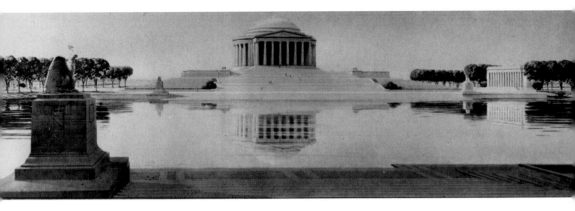

The proposed Thomas Jefferson Memorial, shown in this John Russell Pope rendering, was photographed on February 20, 1937. *Amy Waters Yarsinske*

Barry Faulkner's 1936 Declaration of Independence mural in the rotunda of the National Archives was also photographed by Carol M. Highsmith. *Library of Congress*

Following page, above: Otto R. Eggers and Daniel P. Higgins (left) were photographed by Gottscho-Schleisner in the client room of their firm—Eggers and Higgins—at 542 Fifth Avenue in New York City on February 7, 1941. The pair were longtime associates of John Russell Pope in the firm Pope founded in 1903 as the Office of John Russell Pope, Architect. Eggers was considered, even then, as an enormously talented designer and renderer who worked alongside Pope for almost thirty years. Eggers and Higgins changed the name of the firm to Eggers and Higgins in 1937, shortly after Pope's death. The firm was renamed The Eggers Partnership in 1970, and then as The Eggers Group, P.C. when it became a professional corporation in 1976. The firm eventually merged into what is now RMJM Hillier, a leading architectural firm with offices in the United States, the United Kingdom, and Asia. *Library of Congress*

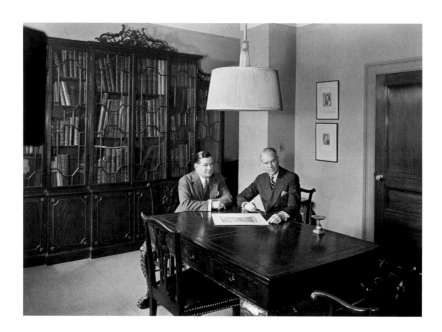

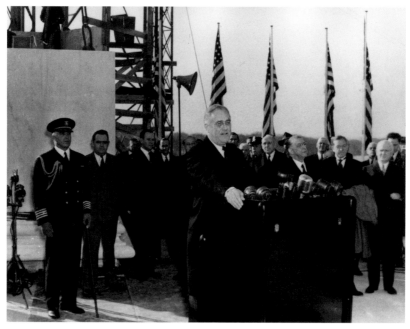

President Franklin D. Roosevelt was the keynote speaker at the memorial cornerstone laying on November 15, 1939. In his remarks, the president eulogized Jefferson's political ideals, praising Jefferson, he said: "He lived as we live in the midst of struggle between rule by the self-chosen individual or the self-appointed few, and rule by the franchise and approval of the many." Digressing from his prepared speech at the outset, Roosevelt told those gathered, "[...] I hope that by January of 1941, I shall be able to come to the dedication of the memorial itself." Roosevelt was referring to the upcoming 1940 election and whether he would win reelection to be on hand for the memorial's opening. *Franklin D. Roosevelt Presidential Library and Museum*

I

Setting the Stage: The Tidal Basin and Potomac Park

The Jefferson Memorial sits on the south side of the Tidal Basin in West Potomac Park on reclaimed land created during the construction of Hains Point. After reclamation and before the memorial was built, the area of newly created parkland was planted with trees and lawn. This area was often used for swimming by city residents. The memorial is bordered on the east and south by the approach to the George Mason Memorial (also called the Fourteenth Street) Bridge and on the north and west by the basin. It lies on the approximate axis of Maryland Avenue, directly south of the White House and due east of Arlington House on the Virginia side of the Potomac River.

Most of the land that became East and West Potomac Parks was originally underwater, unnavigable shoals, and what many would describe as useless swampland. The area was reclaimed first to facilitate bridging the river, and later as an essential sanitary measure. Though the backstory of this warren of mud flats-turned-parks begins prior to the 1809 construction of Long Bridge, for the purposes of this narrative, the building of the first permanent bridge across the Potomac River to the new capital city makes it a reasonable starting point. This first bridge occupied nearly the exact position as the present George Mason Memorial Bridge, and it became so heavily used that Congress authorized and funded construction of a second bridge seventy-five feet downstream. The area between the bridges became known as Potomac Flats. Decades later, in 1857, civil engineer Alfred Landon Rives submitted a plan to reclaim 166 acres of mud flats near Long Bridge to make a park. But it was not until the United States Army Corps of Engineers proposed in 1875 to fill in Potomac Flats using dredge from the silted-in Potomac that the land on which the Jefferson Memorial was later built began to take shape.

The reclamation of Potomac Flats and the excavation of the Tidal Basin had been authorized by Congress by an act dated August 2, 1882, which appropriated $400,000 for the project. But it was not until March 3, 1897, by another act of Congress that "the entire area formerly known as the Potomac Flats, and now being reclaimed, together with the tidal reservoirs, be, and the same are hereby, made and declared a public park, under the name of the Potomac Park, and to be forever held and used as a park for the recreation

and pleasure of the people." This act began the refinement and landscaping of the land for recreational purposes. During the dredging reclamation phase, the army corps of engineers sent then-colonel Peter Conover Hains[4] (1840–1921) to oversee the work. Two separate tracts of land were created. The southern end, roughly two miles long, paralleled the old shoreline of the Potomac River and became known as East Potomac Park.[5] The other, West Potomac Park, fell west of the Washington Monument. History informs that it was Hains who established the flow of water coming into the Tidal Basin through the inlet bridge, and out to the Washington Channel through the outlet bridge, thus solving the city's drainage problems and also the accompanying foul smell coming from surrounding Washington area marshland. The tip of East Potomac Park was subsequently named Hains Point in his honor. But Hains did not design the Tidal Basin nor the outlet design that moves the water in and out of it. The basin was initially named Twining Lake, in honor of army corps of engineers major William Johnson Twining (1839–1882), Washington, D.C.'s first engineer commissioner. According to testimony given to a congressional subcommittee in 1917, it was Major Twining's idea to create a tidal reservoir and use that water to help "flush" the Washington Channel. After Twining's death, Hains carried out his plan. A 1917 army corps of engineers map of Washington already shows the basin with the name "Twining Lake."

After most of the present area had been filled, the Potomac River that had once flowed very near the base of the Washington Monument was now routed some distance westward from the monument. The Washington Channel, which lies between Hains Point (the point of confluence of the Potomac and Anacostia Rivers) and the old Naval Air Station Anacostia, was kept open and separate from the river to provide a quiet harbor. Unlike the river, the channel was inclined to fill with mud. To resolve this, it became necessary to regulate the tidal pools in the western part of the Potomac Park used for washing out the channel daily. This necessitated the creation of the Tidal Basin, an artificial body of water attributed to Hains, which at high tide fills up with water flowing through the inlet bridge and at low tide, expels the surplus water under the Fourteenth Street Bridge at the lower end of the basin. Thus, it sweeps through the Washington Channel taking away mud and sand and keeps the ship lanes of the channel open. Reclamation work on the parks and Tidal Basin was largely completed by 1890.

The Office of Public Buildings and Grounds[6] [a department within the army corps of engineers] set out to develop a new park that "preserved the features of its natural beauty or enhanced the natural landscape." This was done primarily, according to government accounts, to clear the land for playing fields and picnic grounds, and by the erection of several memorials. The 1882 to 1913 program of channel clearing that had produced sufficient fill to create both West and East Potomac Parks also produced a largely flat topography that dips slightly at the Reflecting Pool, rises slightly around the Lincoln Memorial, and declines to the banks of the Potomac River and the Tidal Basin. Most of the site is between ten and fifteen feet above sea level. Due to the fact that West Potomac Park is manmade, it has no natural features with the exception of the Potomac River, which is an important visual component of the park, and which constitutes much of its western boundary.

Much of the credit for the early decision to dedicate the former Potomac Flats as public parkland is due to army corps of engineers colonel Theodore Alfred Bingham (1858–1934),[7] the Office of Public Buildings and Grounds' officer-in-charge from 1897 to 1901. Bingham was keenly in tune with contemporary thought that parks were so-called "breathing spaces" essential to the "promotion of mental growth" and the cultivation of civilized values.[8] Bingham was an apostle of the greater aesthetic and social movement that was afoot in Washington and across the nation. The World's Columbian Exposition of 1893, held in Chicago, Illinois, solidified the City Beautiful movement promoted by architects and landscape architects like Daniel Burnham, Charles McKim, and Frederick Law Olmsted Jr. The fair featured—and lauded—gleaming white, classically inspired buildings arranged in a formal landscaped setting of sparkling fountains and lagoons. As Washington celebrated its centennial, these designers and their colleagues at the American Institute of Architects envisioned Washington as the White City on the Potomac—a permanent manifestation of the ideals exhibited temporarily on the shores of Lake Michigan.[9]

Bingham saw the rising mud flats as an unparalleled opportunity for the extension of the system of Washington's public spaces and the restoration of the National Mall.[10] Reacting to a congressional directive in 1898, Bingham made a thorough study of the history of the federal property in the District of Columbia, assembling all of the early documentation of the city that still existed. It was largely Bingham who generated the intense turn-of-the-century revival of interest in the original plan for Washington, and who prompted Michigan senator James McMillan to push for a series of measures that ultimately resulted in the establishment of the Senate Park Commission, otherwise known as the McMillan Commission.

The historical record indicates that the before the Senate Park Commission was prepared to act, Congress had been persuaded to pass the law that ended the pressures of real estate interests to allow subdivision and private development of the reclaimed flats, or any portion of them, approving the aforementioned March 3, 1897 declaration. In the year that followed, Congress transferred control of all District of Columbia parts to the Office of Public Buildings and Grounds. Bingham, officer in charge just then, soon turned his attention to the improvement of Potomac Park, an open canvas only in the parts that had already been reclaimed. Significant reclamation work and projects tied to the same were still ongoing and technically fell under the auspices of river and harbor improvements until completed. In 1901, the Washington District turned over control of a large parcel of land between the Tidal Basin and Washington Monument grounds to Bingham, which he soon cleared and graded. Further, he raised the Tidal Basin revetment wall, and built a fifty-feet-wide macadam drive along the east side of the reservoir.[11]

The idea for what is today the Tidal Basin inlet bridge originated with the initial plans for the reclamation of Potomac Flats. After the reservoir outlet[12] was finished in 1889, the engineers decided to "let the necessity of inlet gates be determined by experience," according to Hains' documentation of events dated January 1894.[13] It was not until 1907 that action was taken toward building an inlet bridge. The inlet bridge was the last engineering work of the [reclamation] project. Army corps of engineers colonel Charles S. Bromwell,

superintendent of the Office of Public Buildings and Grounds, observed the necessity for a connector—a roadway—over the inlet. In addition to this notation, the district engineer decided also that year that inlet gates were required because of excessive silt in the reservoir. The River and Harbor Act of 1907 made the construction of inlet gates official. Bromwell's recommendation also gained enough traction that additional funds were acquired the following year, in 1908, to combine the inlet gates with a bridge.

Begun in April 1908, construction of the inlet bridge used a cofferdam set in place after dredging and employed the same equipment and tools used in the construction of the reservoir outlet. Carter and Clarke, a Washington, D.C. based contracting company, drove the 1,184 pilings. J. B. Kendall supplied steel gates and the operating mechanisms at a cost of $8,997. Colonel Spencer Cosby and later Major Jay Morrow, both of the army corps of engineers, supervised the construction of the inlet bridge and employed day labor for the construction. Nathan Corwith Wyeth[14] (1870–1963), the architect who designed it, employed the use of ornamental concrete to face the bridge. Wyeth's design also called for bronze lighting standards, since they complimented the design and style of the structure. Wyeth specified that the standards were to be placed on top of the four concrete piers on the central lock span. The final design for the lighting standards was a collaboration between John Williams, Inc. and Wyeth. The Roman Bronze Works, then headquartered in Brooklyn, New York, manufactured the standards at a cost of $2,130. In 1912, upon installation of the standards with their striking white glass globes, the bridge was declared complete. The project, which had taken nearly a full four years, cost $120,000.

From the beginning, park service engineering records indicate that the inlet bridge was not only a functional structure on its own but also an integral link to the larger entity surrounding it—Potomac Park. The bridge reflects the principles of landscape architecture and park design that were promoted by the McMillan Commission of 1901/02 for the National Mall area that included Potomac Park. Since it was located at a point of high visibility in the park, it was considered essential that it be an aesthetically pleasing design, which Wyeth accomplished. There were many activities that occurred in West Potomac Park facilitated by the bridge's construction. Cosby built a bandstand in 1909 near the bridge, and the success of it was largely due to the easy access created by the new inlet span. Further, the inlet bridge facilitated other activities in the park, including Japanese cherry blossom viewing in the spring and future establishment of a public bathing beach in the basin. The amount of vehicular traffic that might use the bridge was incalculable when it was built. But soon after it opened, resulting traffic congestion from all of the aforementioned activities by the end of the nineteen teens prompted attempts to resolve the problem. One-way traffic was established on the bridge in 1922 as a temporary measure. Four years later, in 1926, the bridge was widened from twenty-five feet to thirty-two feet because the traffic flow had become more than the span was intended to handle. At the same time the bridge was widened, Wyeth's lighting standards were also removed.

Most of the early work done in West Potomac Park consisted of grading and paving a roadway, and in 1904 of lining the parkway west of Seventeenth Street with portrait statuary. Three years later, in 1907, a boat dock was constructed near the bathing beach on the Tidal

Basin, and the following year, the polo field west of the basin was graded and a wooden bandstand built. Meanwhile, according to site documentation, macadam roadways, the inlet bridge, bridle paths and walkways were being completed throughout the park. In addition to the Japanese cherry trees planted in the parks and around the Tidal Basin, gifted to the city in the spring of 1912 by the mayor of Tokyo, Japan (and discussed in the chapter that follows), to these were added fifty-five flowering peach trees. Tree planting was not the only improvement to an otherwise blank canvas. Dedicated on April 17, 1912, the John Paul Jones Memorial was the first monument raised in West Potomac Park. The memorial is located near the National Mall at the terminus of Seventeenth Street Southwest near Independence Avenue on the northern bank of the Tidal Basin. The memorial honors John Paul Jones, the United States' first naval war hero; father of the United States Navy; the only naval officer to receive a Congressional Gold Medal during the Revolutionary War, and whose famous quote "I have not yet begun to fight!" was uttered during the Battle of Flamborough Head. Work on the Lincoln Memorial, to also be built in the boundary of West Potomac Park, was started in 1913 with Henry Bacon as the commissioned architect and Daniel Chester French as the Lincoln statue sculptor. The Lincoln Memorial was dedicated on May 20, 1922.

There was a proposal for a bathing beach on the Tidal Basin as early as 1914, when Nebraska senator George Norris first introduced the idea to Washingtonians. But when Norris asked Congress for the $50,000 to do it, some of his congressional colleagues turned him down, enough to kill the project. The objection was clear just then: the basin waters were far too polluted for a bathing beach. Washingtonians would have to stick, for the time being, with the one, whites-only overcrowded public pool in the city. The results of a pollution study reported in the December 11, 1915 *Washington Evening Star*[15] revealed that the basin was full of wastewater and sewage. Still, according to most reports, Norris pressed for a swimming hole for residents at the Tidal Basin, confident the problems it had could be fixed. He persisted. But the argument did not begin to turn in his favor until a drowning in the Tidal Basin on July 19, 1916, changed the narrative. The man who drowned, according to the next day's[16] *Washington Evening Star*, could not be saved "primarily because there was no means of rescuing him when he got into trouble in the water." After this tragedy, Norris garnered the support of army colonel William W. Harts, then superintendent of the Office of Public Buildings and Grounds, to include construction of a proper beach with lifeguards and the facilities to keep swimmers safe.[17] According to published accounts in the February 20, 1917 *Washington Evening Star* and the more recent WETA [Greater Washington public television] history blog, with one man dead and Washington residents and visitors persisting in using the waters of the basin to swim, Congress' hand was forced. On February 2, 1917, Norris' Tidal Basin bathing beach was put into a bill with $35,000 appropriated for the project.

To address the pollution as well as provide proper facilities for bathers in the Tidal Basin, the Sundry Civil Appropriations Act for the fiscal year ending June 30, 1918, authorized the chief of the army corps of engineers to "establish and maintain at a suitable place upon the shore of the Tidal Basin, in Potomac Park, a public bathhouse, with the necessary equipment, with a sloping sandy beach." The act also called for a liquid-chlorine system to

tamp down the dirty waters of the basin for swimmers. With this instruction, not only was the traffic burden borne by the inlet bridge to become much greater, but the structure also was to provide the site for the location of the equipment for chlorinating the waters of the Tidal Basin. Four liquid-chlorine dispensing mechanisms were installed in the arches of the inlet bridge in the spring of 1918.[18] The Tidal Basin beach and accompanying facilities, on the site of the future Jefferson Memorial and juxtaposed nearly halfway between the inlet and outlet bridges and in direct receipt of the freshwater flow between the two, was completed by late summer, same year. Over two thousand people attended the water carnival that opened the beach on August 24, 1918, according the following day's *Washington Herald*. The paper touted, in the story line, the popularity of the tug of war event.[19] The popularity of the Tidal Basin beach grew exponentially in the years that it remained open to patrons. Lines to get in grew long and it was subsequently estimated that more than twenty thousand people visited the beach in the span of one ten-hour day.[20] After a plan for a black beach on the basin's north shore gained traction—and funding—six years later, heated congressional debate ensued. Arguing against the scheme for a beach and facilities for Washington's black population, senators pulled funding already appropriated for the site. When the debate still refused to die quietly, Congress threw up its collective hands and permanently closed all bathing in the Tidal Basin on February 18, 1925, all, in truth, to avoid further discussion of racial integration.

Elsewhere in West Potomac Park, Woodrow Wilson's administration authorized the construction of two concrete office buildings along Constitution Avenue, west of Seventeenth Street, to be occupied by the War and Navy Departments during the First World War; they were completed in 1918 as "temporary" but were not demolished until 1970. With the completion of the Reflecting Pool and the smaller transverse pool at its east end in 1922, the basic present design of West Potomac Park was completed. Although there would be later construction in the park, all land just then was considered reclaimed and in use for recreational purposes.

Also of note, the first improvements to East Potomac Park during this period consisted of construction of a macadam roadway around the fringes of the park, filling in low spots behind the seawall, planting more cherry trees and laying out a bridle path. During the war years, several acres of East Potomac Park were used by local Boy Scouts as "war gardens" to produce corn. The first nine of the golf greens at the east end of the island were completed in 1917 and the last nine in 1922. During this era, fifteen acres of East Potomac Park were occupied by forty-one wooden buildings housing regular army troops on guard duty in Washington. A ferry was launched at this time and for three years carried visitors from Seventh Street across the Washington Channel to Hains Point. An automobile tourist camp was set up in 1921 near the railroad bridge on the site of the buildings that had housed the troops during the war. In 1920, a permit was granted to the Girl Scout Association of the District of Columbia to serve tea and refreshments to the public, and to erect a temporary shelter and install tables in the northern portion of Hains Point. The Girl Scouts called it the Willow Point tea house, an old streetcar erected under a large willow tree. They pitched tables on the lawn out front, which proved to be an attractive stopover to the public.

Two years after the Willow Point tea house opened, the Office of Public Buildings and Grounds made a request to Congress to construct a comfort station at Hains Point. The increased use of East Potomac Park by motorists using the so-called Speedway necessitated the provision of shelter and toilet facilities at the extreme end of the park, just then at least three miles from the nearest lodging or comfort station. Drawings for the new shelter were approved by army corps of engineers' lieutenant colonel Clarence O. Sherrill, in charge of the Office of Public Buildings and Grounds, in late 1923. Construction of the new shelter and comfort station was practically completed the following year. In September 1924, the Girl Scout Association, District of Columbia, which had operated the lunch and refreshment stand at Hains Point were permitted to move into and occupy three rooms in the new building to continue the tea house, after which their old quarters were torn down and the site returned to parkland.

Meanwhile, according to National Park Service historical record, the Office of Public Buildings and Grounds was abolished and the Office of Public Buildings and Public Parks of the National Capital was created by an act of Congress dated February 26, 1925. The new office consolidated the old Office of Public Buildings and Grounds with the office of Superintendent of the State, War and Navy Buildings. The new director of the office was still selected from officers of the army corps of engineers. Appointed director of the new agency, Lieutenant Colonel Ulysses S. Grant III informed the Girl Scouts that their concession at the tea house expired on December 31, 1925, and would not be renewed.

With the reorganizing of park management, also in 1925, one of the first jobs completed by Grant's new mandate was the elimination of the Tidal Basin bathing beach, thus restoring the lawn area around the basin. But this new management arrangement did not last long. On June 10, 1933, the Office of Public Buildings and Public Parks of the National Capital was reorganized under the United States Department of the Interior and on March 2, 1934, was further reorganized as part of the National Park Service.

The Second World War also brought a reversal in the use of both parks and the Tidal Basin, although it did not stop construction of the Jefferson Memorial, which was well underway when the Japanese attacked the United States Pacific Fleet at Pearl Harbor on December 7, 1941. Many temporary wartime measures affecting the parks were enacted. Notably, the polo field[21] was covered with six inches of asphalt for a parking lot. Dormitories were built to provide housing for women working in Washington, D.C., during the war. Four years later, in 1949, these buildings were converted into offices for the War Assets Administration but ultimately razed in 1965. In the intervening years, of note, a plaque memorializing the first air mail flight from Washington, D.C., was also dedicated near the river in West Potomac Park in 1958. At one time, several acres of the park had been used for an airfield and the first air mail flight to New York, via Philadelphia had taken three hours just four decades before, in 1918.

Meanwhile, on the east end of Potomac Park, Hains Point settling necessitated recurrent dumping of dredged mud. The National Park Service operated a restaurant out of the former Girl Scout tea house until 1962, when it became a visitor center. In 1969, it was used as office space, housing the park service's ecological services laboratory, which continued

until January 20, 1985, when the condition of the building violated numerous health and safety codes for laboratory use. Periodic flooding from the Potomac River made the building uninhabitable. Concurrence to tear down the building came on July 16, 1987.

West Potomac Park is a designed landscape that contains numerous naturalistic vistas, such as grassy areas, others occupied by shrubbery, trees and other vegetation, and bodies of water, which vary in size from the one hundred and ten-acre Tidal Basin to the relatively diminutive (defined as less than an acre) Rainbow Pool. The four major bodies of water in the park are thus the Tidal Basin, the Reflecting Pool, the Rainbow Pool, and the lake in Constitution Gardens. The stone retaining walls[22] ringing the Tidal Basin date largely from the 1880s and 1890s; however, major sections of the walls were replaced when the Kutz Bridge was built in the 1940s, and when the Jefferson Memorial was constructed between 1939 and 1943. An eight-foot-wide concrete walk caps the retaining walls around the perimeter of the Tidal Basin.

West Potomac Park today is a large, complex site that encompasses numerous elements of historical, landscape, and architectural significance. In the northern portion of the park, the axis created on the National Mall, the long east-west greensward stretching from the Washington Monument grounds to the Capitol, is extended west to the Lincoln Memorial. This portion of the park is part of one of the single best-known and most important land-scapes in the United States, what has been called "the most beautiful place man has made in America."[23] In addition to many other monuments, the park is the site of the Lincoln and Jefferson Memorials, two of the three major commemorative monuments that define Washington, D.C.'s monumental core and that also define the nation's capital.

Because it is an integral feature of the ceremonial heart of Washington, the landscaping, placement of built features, and physical shape of West Potomac Park have been molded by successive city planning efforts, all well documented by federal and district government departments and agencies. West and East Potomac Parks are, in fact, a central feature of these plans, the most prominent of which were the L'Enfant Plan of 1791 and the McMillan Plan of 1901/02. Although the L'Enfant Plan established the overall concept that was to be later applied to West Potomac Park, because most of the land was not created just then—and would not be for nearly a century later—most aspects of the park's overall design, to include its traditionally baroque plan, long vistas, axial relationships, and expansive open spaces—are associated with the later McMillan Plan.

Covering roughly four hundred acres in the northwest and southwest quadrants of Washington, the boundaries of West Potomac Park are generally defined by Constitution Avenue Northwest to the north, Seventeenth Street and the banks of the Tidal Basin to the east, the Potomac railroad bridge to the south, and the Potomac River to the west. Nearly a quarter of the total acreage of the park is occupied by the asymmetrical quatrefoil-shaped Tidal Basin. Spatial relationships, most of which are a direct legacy of the McMillan Plan, are a key component of the design of the park. These relationships are distinctly different north and south of Independence Avenue Southwest. Most of the land area of the park, which is located to the north of Independence Avenue Southwest, has distinct, linear, east-west orientation representing the continuation of axis established on the National Mall running

westward from the Capitol. The strong axial relationship between the Lincoln Memorial and the Capitol, one of the touchstones of the McMillan Plan, is the defining feature of this section of the park. But south of Independence Avenue Southwest, West Potomac Park has an irregular, asymmetric shape, influenced by the equally irregular shape of the Tidal Basin. To the west of the Tidal Basin, the park consists mostly of a peninsula of land defined by the curvilinear shape of the Tidal Basin on the north and east and by the generally linear Potomac River bank on the southwest. This spit of land ends at the inlet to the Tidal Basin. The small portion of the park on the west of the Tidal Basin is also irregular in shape; it is defined by the curved outline of the Tidal Basin from the northeast to the southwest and by the straight northeast/southwest line of the Potomac Railroad Bridge, the farthest south of the grouping of roads and bridges clustered at Fourteenth Street. This piece of land, which is actually the westernmost part of the land mass on which East Potomac Park is also located, is the site of the Jefferson Memorial.

Although physically separated from the National Mall by the Tidal Basin, the location of the Jefferson Memorial was also an integral feature of the plans that molded the design of Washington's monumental core. The site is the "open end point" of the axis, a continuation of Sixteenth Street, which runs south from the White House. This cross axis, one of the integral features of the L'Enfant Plan of 1791, was affected by the off-axis placement of the Washington Monument. The restoration of this important feature of the L'Enfant Plan was one of the major goals of the McMillan Plan, as was the location of a major monument at its southern end (that "monument" became the site of the Jefferson Memorial).[24]

The National Park Service, in its extensive documentation of the parks and Tidal Basin, much of which has been cited here, has placed significant emphasis on and maintaining of the vistas that further define West Potomac Park. Of these, the view along the axis between the Capitol and the Lincoln Memorial is such a well known American image that it has become a symbol of Washington as the nation's capital. The most important vistas follow the axial relationships in the park. The two most significant of these are the vista between the Lincoln Memorial and the Washington Monument, and the vista between the Jefferson Memorial and the White House. Both of these vistas were integral features of the McMillan Plan, and the vista from the current site of the Jefferson Memorial was also called for in the L'Enfant Plan. Other important vistas include those along Twenty-Third Street from Washington Circle to the Lincoln Memorial, from the Lincoln Memorial across the Arlington Memorial Bridge to Arlington House, and along Seventeenth Street from Constitution Avenue Northwest to the John Paul Jones Memorial. Additionally, due to large open spaces, there are many other views that are essential features of the park, including but no limited to views in all directions to and from the Jefferson Memorial, views in all directions to and from the Lincoln Memorial, and views beneath the canopy of the elm trees that line the axial section of the park near the Reflecting Pool.

Circulation in the northern section of West Potomac Park is dominated by the continua- tion of patterns established on the National Mall. Major east-west vehicular circulation in the park is bounded by Constitution Avenue Northwest (to the north) and Independence Avenue Southwest (to the south). At their western ends, these roads connect to Rock Creek

and Potomac Parkway and provide access to two Potomac River bridges: Arlington Memorial Bridge, built between 1926 and 1932, and Theodore Roosevelt Bridge (1964). North and south circulation in the park is via Seventeenth Street (the eastern boundary of the park), and Twenty-Third Street (to the west). Keyed to more localized traffic is Ohio Drive Southwest, which runs parallel to the Potomac River from the Lincoln Memorial southeast to East Potomac Park. Also smaller and more park-oriented, West Basin Drive follows the Tidal Basin northward from the Tidal Reservoir Inlet Bridge. At the Kutz Bridge, the road becomes East Basin Drive as it continues around the Tidal Basin to the Jefferson Memorial. To the south and east of the Tidal Basin, a collection of roads, including Fourteenth and Fifteenth Streets, act as access routes to Potomac River bridges. Parallel and to the south of these, the elevated Potomac Railroad Bridge constitutes the dividing line between West and East Potomac Parks. Bridges that cross the Potomac here include (from north to south): the George Mason Memorial Bridge (1962), the Rochambeau Memorial Bridge (1950), the Arland D. Williams Jr. Memorial Bridge (1971), the Metrorail [subway] Bridge (1980), and the Potomac Railroad Bridge (1906).

West Potomac Park continues to be one of the nation's preeminent public spaces. The park is the primary location for national political demonstrations, rallies, and parades, and is also the site of more festive gatherings such as Washington's annual Fourth of July celebration, held around the Washington Monument, and the National Cherry Blossom Festival, centered on the Jefferson Memorial. As the site of the Lincoln, Jefferson, Franklin Delano Roosevelt, and Vietnam Memorials, as well as many smaller or lesser known memorials and monuments, the part remains one of the foremost tourist destinations in the nation's capital.

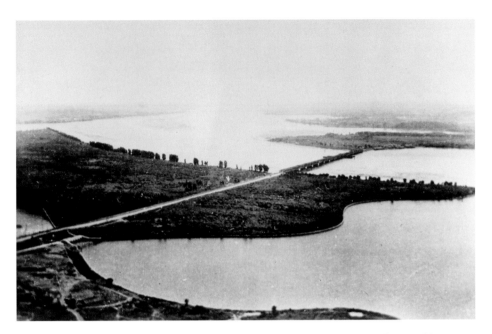

This view of the Potomac River and Tidal Basin was probably taken from the Washington Monument during the Civil War. The land mass center on the basin is the site of the future Thomas Jefferson Memorial. *National Archives*

This view looking west-southwest with Maryland Avenue Southwest and B Street Southwest (later Independence Avenue Southwest) to the left, Maine Avenue, Third, Four-and-a-half, and Sixth Streets Southwest to the center includes several important landmarks of the nation's capital as it looked at the height of the Civil War: The Mall, Washington Armory, Armory Square Hospital, Smithsonian Castle, Washington Canal, botanic garden, gas works, Washington Monument (under construction), and the Potomac River. *Library of Congress*

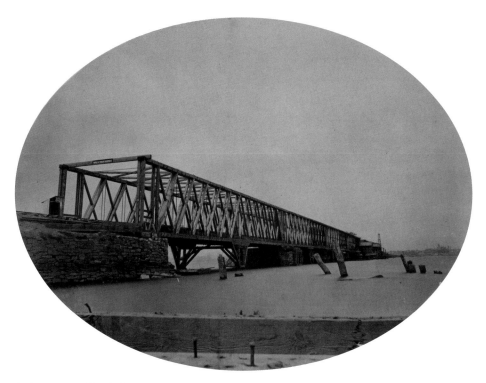

Andrew J. Russell took this picture of the early Long Railroad Bridge over the Potomac River from the Virginia shore during the Civil War. *Library of Congress*

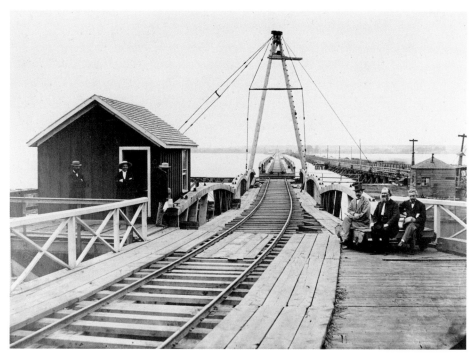

Long Railroad Bridge across the Potomac River is shown here as it looked in 1865. *Library of Congress*

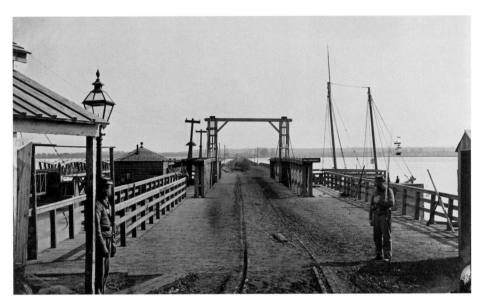

Taken in May 1865, this picture of Long Railroad Bridge was photographed from the Washington, D.C. side of the Potomac River. *Library of Congress*

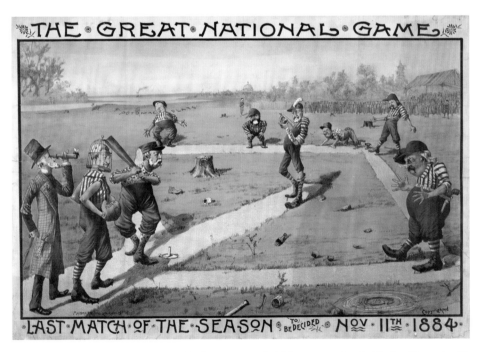

The great national game, the last match of the season of which was set to be decided on November 11, 1884, is the subject of this period MacBrair and Sons lithograph. The print shows a sandlot baseball game of presidential hopefuls with James G. Blaine pitching to Chester A. Arthur, with Samuel J. Tilden behind the plate and Roscoe Conkling as umpire. At first base is Benjamin F. Butler with a handgun in his belt, at second base is John A. Logan holding Ulysses S. Grant close to the bag, at shortstop is John Kelly, and at third base is Sereno E. Payne. In left field is John Sherman and in centerfield is Samuel J. Randall. They are playing on a field labeled "Potomac Flats" with the Potomac River in the background. *Library of Congress*

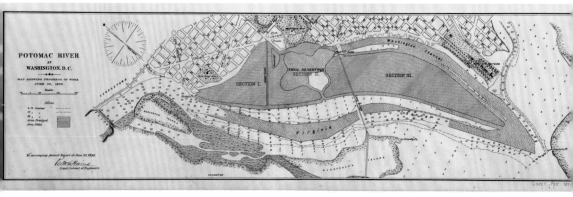

Lieutenant Colonel Peter Conover Hains submitted this map of the Potomac River showing progress of reclamation work with a copy of his written report dated June 30, 1890 [as is the map]. The map, oriented with north toward the upper left, indicates dredged and reclaimed Potomac Park areas, and depths determined by soundings and contours. *Library of Congress*

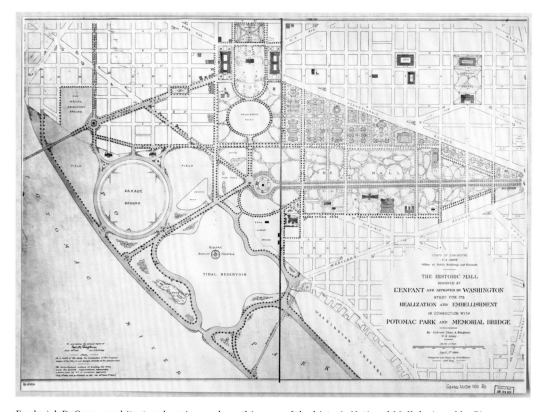

Frederick D. Owen, architect and engineer, drew this map of the historic National Mall designed by Pierre L'Enfant and approved by George Washington as a study piece for its realization and embellishment in connection with Potomac Park and Memorial Bridge. Owen completed the map under the supervision of Colonel Theodore A. Bingham on April 1, 1900. The map also shows existing and planned government buildings. *Library of Congress*

President Theodore Roosevelt (left) and Colonel Theodore A. Bingham, the president's military aide, were photographed leaving the German embassy in Washington, D.C., by carriage on April 5, 1902. Roosevelt, accompanied by Bingham, was returning Prince Henry of Prussia's call. The prince (1862–1929), a career naval officer who rose to the rank of grand admiral, was the younger brother of German emperor Wilhelm II (also known as Kaiser Wilhelm II) and a grandson of Great Britain's Queen Victoria. Bingham's stint working in the White House as a presidential aide was short-lived. According to the White House Historical Association, in 1903, Washington newspapers declared a "social war" had broken out between Bingham and Isabella Hagner, first lady Edith Roosevelt's executive clerk. With the first lady backing Hagner, Bingham "got his walking papers."[25] *Library of Congress*

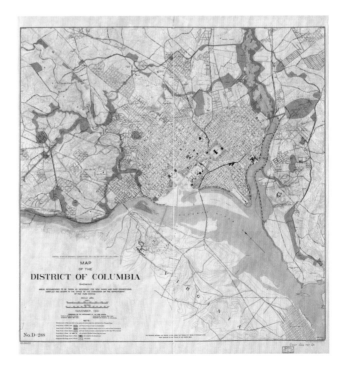

The map of the District of Columbia shown here, dated November 1901, and drawn in the Office of the Commission on the Improvement of the Park System, illustrates the public reservations and possessions and areas recommended to be taken as necessary for new parks and park connections. The quatrefoil-shaped body of water near the center of the drawing is the Tidal Basin. *Library of Congress*

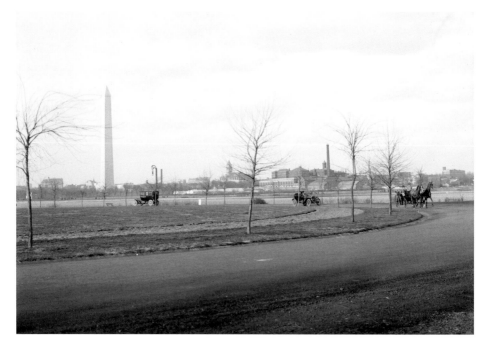

The Boulevard in West Potomac Park was photographed in 1905 by the Detroit Publishing Company and was taken of the approximate location of the future Thomas Jefferson Memorial. The picture also shows the Washington Monument and Washington Channel. *Library of Congress*

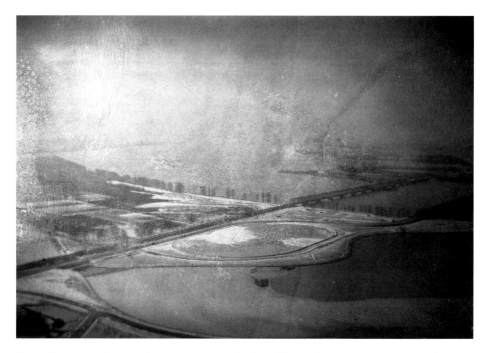

Sidney Duff took this picture looking south from the top of the Washington Monument that shows ice covering half of the Tidal Basin as well as the future site of the Jefferson Memorial in January 1908. *Robert Ketcherside*[26]

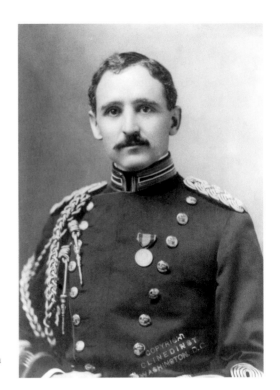

The half-length portrait of Spencer Cosby in his army colonel's dress uniform, facing left, (shown here) was taken in 1909. *Library of Congress*

A Harris and Ewing photographer took this picture of Washington, D.C. residents traveling to a concert in Potomac Park between 1909 and 1913. The touring car bears the seal of the president of the United States. Seated left in the car (looking at the photographer) is Helen Herron Taft, wife of President William Howard Taft. *Library of Congress*

Looking north across the Tidal Basin to the Washington Monument and United States Bureau of Engraving and Printing between 1911 and 1917, this Harris and Ewing photograph provides a particularly early ground-level view of the area. This picture was also taken before the Lincoln Memorial. Note the aerial balloon (right). The future Jefferson Memorial site is out of frame, also to the right. *Library of Congress*

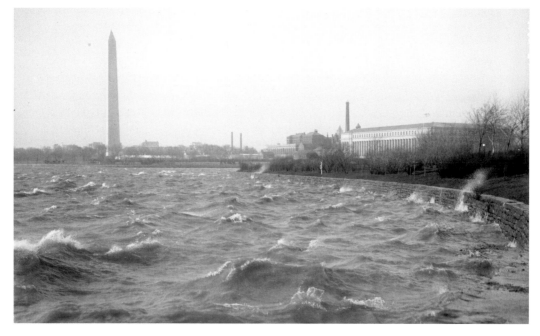

A Harris and Ewing photographer took this picture of a storm that produced white caps on the waters of the Tidal Basin between 1910 and 1917. The shoreline to the right was eventually designated as the future site of the Jefferson Memorial and surrounding grounds. *Library of Congress*

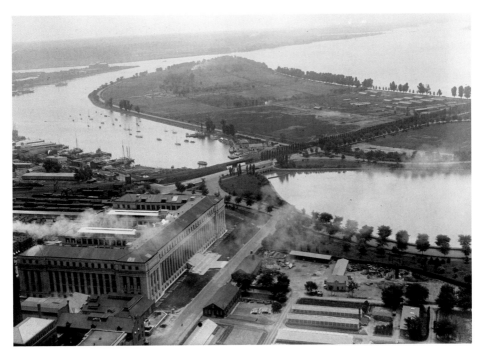

This aerial view of the Tidal Basin, taken between 1916 and 1919 by a Harris and Ewing photographer, also shows the Bureau of Engraving and Printing (lower left). Hains Point can also be seen at the top, center of the picture. *Library of Congress*

Glenn H. Curtiss (standing in the cockpit) conducted airplane tests and demonstrations of a twin-engine biplane in Potomac Park. The photograph by Harris and Ewing dates to 1916. *Library of Congress*

This is another view of the twin-engine biplane tested by Glenn Curtiss in Potomac Park in 1916. *Library of Congress*

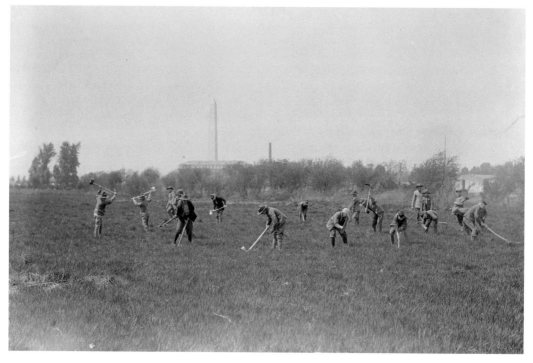

Boy Scouts were photographed in 1917 preparing a field in Potomac Park south of the future Jefferson Memorial site for their corn crop. The Washington Monument is visible center. *Library of Congress*

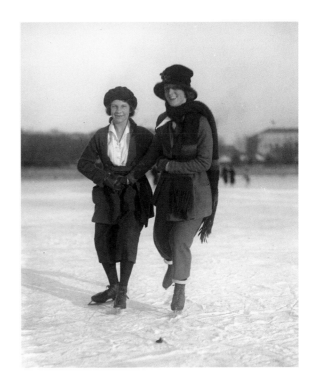

Elizabeth "Betty" Baker (left), daughter of Secretary of War Newton Diehl Baker Jr. and Elizabeth Wells Leopold Baker, and Annie Kittleson were skating on the Tidal Basin when this picture was taken on January 5, 1920. Baker was Woodrow Wilson's war secretary from 1916 to 1921. *Library of Congress*

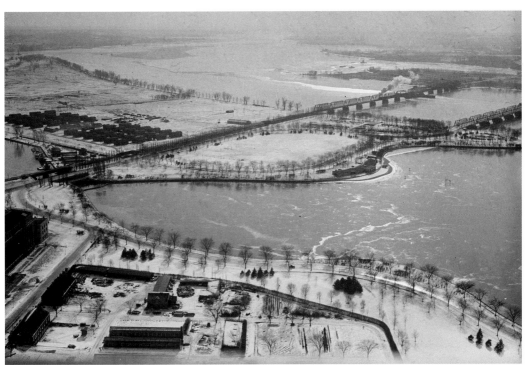

A January/February 1922 snow storm blanketed Washington, D.C., and the Tidal Basin (shown here). The basin froze over. Note the bathing facilities and beach (right center on the shoreline), the large area behind and down to the basin were the future site of the Jefferson Memorial. *Library of Congress*

Above: Frances Benjamin Johnston (1864–1952) took this picture of West Potomac Park in 1921. West Potomac Park, a national park, is adjacent to the National Mall and includes the parkland that extends south of the Lincoln Memorial Reflecting Pool, from the Lincoln Memorial to the grounds of the Washington Monument. The park is the site of many national landmarks, including the Korean War Veterans Memorial, Jefferson Memorial, Franklin Delano Roosevelt Memorial, George Mason Memorial, and the Martin Luther King Jr. National Memorial. The park includes the surrounding land on the shore of the Tidal Basin, an artificial inlet of the Potomac River created in the nineteenth century and that links the Potomac with the northern end of the Washington Channel. The land was set aside for development by the McMillan Commission in 1902, and the park was completed in May 1922. *Library of Congress*

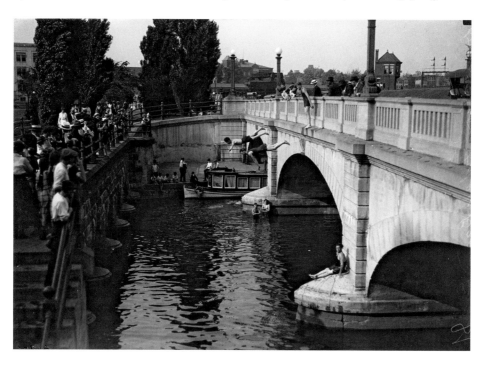

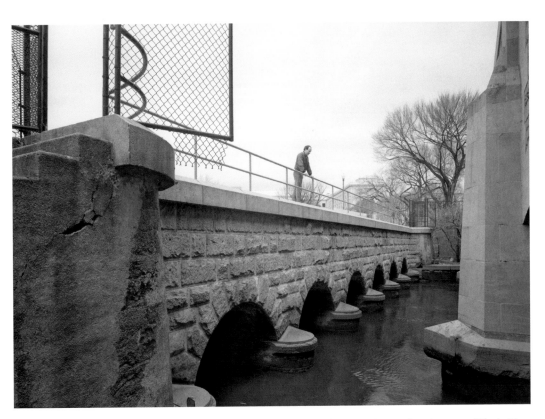

Above: Decades later, in 1988, Jet T. Lowe took this view from the opposite southeast corner of the bridge, looking north along the eastern elevation of the tidal reservoir outlet. The Fourteenth Street Bridge is to the right. *Library of Congress*

Opposite below: Before there was a Tidal Basin bathing beach with a diving platform, young Washingtonians were using the waters between the tidal reservoir outlet (left, with onlookers) and Fourteenth Street Bridge (right, with divers and a few curious passersby), shown here during a warm summer day between 1915 and 1918. Built between 1888 and 1889 as part of the reclamation plan for the Potomac Flats, the tidal reservoir outlet originally operated without accompanying inlet gates to control and regulate water flow from the channel through the reservoir to the river. Its stone masonry arch construction is representative of its functional design and purpose since the tidal gates were fitted into the arch spans. The tidal reservoir outlet was considered an engineering feat because of the dangerous nature of the river bottom at this location (the very spot into which the divers in this picture were going into the water). The outlet's function later changed to include foot traffic crossing over the channel to the flats. *Library of Congress*

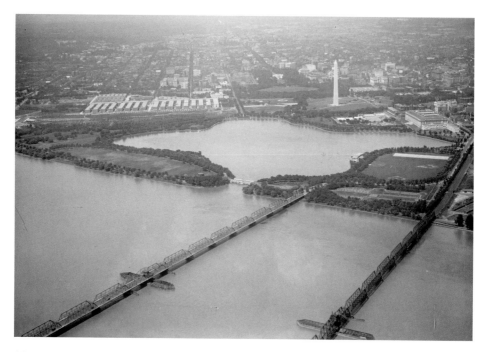

A Harris and Ewing photographer took this aerial picture of the Long Railroad Bridge (lower right); the Tidal Basin, to include the future site of the Thomas Jefferson Memorial; the Washington Monument, and the White House in 1919. *Library of Congress*

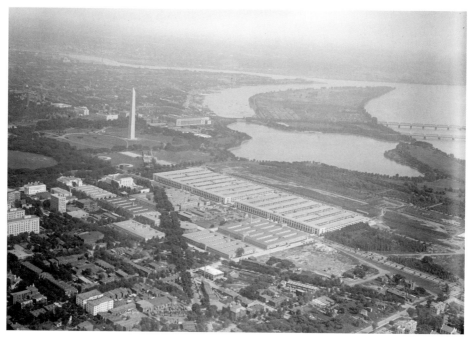

This aerial view of District Columbia parks, to include West and East Potomac Parks—and the Tidal Basin site of the future Thomas Jefferson Memorial—was photographed in 1919 by a Harris and Ewing photographer. *Library of Congress*

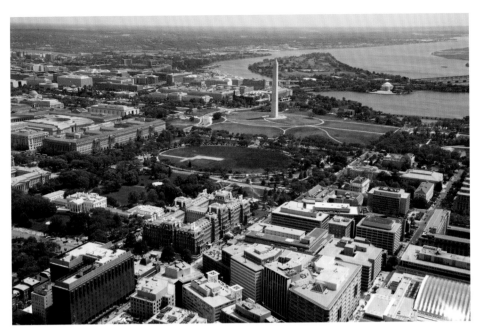

Less than a century later, Carol M. Highsmith took this aerial photograph, to include the White House, Old Executive Office Building, Washington Monument, and the Jefferson Memorial. *Library of Congress*

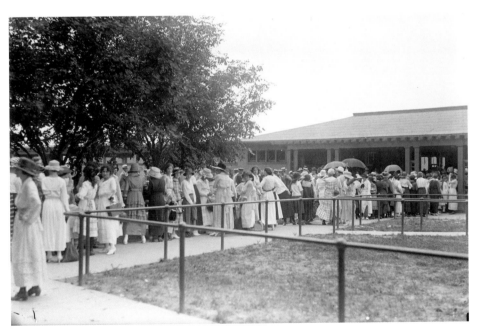

The Tidal Basin bathing beach had opened to great fanfare with a water carnival on August 24, 1918, and the following year thousands of Washingtonians visited it during the summer swimming season. Here, a large crowd gathered in the summer of 1919 for the annual bathing beauty contest. Of note, swimmers and bathing beauties had been coming to the Tidal Basin to recreate and compete since it was first constructed from the mud flats of the Potomac. The Tidal Basin was completed in 1896 as the centerpiece of the National Mall. *Library of Congress*

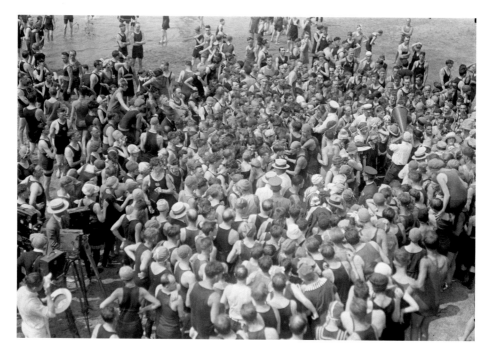

Contestants in the 1919 annual bathing beauty contest (right with the man holding the megaphone) were surrounded by a large crowd and several cameramen (left) eager to get photographs for their news service. *Library of Congress*

Robert Lloyd Eller Jr., the two-year-old son of Robert Lloyd and Margaret Miller Eller, was photographed at the Tidal Basin bathing beach (also referred to as the Washington bathing beach) on June 23, 1920. The boy's father was a former—and famous—Georgetown University hurdler and at the time he took the picture, a well-respected dental surgeon in Washington, D.C. "Little Lloyd" followed in his father's footsteps and also became a dental surgeon. *Library of Congress*

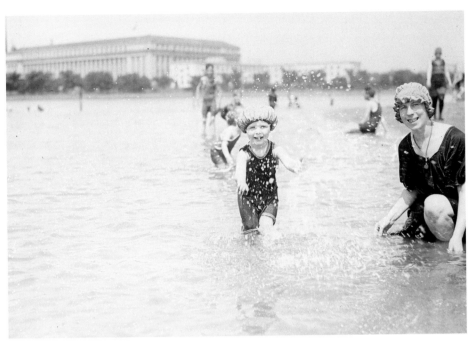

Marguerite Pearl Goss, the three-and-a-half-year-old daughter of Charles and Violetta Mae Goss, shown here on June 23, 1920, enjoyed a day of splashing around at the Washington bathing beach with her mother (right). The Goss family, from Detroit, Michigan, were brief transplants in the nation's capital. Charles Goss had come to the city to do carpentry work on a federal government contract. *Library of Congress*

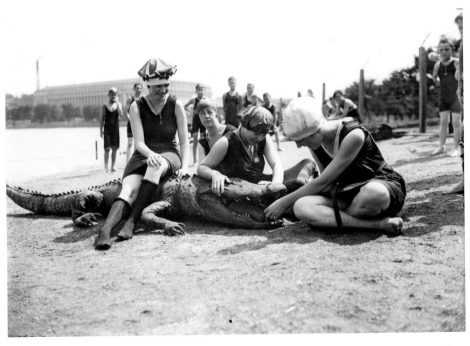

Four young women posed with a taxidermied alligator on the Tidal Basin bathing beach sometime between 1918 and 1920. *Library of Congress*

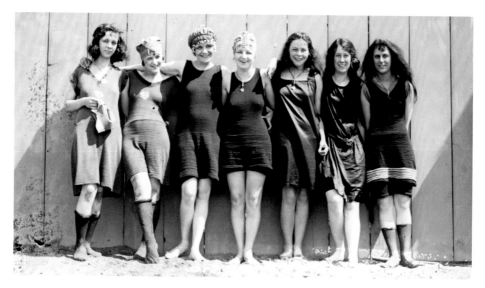

These seven young women were enjoying a day of swimming at the Tidal Basin bathing beach when this picture was taken in 1920. *Library of Congress*

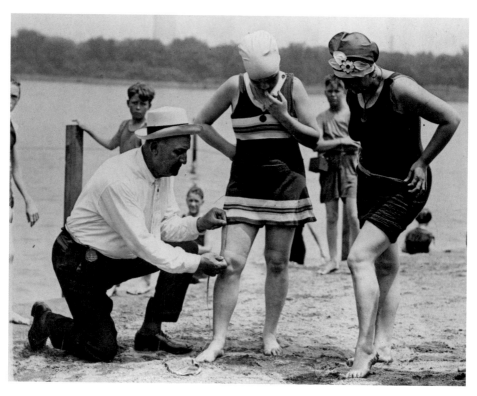

Lieutenant Colonel Clarence Osborne Sherrill (1876–1959), the superintendent of the Office of Public Buildings and Grounds, issued an order that bathing suits at the Washington bathing beach must not be over six inches above the knee. Here, Bill Norton, known as the bathing beach "cop," used a tape measure to determine the distance between a woman's knee and the bottom of her bathing suit. The picture was taken in the summer of 1922. *Library of Congress*

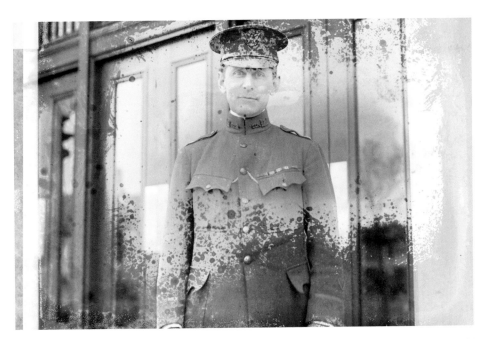

This photograph of United States Army Corps of Engineers lieutenant colonel Clarence Osborne Sherrill was taken on March 23, 1921. *Library of Congress*

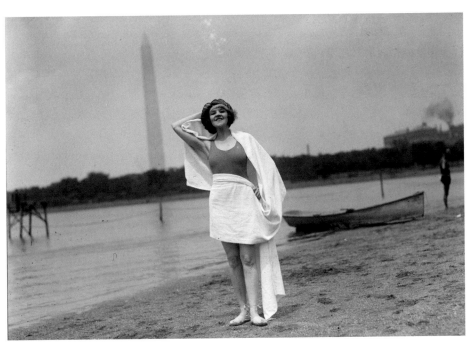

Actress Kay Laurell (1890–1927) posed on the Tidal Basin bathing beach in July 1922. Laurell was an American stage and silent film actress. She was an artists' model when she caught the eye of Florenz Ziegfeld Jr., who subsequently cast her in the *Ziegfeld Follies*, where she debuted in 1914. Laurell followed with stage productions on Broadway and in vaudeville, and then three silent films, which made her a recognizable star when she showed up on the beach in Washington, D.C. *Library of Congress*

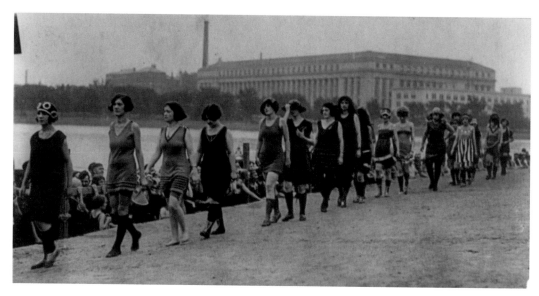

An annual beauty contest was held at the bathing beach on the Tidal Basin (the location of the future Jefferson Memorial) in August 1922. *Library of Congress*

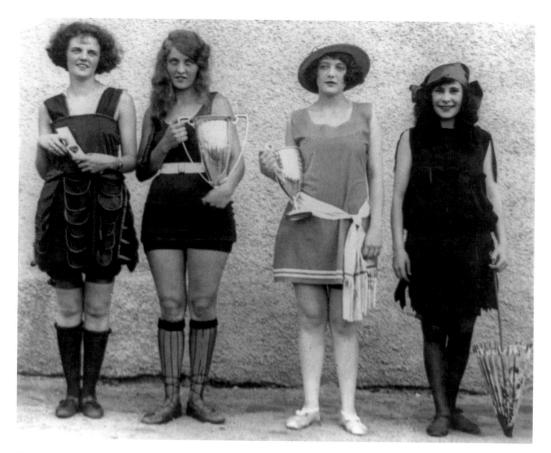

Winners of the August 1922 annual bathing beauty contest posed with their trophies. *Library of Congress*

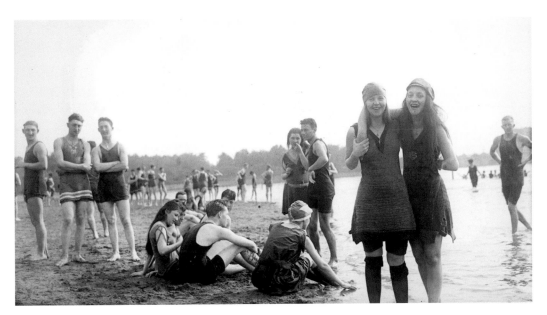

Taken between 1917 and 1920 on a beautiful summer day, this picture shows a gathering of young people enjoying the beach and waters of the Tidal Basin. *Library of Congress*

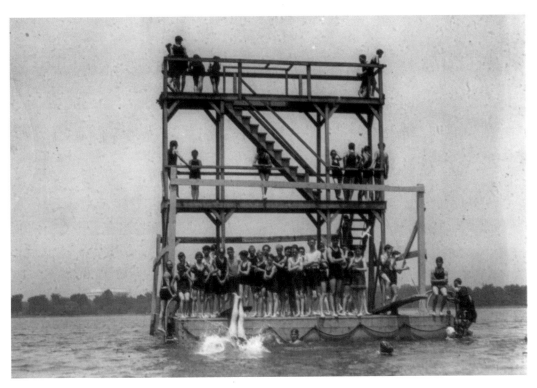

Swimmers at the Tidal Basin used this large platform to jump off and dive into the water below. The bathing beach in the basin was the location of the future Jefferson Memorial and the platform was located just off of that site. The Lincoln Memorial is in the background of this National Photo Company picture taken on June 2, 1923. *Library of Congress*

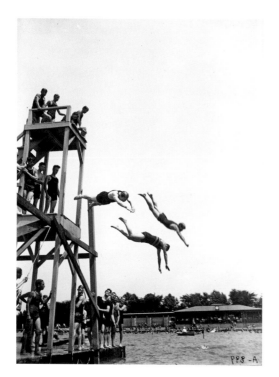
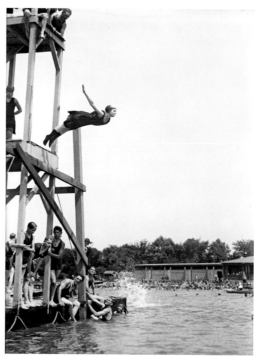

The diving platform in the Tidal Basin (shown here, also in or about 1923) made daredevils out of many of the city's young people. *Library of Congress*

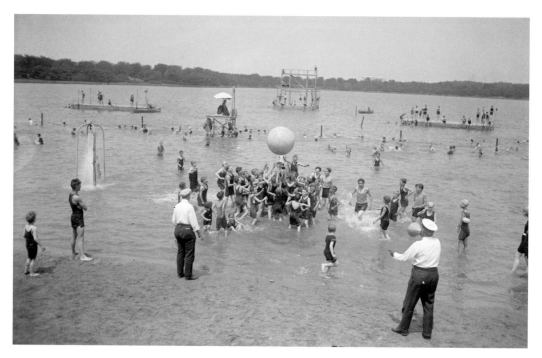

Children at the Tidal Basin bathing beach were playing push ball when this picture was taken on July 10, 1924. *Library of Congress*

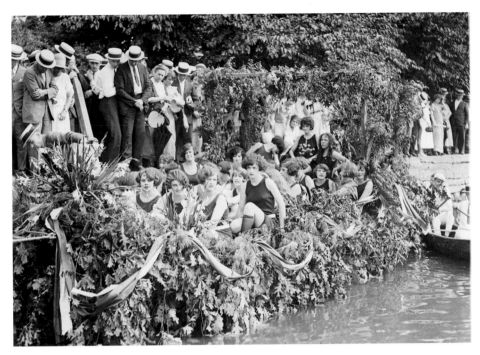

Above and below: The annual water carnival and canoe regatta held in the Tidal Basin attracted large crowds and many participants. The event had not yet gotten underway on August 4, 1924, when the pictures shown here were taken. The bathing beauties on this barge off the bathing beach in the Tidal Basin were towed out to meet up with a tiki boat offshore (see below) featuring musicians and more women in swimsuits of the period. The shore from which all of this activity took place was subsequently used to build the Thomas Jefferson Memorial. *Library of Congress*

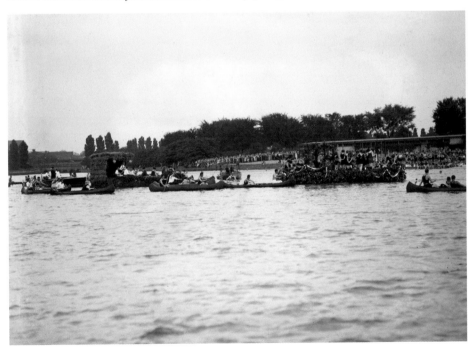

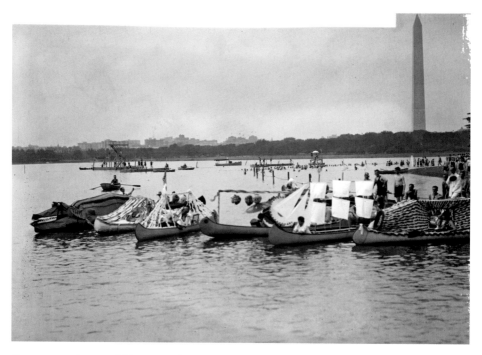

Canoes were decorated (shown here) for the August 4, 1924 races held in the Tidal Basin. Note the swimming platform in the background. The winner of the race shown here is far right. *Library of Congress*

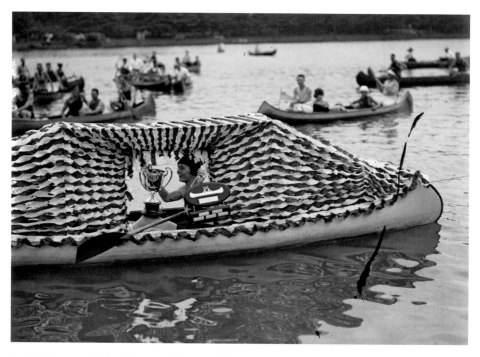

Bertha Schrepper Eaton, the wife of Charles B. Eaton and a member of the Potomac Boat Club, won her race at the canoe regatta on August 4, 1924, and was photographed showing off her trophy and plaque. *Library of Congress*

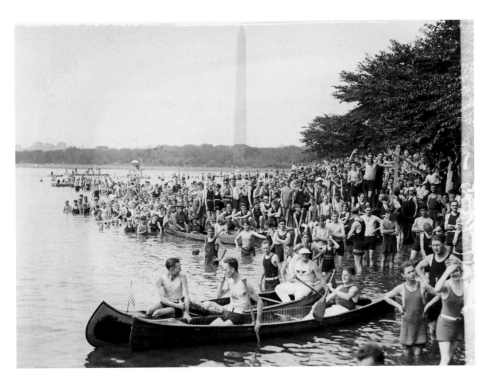

From this August 4, 1924 photograph, the crowd gathered on the banks of the Tidal Basin on the jut of land on which the Jefferson Memorial would eventually be built was in the thousands. While many had come to swim, others just wanted to watch the fun at the carnival. *Library of Congress*

Warren Kealoha, the Hawaiian Olympic swimmer (right) was photographed at the Tidal Basin on August 7, 1924. *Library of Congress*

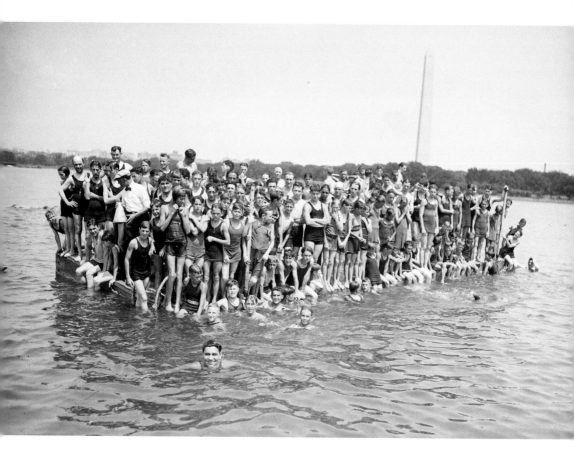

A group of young swimmers crowded the platform to watch Warren Kealoha (foreground in the water) demonstrate the techniques that made him an Olympian. This photograph was also taken on August 7, 1924. *Library of Congress*

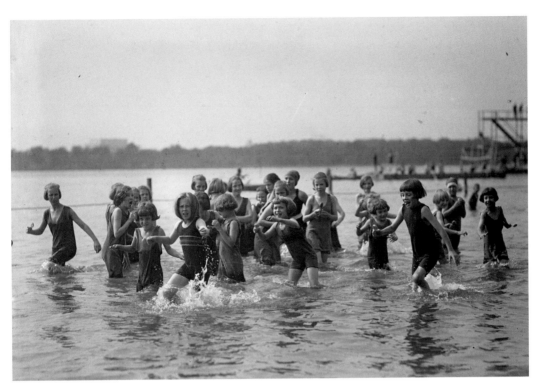

On August 21, 1924, these orphans were treated to a day at the Tidal Basin bathing beach. The trip was sponsored by Senator Jasper Post Number 13 of the American Legion. *Library of Congress*

The United States Marine Corps pitched a camp at East Potomac Park, shown here on August 25, 1924. *Library of Congress*

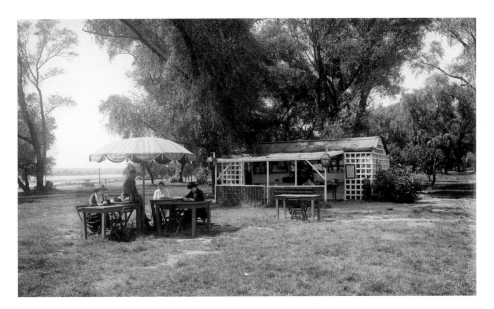

The Girl Scouts first opened a tea house at Hains Point in East Potomac Park in 1920 for tea and other refreshments. The paved road that ran around the point was dubbed the "Speedway" and this made it a popular drive on a nice day. The Girl Scouts set up shop in a converted streetcar (shown here in 1921) nestled under a large willow tree. That tree—and others on the point—inspired the Girl Scouts to name it the Willow Point tea house. *Library of Congress*

The smaller Willow Point tea house was a great success attracting motorists and cyclists, so much so that the Office of Public Buildings and Grounds went to Congress to ask permission to build a larger shelter and comfort station, a request that was quickly approved. In September 1924, the Girl Scouts moved into the building shown here, still at Hains Point, where they operated a tea room. This arrangement lasted just over a year before the Girl Scout concession ended on December 31, 1925, and even though they were gone, the building continued to be referred to as the Girl Scout tea house. The picture was taken on June 21, 1926. *Library of Congress*

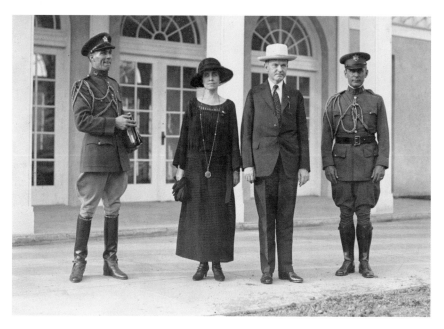

President John Calvin Coolidge Jr. and first lady Grace Goodhue Coolidge (between two White House army aides) were frequent visitors to the Girl Scout tea room at Hains Point, which the Girl Scouts still called Willow Point (for the first small tea house on the site) out of affection for their history with the park. The Coolidges were photographed during a visit in the fall of 1924, shortly after the Girl Scouts reopened a tea room in the new comfort station. *Library of Congress*

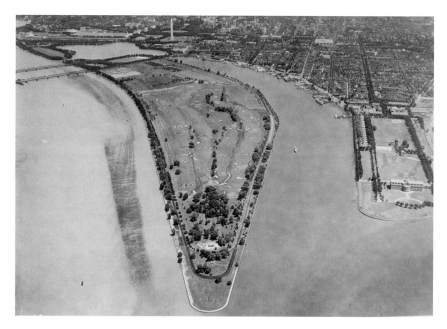

An aerial view of East Potomac Park, the opposite end of the island from the future site of the Jefferson Memorial, is shown in this 1935 photograph looking toward the National Mall. Landmarks include the East Potomac Golf Club and the new comfort station, home to the former Girl Scout tea room (white-columned building, bottom of the picture) on Hains Point. *Library of Congress*

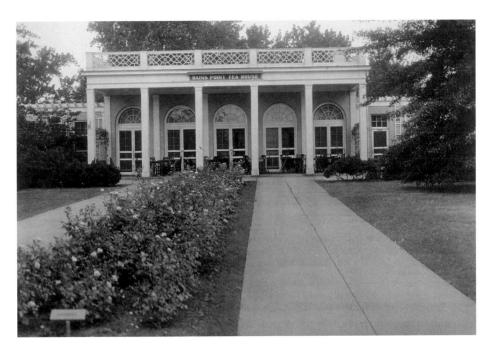

The former Girl Scout concession had evolved to the Hains Point tea house when this picture was taken on November 21, 1949. *Library of Congress*

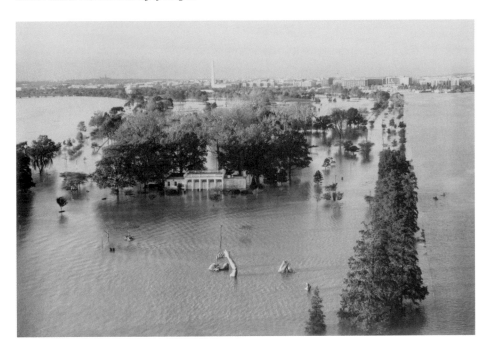

The tea house had been shuttered and empty for many years when it—and the rest of East Potomac Park—were completely flooded in 1985. Sculptor J. Seward Johnson Jr.'s "The Awakening," a seventy-two-foot statue of a giant embedded in the earth, struggling to free himself, can be seen at the bottom center of the picture. Johnson completed the statue in 1980 as part of the city's annual sculpture conference. The statue was removed from Hains Point in 2008 to the National Harbor. *Library of Congress*

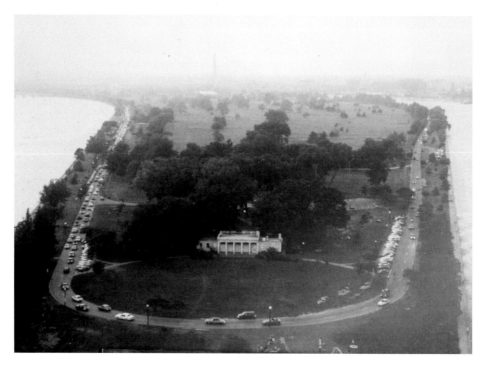

This aerial view of the former Girl Scout tea house (later the Hains Point tea house and Hains Point Inn) and Hains Point traffic dates to 1987. *Library of Congress*

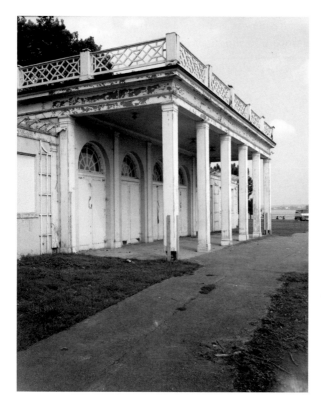

William Clark took this picture of the old Girl Scout tea house portico detail in 1987 for a Historic American Buildings Survey (HABS) ahead of the building being razed that year. *Library of Congress*

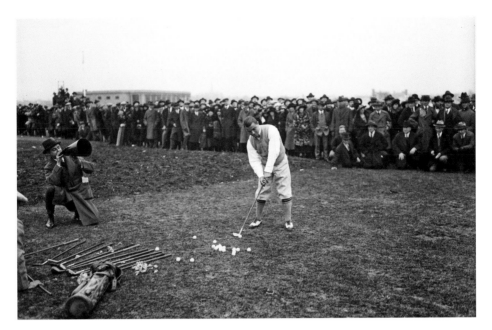

Golf legend Gene Sarazen (1902–1999) gave a lesson to golf fans at Washington, D.C.'s East Potomac Park links in 1922. During this time, Sarazen was one of the world's top players. Sarazen is one of five golfers, to include Ben Hogan, Gary Player, Jack Nicklaus, and Tiger Woods, to win all of the current major championships in his career. During the 1920s and 1930s, he won the United States Open in 1922 and 1932; the Professional Golfers Association (PGA) Championship in 1922, 1923, and 1933; the Open Championship in 1932, and the Masters Tournament in 1935. *Library of Congress*

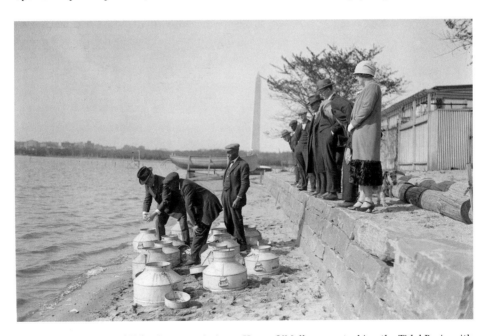

United States Bureau of Fisheries commissioner Henry O'Malley was stocking the Tidal Basin with fish when this picture was taken on April 16, 1925. O'Malley was head of the bureau from 1922 to 1933. *Library of Congress*

69

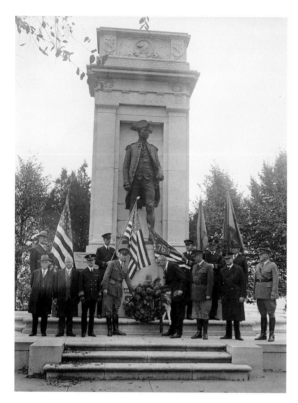

Left: The Commodore John Paul Jones Memorial is located a short distance from the National Mall at the terminus of Seventeenth Street Southwest near Independence Avenue in a traffic circle. The ten-foot bronze statue of Jones was the work of sculptor Charles H. Niehaus and it is backed by a fifteen-foot marble pylon. On the reverse side of the pylon is a bas-relief of Jones raising the American flag on his flagship, the *Bonhomme Richard*. This Harris and Ewing phototgraph of the Jones memorial was taken of a ceremony held there in 1928. *Library of Congress*

Below left: Authorized by an Act of Congress in 1924, funds to construct the World War I Memorial were provided by the contributions of both organizations and individual citizens of the District of Columbia. Designed by Washington, D.C. architect Frederick H. Brooke with the assistance of architects Horace W. Peaslee and Nathan C. Wyeth, the memorial commemorates the 26,000 citizens of Washington, D. C., who served in the "war to end all wars." Construction of the World War I Memorial began in the spring of 1931, and it was dedicated by President Herbert Hoover on Armistice Day—November 11—of that year. It was the first war memorial to be erected in West Potomac Park. The memorial is a forty-seven-foot-tall circular, domed, Doric temple. Resting on concrete foundations, the four-foot high marble base defines a platform, forty-three-feet, five inches in diameter, intended for use as a bandstand. Inscribed on the base are the names of the 499 District of Columbia citizens who lost their lives in the war, together with medallions representing the branches of the armed forces. Twelve twenty-two-foot-tall fluted Doric marble columns support the entablature and dome. Jack E. Boucher took this picture of the west elevation of the memorial in 2005 as part of a Historic American Buildings Survey (HABS). *Library of Congress*

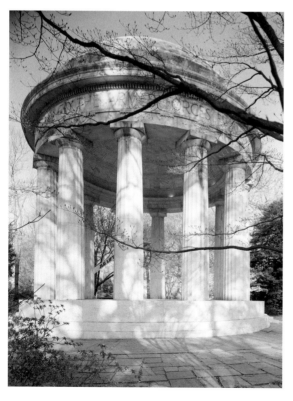

Detail of the west medallion at the base of the World War I Memorial—the seal of the District of Columbia—was also photographed by Jack Boucher in 2005. *Library of Congress*

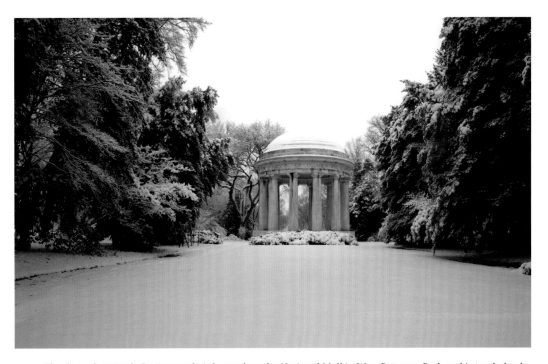

The domed peristyle Doric temple is located on the National Mall in West Potomac Park and intended to be used as a bandstand large enough to accommodate the eighty-member United States Marine Corps Band. Carol M. Highsmith took this photograph of the World War I Memorial on February 12, 2006. *Library of Congress*

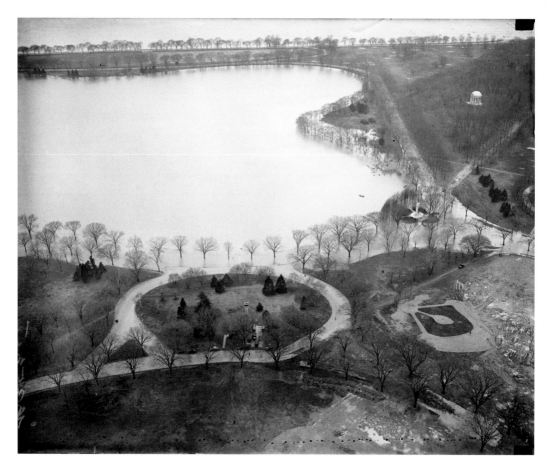

Flooding along the Potomac River and into the Tidal Basin, photographed by Harris and Ewing on March 19, 1936, is shown here. The area in this picture was across the basin from the site of the future Thomas Jefferson Memorial and includes several prominent monuments. The World War I Memorial, the white domed structure right center and near the Lincoln Memorial (out of frame) and today's Martin Luther King Memorial and often referred to as the District of Columbia War Memorial, is the only city monument on the National Mall but also the only remembrance to the "war to end all wars" in the nation's capital. Below and to the left of the World War I Memorial on the northern bank of the Tidal Basin is the Commodore John Paul Jones Memorial, a tribute to the father of the United States Navy, was dedicated on April 17, 1912, and was the first monument raised in West Potomac Park. *Library of Congress*

Opposite above: President Franklin D. Roosevelt (in the car) and first lady Eleanor Roosevelt (with bouquet of flowers) made a surprise visit to a 4-H gathering on the banks of the Tidal Basin on June 14, 1940. Earlier in the day, the president told a meeting of 4-H members that their organization was one of the bulwarks of American democracy, since it was not regimented like youth groups in other countries. Flowers were presented to the first lady by Elizabeth White, of Virginia, along with a book about the activities of the 4-H club given to the president by David Landers, of New York. (Left to right) Elizabeth White, first lady Eleanor Roosevelt, President Roosevelt, and David Landers. *Library of Congress*

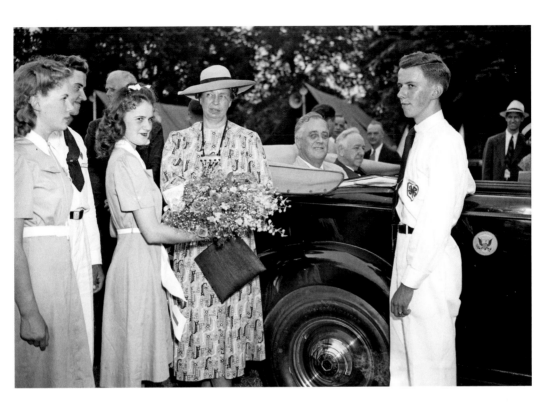

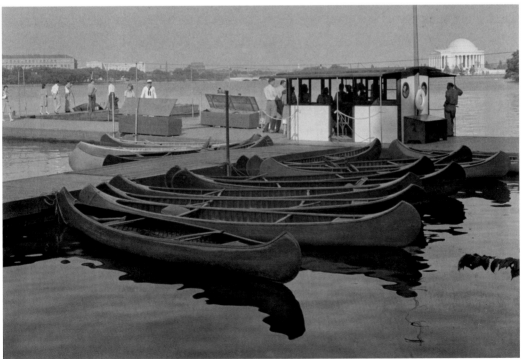

Office of War Information photographer John Collier (1913–1992) took this picture of the canoe rental pier on the Tidal Basin in July 1942. The Jefferson Memorial is in the background. *Library of Congress*

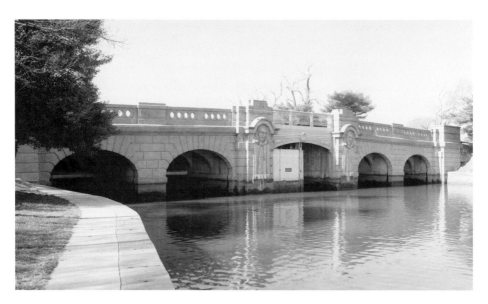

The tidal reservoir inlet bridge is a successful blending of engineering designs and necessities while achieving the height of aesthetics. The tidal gates at the inlet control and regulate the water received from the river according to the tidal action and the pressure exerted or not exerted on the tidal gates. As a focal point of Potomac Park, the tidal reservoir inlet bridge contributed to the monumental design of the nation's capital city. Its configuration adheres to the park design concept that a bridge should blend into a park setting effectively so as not to detract from the park. The bridge was also designed to include a roadway at a time automobile traffic was only beginning to appear. The design of the bridge shows the influence of the neoclassical style with ornate details such as gargoyles and classical balustrades. Jet T. Lowe took this wide-angle picture of the north elevation (the reservoir side) from the east bank as part of a Historic American Engineering Record (HAER) survey completed in March 1989. *Library of Congress*

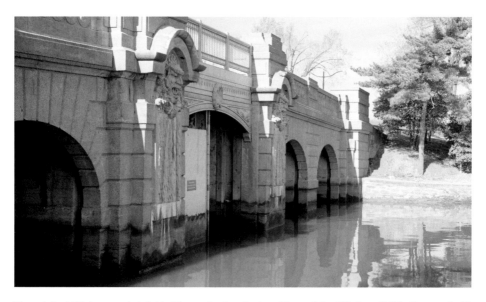

The original tidal reservoir inlet bridge and gates, designed by architect Nathan C. Wyeth, were built between 1908 and 1909, and altered in 1926, 1970 and 1986. Jet Lowe took this photograph of the north elevation looking west in March 1989. *Library of Congress*

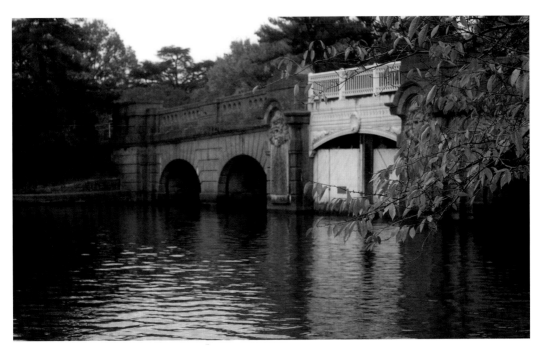

This contemporary photograph of the tidal reservoir inlet bridge and gates, over which Ohio Drive passes and that also spans the inlet of the Tidal Basin, was taken by Jamie Adams and is of the north elevation of the span looking east. *Jamie Adams*[27]

This detail shot of the tidal reservoir inlet bridge (also taken by Jet Lowe, March 1989) shows the decorative balustrade on the north side of the span. The top of the Washington Monument is barely visible (top center). *Library of Congress*

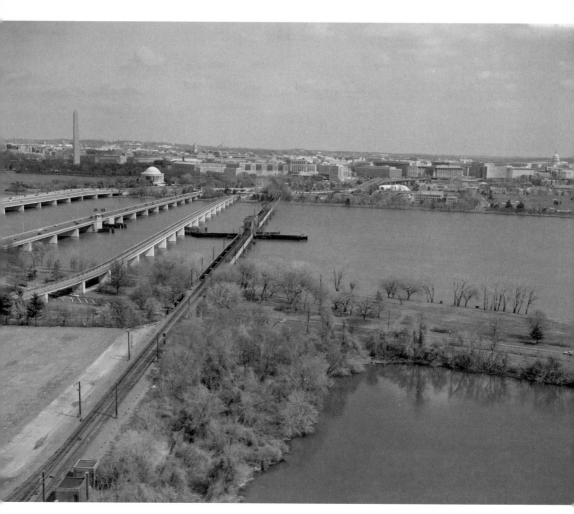

This aerial view looking north towards Washington, D.C., shows the Fourteenth Street (also called the George Mason) Bridge far left, Jefferson Memorial and Washington Monument. The Long Railroad Bridge is far right. Jack Boucher took the picture in 1992 as part of an Historic American Engineering Record study of the Long Railroad Bridge. *Library of Congress*

II

THE GIFT OF CHERRY BLOSSOMS

Visitors strolling to the Thomas Jefferson Memorial along the Tidal Basin when the cherry trees are in full bloom enjoy a spectacular view that is unmatched elsewhere in the nation's capital in the spring. Yet the story behind the scenery and the memorial is filled with turmoil and controversy, one that pitted powerful Washington figures against one another and might have derailed the memorial on its current site had the president of the United States not prevailed. Strident protests against the building of the memorial and the removal of cherished trees—not all of them cherry—resulted in a great clash by several Washingtonians that has since been dubbed the "Cherry Tree Rebellion."

The backstory of the Tidal Basin cherry trees began with the planting of the first trees in 1912, and while practical in their anticipated beauty, signified the gift of friendship that then existed between the United States and Japan. In Japan, the flowering cherry tree (also called the "Sakura") is an exalted flowering plant. The beauty of the cherry blossom is a potent symbol equated with the evanescence of human life and epitomizes the transformation of Japanese culture throughout the ages. Since the first trees were planted, gifts have continued to be exchanged between the two countries. Three years later, in 1915, the United States Government gifted flowering dogwood trees to the people of Japan. The cycle of giving came full circle in 1981, when Japanese horticulturists were given cuttings from the trees to replace cherry trees in Japan which had been destroyed in a flood.[28]

The National Park Service historical documentation of the cherry trees that line the Tidal Basin, enjoyed by millions of visitors each year, begins with the story of Eliza Ruhamah Scidmore, a writer, who upon returning to Washington, D.C., from her first visit to Japan in 1885, approached the United States Army Superintendent of the Office of Public Buildings and Grounds with a proposal that cherry trees be planted one day along the reclaimed Potomac waterfront. Her request failed to resonate just then, and Scidmore's idea went largely ignored. But over the twenty-four years that followed, Scidmore persisted in her request, submitting it repeatedly to each new superintendent. Still, no one took it seriously. Enter David Fairchild, Hon. D.Sc., a botantist, plant explorer and United States Department of Agriculture official, to the cherry tree story.

In 1906, Fairchild imported seventy-five flowering cherry trees and twenty-five single-flowered weeping varieties from the Yokohama Nursery Company in Japan. As soon as they arrived, Fairchild planted them on a hillside on his own property in Chevy Chase, Maryland, where he and his wife, née Marian Hubbard Bell, then proceeded to test their hardiness. The following year, in 1907, the Fairchilds, pleased with the success of the trees, began to promote Japanese flowering cherry trees as the ideal type of tree to plant along avenues in the Washington area. Friends of the Fairchilds also became interested in this plan and on September 26 of that year arrangements were completed with the Chevy Chase Land Company to order three hundred oriental cherry trees for the Chevy Chase area. Another year passed, and in 1908, Fairchild presented cherry saplings to children from each District of Columbia school to plant in their schoolyard for the observance of Arbor Day. In closing his Arbor Day lecture, Fairchild expressed an appeal that the "Speedway" as it was then known (marked today by portions of Independence and Maine Avenues Southwest and East and West Basin Drives Southwest around the Tidal Basin) be transformed into what he described as a "field of cherries." In attendance at this lecture was the inimitable Eliza Scidmore, to whom he referred later as a great authority on Japan.

Scidmore took Fairchild's message as a clarion call. Within a year of his lecture, in 1909, she began the task of raising the money needed to buy the cherry trees and donate them to the city of Washington, D.C. Scidmore even sent a note to the nation's new first lady, Helen Herron Taft, who had lived in Japan and was familiar with the country's beautiful flowering cherry trees. Two days after receiving Scidmore's correspondence the first lady responded on White House letterhead dated April 7, 1909:

Thank you very much for your suggestion about the cherry trees. I have taken the matter up and am promised the trees, but I thought perhaps it would be best to make an avenue of them, extending down to the turn in the road, as the other part is still too rough to do any planting. Of course, they could not reflect in the water, but the effect would be very lovely of the long avenue. Let me know what you think about this.

Sincerely yours,
Helen H. Taft

The day following the receipt of the first lady's letter to Scidmore, Jokichi Takamine, Hon. Eng.D., a renowned biochemist and industrialist (1854–1922), became an important part of the cherry tree story. Takamine is known for two important discoveries. First, he isolated the starch-eating enzyme takadiastase, which catalyzes the breakdown of starch. Takamine developed his diastase from *koji*, a fungus used in the manufacture of soy sauce and *miso*. A practical application of this enzyme was thereafter used by the distilling industry, beginning in 1890, when Takamine came to the United States from Japan to take up permanent residency with his American wife, the former Caroline Field Hitch, and set up a new laboratory in Clifton, New Jersey. Takamine subsequently licensed the exclusive production rights for takadiastase to Parke-Davis, one of the largest pharmaceutical companies in the United States. Takamine's second discovery was the isolation of the chemical adrenalin,

later called epinephrine, from the suprarenal gland in 1901, the first pure hormone to be isolated from natural sources. This pioneering adrenalin research was conducted at his New Jersey laboratory. Both of these discoveries and patents that followed made Takamine a very wealthy man with an estimated worth in excess of $30 million at the dawn of the twentieth century.[29] But on April 8, 1909, Takamine's attentions turned to Washington, D.C., and cherry trees. That day Takamine was in the nation's capital with Kochi Midzuno, the Japanese consul general in New York City. When told that Washington was to have Japanese cherry trees planted along the Speedway, Takamine inquired whether Helen Taft would accept a donation of an additional two thousand trees to fill out the area. Though Midzuno believed this was a good idea, he suggested that the trees be donated in the name of the city of Tokyo, thus keeping the gift in official diplomatic channels. The first lady agreed to Takamine's donation of two thousand cherry trees.

Five days after first lady Helen Taft's request, on April 13, the superintendent of the Office of Public Buildings and Grounds, United States Army colonel Spencer Cosby, initiated the purchase of ninety Fugenzo cherry trees (*Prunus serrulata* "Fugenzo") from Hoopes Brothers and Thomas Company, of West Chester, Pennsylvania. The trees were planted along the Potomac River from the site of the Lincoln Memorial southward toward East Potomac Park. After planting, it was discovered that the trees were incorrectly named, and it was soon determined that they were the cultivar Shirofugen (*Prunus serrulata* "Shirofugen"), which have since disappeared from the landscape. Later that year, on August 30, 1909, the Japanese embassy informed the United States Department of State that the city of Tokyo intended to donate the two thousand cherry trees funded by Takamine to be planted along the Potomac River. On December 10, those trees arrived by steamer in Seattle, Washington, from Japan. The trek from Seattle to Washington, D.C., took nearly a month. Tokyo's donation arrived on January 6, 1910, in the capital. This first attempt to gift cherry trees from Japan was a story without a happy ending. When a United States Department of Agriculture inspection team arrived at the delivery point to take a look at the shipment on January 19, it was quickly discovered that the trees were infested with insects and nematodes, and were diseased. To protect American growers, the department recommended that the trees must be destroyed. President William Howard Taft consented to the agriculture department's request that the trees be burned on January 28, which was done immediately after the order was given.

A January 29, 1910 article in the *Washington Evening Star* mentioned that approximately one dozen of the "buggiest trees" were preserved for further study, and "planted out in the experimental plot of the bureau, and there will be an expert entomologist with a dark lantern, and a butterfly net, cyanide bottle and other lethal weapons placed on guard over the trees, to see what sort of bugs develop."[30] The loss of the first gifted cherry trees dismayed all involved but what might have otherwise been a diplomatic setback was alleviated, according to the National Park Service account of events, by letters from Secretary of State Philander Chase Knox to Japanese ambassador viscount Uchida Kōsai expressing the deep regret of all concerned. The Japanese took the disappointing news with what was described as determination and good will; in fact, Tokyo mayor Yukio Ozaki and others suggested a second donation be made, and without hesitation the Tokyo city council authorized

Ozaki's plan. The number of trees had now increased to 3,020. The scions for these trees were taken in December 1910 from the famous collection along the bank of the Arakawa River in Adachi Ward, a suburb of Tokyo, and grafted onto specially selected understock produced in Itami City, Hyogo Prefecture.

Cherry trees from twelve varieties were shipped from Yokohama, Japan, on February 14, 1912, on board the steamship *Awa Maru*, bound for Seattle. Upon arrival, they were transferred to insulated freight cars for the shipment to Washington. D.C. The new batch of 3,020 cherry trees arrived in the district on March 26 and were comprised of the following varieties (quantities in parentheses): Somei-Yoshino (1,800), Ariake (100), Fugenzo (120), Fukurokuju (50), Gyoiko (20), Ichiyo (160), Jonioi (80), Kwanzan (350), Mikurumagayeshi (20), Shirayuki (130), Surugadainioi (50), and Takinioi (140). The Gyoiko were all planted on the White House grounds.[31]

The day after the trees arrived, on March 27, 1912, first lady Helen Taft and Viscountess Iwa Sato Chinda, wife of Japanese ambassador Viscount Sutemi Chinda, planted two Yoshino cherry trees on the northern bank of the Tidal Basin, roughly one hundred and twenty-five feet south of what is now Independence Avenue Southwest. At the conclusion of the ceremony, the first lady presented a bouquet of American Beauty roses to Viscountess Chinda. Washington's renowned National Cherry Blossom Festival grew from this simple ceremony, witnessed by just a few persons. These two original trees still stand several hundred yards west of the John Paul Jones Memorial, located at the terminus of Seventeenth Street Southwest. Situated near the bases of the trees is a large bronze plaque which commemorates the occasion. But more than a century later, the Chindas have faded from the pages of history, even though their travel to the United States and arrival at Washington's Union Station on the evening of February 22 that year was lauded with much pomp and circumstance as Viscount Chinda assumed his duties as Tokyo's ambassador in Washington and the couple made their home in the handsome stone mansion on K Street that served double-duty as the Japanese embassy. In many ways, they have been forgotten much the way the ceremony of which Viscountess Chinda was a key participant, went largely unreported and memory of the same overwhelmed by the world war to follow. "There is little record of what transpired at the Tidal Basin. A weathered plaque, between two gnarled trees that are said to be the originals, offers a bare-bones summary. The newspapers carried only a few paragraphs, and no photographs appear to have survived," wrote Michael E. Ruane in the March 26, 2010 *Washington Post*.

Between 1913 and 1920, workers continued to plant Yoshino cherry trees around the Tidal Basin. Eleven other cherry tree varieties and the remaining Yoshinos were planted in East Potomac Park and the Washington Monument grounds. On April 27, 1927, the original planting of Japanese cherry trees was commemorated with a re-enactment of the event by Washington, D.C. schoolchildren. Seven years later, in 1934, according to the National Park Service time line, District of Columbia commissioners sponsored a three-day celebration around the Tidal Basin cherry trees, an event that evolved the following year as the first cherry blossom festival, sponsored jointly by many civic organizations and that became an annual event in the years to come. In the spring of 1940, a cherry blossom pageant[32] was added.

For Washingtonians, the trees came to symbolize a natural splendor at the center of our nation's capital, adding rich and colorful backdrop to the city, and something that would be cherished and visited by thousands of visitors each year. But then came the proposal to locate the Thomas Jefferson Memorial at the Tidal Basin, a plan that would result in the removal of Japanese cherry trees from the area. By 1937, when the public was informed of the memorial location, Washington citizens, clubs, boards, and associations of the city organized a city-wide protest against the destruction of the trees. This so-called "Cherry Tree Rebellion," which quickly escalated to the front pages of the city's newspapers, was intended, in all practicality, to interrupt workers preparing to clear ground for the construction of the memorial. In an attempt to quiet the press and dispel rumors that six hundred trees were going to be lost, the National Park Service advised the Thomas Jefferson Memorial Commission of the much smaller number of trees actually involved. The following is paraphrased from a memorandum for President Roosevelt, from Stuart G. Gibboney, acting chairman of the memorial commission, dated November 15, 1938:

> Of the cherry trees within the circle of 600 feet diameter, which will include the area occupied by the Memorial proper and surrounding roads, forty-six cherry trees are to be moved, and 35 cherry trees cut due to the change in shoreline of the Tidal Basin to conform to the Olmsted landscape plan approved by the Fine Arts, Parks and Planning and Jefferson Memorial Commissions. In summation, this will make a total of 88 cherry trees to be cut and 83 cherry trees to be moved when the entire landscape plan is carried out.[33]

The press was not deterred and the "rebellion" had help. Eleanor "Cissy" Patterson, the owner and editor of the *Washington Times-Herald*, published several articles criticizing the Franklin D. Roosevelt administration, and organized efforts to block the removal of the trees. On November 17, 1938, the day construction began on the Thomas Jefferson Memorial, fifty women marched on the White House, armed with a petition to stop the damage to the trees. The following day, the same women chained themselves to a tree at the construction site, with hopes of stopping the work. Unsatisfied still, a group of approximately one hundred and fifty women, led by Patterson, seized shovels from workers, refilled holes, and prepared for a standoff against workers and bulldozers in order to help save the trees. President Franklin D. Roosevelt claimed that Patterson and other Washington newspapers were exaggerating, repeating the script he had been provided by Gibboney that just eighty-eight trees would be destroyed in the construction. Meanwhile, the *Washington Post* quoted a park official as saying, "For the past two weeks we have been removing trees in the Tidal Basin area for transplanting. None have been chopped down nor will any be."[34] But that was not true, as some trees were lost as the result of memorial construction. According to one account, the women were ultimately convinced to stand down after being served lunch by Assistant Secretary of the Interior Michael Strauss. After never-ending cups of coffee, the ladies' need for restrooms hastened their decision to remove the chains. Roosevelt then had the rest of the trees removed in the middle of the night to avoid any further conflict. A compromise was subsequently reached wherein more trees would be planted along the south side of the Tidal Basin to frame the memorial.

President Roosevelt spoke eloquently of Jefferson and the many facets of his personality at the November 15, 1939 cornerstone laying ceremony, emphasizing that Jefferson's outlook transcended traditional political philosophy and that the Founding Father struggled with the idea of living in-between the rule of a chosen few and the opinions and desires of the individual. Ultimately and ironically, Jefferson's vision of individual self determination led to the rebellion against the removal of the cherry trees.[35]

On December 11, 1941, four cherry trees were cut down in what park authorities believed was suspected retaliation for the Japanese attack against the United States Pacific Fleet at Pearl Harbor, Hawaii, four days earlier. The exact reason for the vandalism was never substantiated but such retaliation was proved in other cities across the nation just then, to include the basin bridge gifted to the Jamestown Exposition, one of the many world's fairs and expositions that were popular in the United States in the early part of the twentieth century. Commemorating the three hundredth anniversary of the founding of Jamestown in the Virginia Colony, it was held from April 26 to December 1, 1907, at Sewell's Point on Hampton Roads. Post-Pearl Harbor, the bridge was destroyed and the remnants used as rip rap at the shoreline. In hopes of sidestepping future damage to the trees that lined the Tidal Basin, East Potomac Park and the Washington Monument grounds during the Second World War, it was decided that they would be referred to simply as the "oriental" flowering cherry trees.

In 1952, it became known that the famed cherry grove along the Arakawa River near Tokyo, parent stock for Washington's first trees, had fallen into decline during the Second World War. Japan requested help to restore the grove in the Adachi Ward, and the National Park Service shipped budwood from descendants of the trees first planted in 1912 back to Tokyo in an effort to restore the original site.[36] Two years later, on March 30, 1954, Sadao Iguchi, the Japanese ambassador to the United States, presented a three-hundred-year-old Japanese stone lantern to the city of Washington, D.C., a gift from the mayor of Tokyo to commemorate the one hundredth anniversary of the first Treaty of Peace, Amity and Commerce between the United States and Japan signed by Commodore Matthew Calbraith Perry at Yokohama on March 31, 1854. The lantern, made of granite, is eight feet high and weighs approximately two tons. The National Cherry Blossom Festival is officially opened by the lighting of this lantern.

In 1957, Yositaka Mikimoto, president of Mikimoto Pearls, donated the Mikimoto pearl crown that is used at the coronation of the National Cherry Blossom Festival queen on the night of the grand ball. The crown contains more than two pounds of gold and has 1,585 pearls. This magnificent crown is ceremonial, and because of its weight the young lady crowned queen wears the famous piece for just a few moments before donning a miniature gold crown with a pearl topping each point that she dons for the remainder of the evening. The miniature crown is hers to keep.

The Japanese government made another generous gift of 3,800 Yoshino cherry trees to another first lady dedicated to the beautification of Washington, Lady Bird Johnson, wife of President Lyndon Baines Johnson, in 1965. American-grown this time, many of these are planted on the grounds of the Washington Monument. Lady Bird Johnson and the

wife of Japanese ambassador to the United States Ryuji Takeuchi re-enacted the planting ceremony of 1912.

In 1973, United States National Arboretum botanist Roland Maurice Jefferson began to compile historical and scientific data about the Japanese cherry trees first planted in Washington's East and West Potomac Parks in 1912. The national arboretum published his work in 1977 as *The Japanese Flowering Cherry Trees of Washington, D.C.: A Living Symbol of Friendship*, which was later translated into Japanese.[37] Jefferson observed that many of the surviving 1912 Japanese cherries were aged and dying. Thus, to save this original cherry stock, from 1976 to 1979, he took cuttings to be propagated at the arboretum. It was due to Jefferson's preservation effort that the arboretum was able to give Japan three thousand cuttings from the 1912 trees to replace lost Japanese parent stock in 1981, after a flood ravaged Japan's grove. First lady Nancy Reagan presented Japanese ambassador Yoshio Okawara with the President Reagan Cherry Tree, which Jefferson had propagated from the commemorative tree planted by first lady Helen Herron Taft in 1912. Jefferson's contributions to cherry tree preservation did not end there.

The National Arboretum history indicates that Jefferson undertook several expeditions to study ornamental trees and collect germplasm. In 1978 and 1979, he traveled to Holland, England, and Germany to study cherry and crabapple trees. From 1981 to 1983, he visited Japan several times to locate, study, and collect seeds and budwood from cherry trees. Concerned that he would not be able to collect enough of the seeds himself before they were carried off by birds and other animals, he enlisted the help of Japanese schoolchildren. Jefferson began a seed exchange program in which children in Japan collected cherry seeds in exchange for dogwood seeds collected by American children, an effort that was both practical and educational. In 1986, Jefferson led expeditions into Japan, Korea, and Taiwan to collect additional cherry seeds. Retirement from the arboretum in 1987 did not slow Jefferson, who continued his work to preserve cherry tree germplasm and to establish cherries across the United States. In 1995, he gave a lecture in Japan on the deteriorating condition of the original 1912 cherry trees in East and West Potomac Parks. Subsequent newspaper coverage of the problem prompted the National Park Service to take action to preserve the genetic heritage of those trees. On June 17, 1997, in cooperation with the national arboretum, cuttings were taken from the documented, surviving 1912 Yoshino cherry tree shipment, to preserve the genetic legacy and generate a stock of trees to be used later as replacement plantings. Two years later, the arboretum subsequently, presented the park service with five hundred propagated replacements for the dying cherries.[38] Apart from cherry tree propagation and preservation, less than one year earlier, on March 27, 1996, the Sister River Agreement was signed that formally bound the Potomac, which flows through Washington, D.C., and the Arakawa, which originates on scenic Mount Kobushi in Saitama Prefecture.

Jefferson's Japanese counterparts were just as busy. In 1982, approximately eight hundred cuttings from the Tidal Basin Yoshino trees were collected by Japanese horticulturists to retain the genetic characteristics of the trees and replace those destroyed in Japan when the course of a river was changed the year before; other exchanges and gifts have benefitted

Washington, D.C., and Tokyo much the same. Between 1986 and 1988, a total of 676 new cherry trees were planted at a cost of $101,000, paid in private funds donated to the National Park Service to restore the number of trees to what they had been at the time of the original gift. Then, on November 15, 1999, fifty trees, propagated from the over 1,400-year-old Usuzumi cherry tree growing in the village of Itasho Neo in Gifu Prefecture, Japan, were planted in West Potomac Park. It is believed that Emperor Keitai, also known as Keitai-okimi, the twenty-sixth emperor of Japan, planted the tree. While there are no firm dates assigned to this emperor's life or reign, he is conventionally considered to have reigned from 507 to 531 (the early sixth century). Significant differences exist in the records of the *Kojiki* and the *Nihon Shoki. Kojiki* puts Keitai-okimi's birth year at 485, and his date of death is said to have been April 9, 527. In the extant account, he is called Ōdo no Mikoto. *Nihon Shoki* gives his birth year at 450, and he is said to have died on February 7, 531 or 534. In this historical record, he is said to have been called Ōdo no Kimi and Hikofuto no Mikoto. There are further records that identify him as *Wo Ofu Ato-no-Hiko Fudo no Mikoto.* Emperor Keitai reportedly planted the tree to celebrate his ascension to the throne. The Usuzumi tree was declared a National Treasure of Japan in 1922.

The National Cherry Blossom Festival continued to grow commensurately since the events of 1927 and the first expansion in 1935. Though it was pushed to a two-week celebration in 1994, the festival grew again in 2012, the one hundredth anniversary of the first gift of Japanese cherry trees to Washington, D.C., when it was celebrated over a five-week period. The festival spans four weekends and welcomes over one-and-a-half million visitors annually to the nation's capital.

Taking up the preservation effort at the beginning of the twenty-first century, and over a four-year-period from 2002 to 2006, some four hundred trees, propagated from the surviving 1912 donation, were planted in the reaches of the Tidal Basin and East and West Potomac Parks, again to preserve the cherry trees' genetic pedigree. Later, approximately one hundred and twenty propagates from the surviving 1912 trees around the Tidal Basin were collected in 2011 by National Park Service horticulturists and sent back to Japan to the Japan Cherry Blossom Association to also retain the genetic lineage. Through this cycle of giving, the cherry trees continue to fulfill their role as a symbol and as an agent of friendship, just as they were over a century ago. Cuttings continue to be taken from the trees throughout the Tidal Basin and West Potomac Park, propagated at a nursery, and planted five to six years later, after the trees are large enough to be transplanted.

Since first lady Helen Herron Taft's involvement, many of the nation's first ladies have historically continued to play a participatory role in the cherry tree story, to include the National Conference of State Societies' Princess Program, a cultural, educational, and professional development program for women leaders ages nineteen to twenty-four held each year during one week of the National Cherry Blossom Festival. First lady Mamie Eisenhower crowned Queen Janet Bailey in 1953, and first lady Betty Ford invited the princesses to the White House in 1976. All first ladies in recent years have served as honorary chair of the festival but some have also had participatory roles. First lady Laura Bush delivered remarks at the cherry blossom festival on March 25, 2001, at the Kennedy Center for Performing

Arts. "[W]hen Americans think of Washington, D.C., in the spring, they think of the cherry blossoms," Bush observed. "The cherry trees in bloom represent the coming of spring—and the enduring relationship between the United States and Japan." The first lady further acknowledged the importance of the cherry trees to the people of Japan. "Every spring in Japan, millions of people spend time outdoors admiring the flowering cherry trees. Their blossoms are a powerful poetic image in Japanese culture; a symbol of the brevity of the seasons and of life itself. In the United States," she continued, "the cherry blossoms also draw thousands of visitors to our nation's capital."

Japanese cherry trees (*Prunus pseudocerasus*) were photographed on January 6, 1910, in the original packages as received at the United States Propagating Gardens, Washington, D.C. *USDA National Agricultural Library*

Inspection of the Japanese cherry trees by the entomologists and pathologists of the United States Department of Agriculture at the United States Propagating Gardens, Washington, D.C., was photographed on January 8, 1910. *USDA National Agricultural Library*

The first shipment of Japanese cherry trees was inspected by United States Department of Agriculture (USDA) inspectors who discovered they were diseased. Shortly thereafter, on February 27, 1910, (shown here), the trees were burned at the United States Propagating Gardens, in Washington, D.C. *USDA National Agricultural Library*

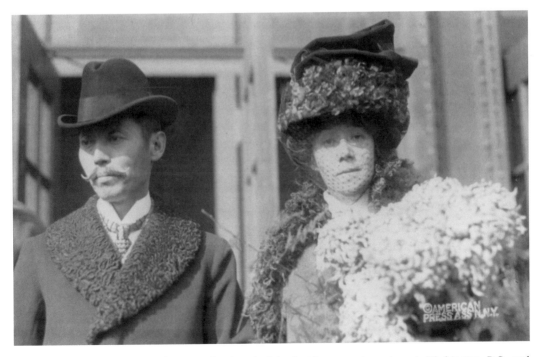

Tokyo mayor Yukio Ozaki (1858–1954), who gifted the first Japanese cherry trees to Washington, D.C., and wife Yei Theodora Ozaki were photographed on October 25, 1910. *Library of Congress*

On March 27, 1912, first lady Helen Herron Taft and Viscountess Iwa Chinda, wife of the Japanese ambassador, planted the first two cherry trees from Japan on the north bank of the Tidal Basin in West Potomac Park. This Bain News Service photograph of the ambassador, Count Sutemi Chinda (1857–1929) and his wife was taken in or around that time. *Library of Congress*

Japanese statesman count Uchida Kōsai (1865–1936) is shown in this Bain News Service photograph taken on February 28, 1917. He was ambassador to the United States from 1909 to 1911. As a statesman, diplomat and interim prime minister, Kōsai was active in Meiji, Taishō and Shōwa period in Japan. *Library of Congress*

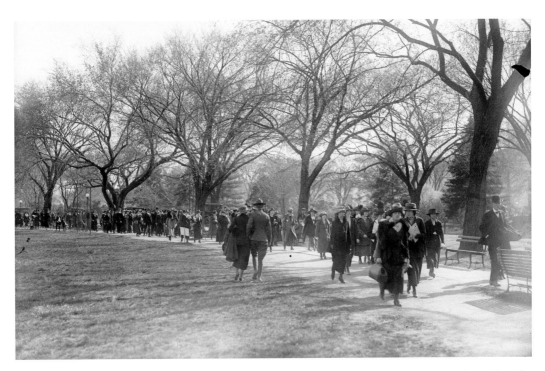

Crowds turned out in large number in the spring of 1919 to see the cherry blossoms in full bloom along the Tidal Basin. *Library of Congress*

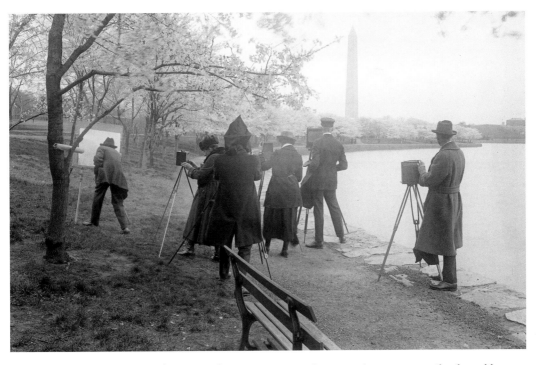

Photographers and artists (shown here) turned out in significant number to preserve the cherry blossoms on film and canvas. The picture was taken on April 7, 1922. *Library of Congress*

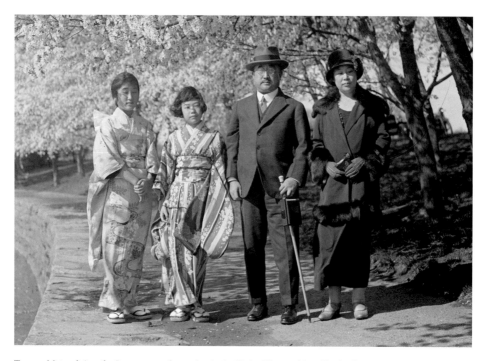

Tsuneo Matsudaira, the Japanese ambassador to the United States, his wife, the former Nobuko Nabeshima, and daughters were enjoying a stroll under the Tidal Basin cherry blossoms on March 28, 1925, when this picture was taken. Matsudaira was the son of Lord Matsudaira Katamori of Aizu. He served as Japan's ambassador to Washington, D.C., from 1924 to 1926. Tsuneo Matsudaira was the father of Setsuko Matsudaira (far left, in traditional dress), who married Prince Chichibu Yasuhito, the second son of Emperor Taisho (1879–1926), the one hundred and twenty-third emperor of Japan, and Empress Sadako Kujo, and the younger brother of Emperor Showa Hirohito, who succeeded their father. *Library of Congress*

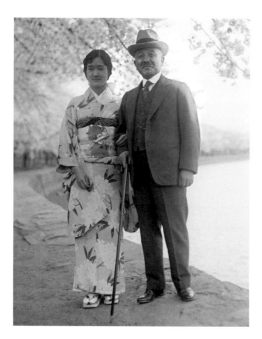

Japanese ambassador to the United States Katsuji Debuchi and his daughter, Takako Debuchi, took a walk along the Tidal Basin on March 29, 1929, under cherry blossoms in full bloom. *Library of Congress*

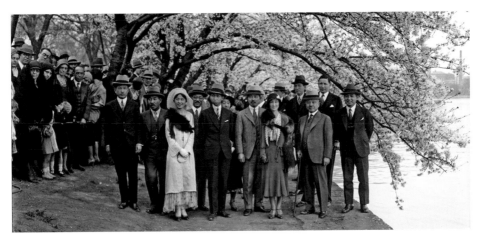

Princess Kikuko Tokugawa Takamatsu (in white hat) was photographed standing next to her husband Prince Takamatsu Nobuhito (in striped tie), and Japanese ambassador to the United States Katsuji Debuchi on the right holding the cane. The ambassador's wife (in black hat) is standing next to her husband. The group posed on April 16, 1931 under the Japanese cherry trees gifted by Tokyo to Washington, D.C. The prince was the third son of Emperor Taisho and Empress Sadako Kujo, and the younger brother of Emperor Showa Hirohito. *Library of Congress*

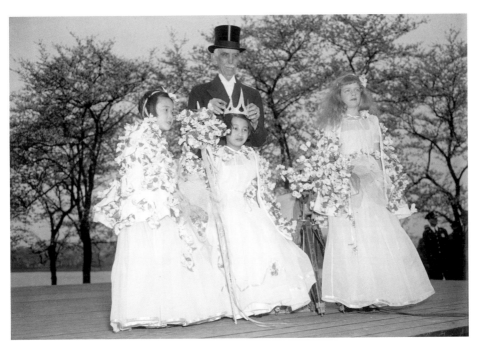

A colorful ceremony attracted thousands of onlookers to the Tidal Basin on April 8, 1937, to watch the crowning of Sakiko Saito (center), daughter of Japanese ambassador Hiroshi Saito (1886–1939), as the queen of the cherry blossoms by Melvin Hazen, commissioner of the District of Columbia. The festival was held to celebrate the anniversary of the presentation of Japanese cherry trees to the nation's capital by the citizens of Tokyo, Japan, during the William Howard Taft administration. With the queen are her two attendants, Masako Saito (left), also a daughter of the ambassador, and Barbara Caldwell, an American playmate of the Saito children. *Library of Congress*

Ambassador Hiroshi Saito and Madame Miyo Nagayo Saito were dressed for a White House diplomatic reception presided over by President Franklin D. Roosevelt on December 16, 1937. *Library of Congress*

Japanese ambassador Hiroshi Saito, shown here on January 10, 1938, was photographed by a Harris and Ewing cameraman. Saito was assigned to Washington, D.C., from 1934 to 1938, and died in the city on February 26, 1939, at the age of fifty-one. The Saito daughters were born in the nation's capital during his tenure as ambassador. Due to his directness in dealing with other diplomats and newspaper men, Saito was called "the indiscreet diplomat"[39]—a title that he wore like a badge of honor. *Library of Congress*

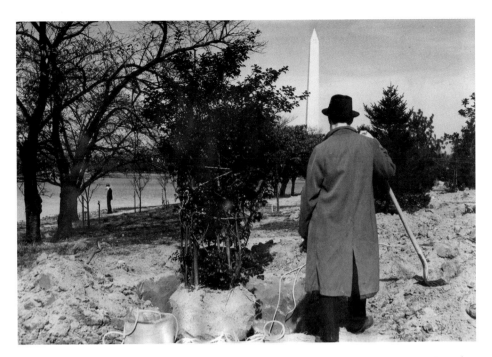

This picture, taken on the site of the proposed Thomas Jefferson Memorial at the Tidal Basin on November 17, 1938, shows an uprooted holly bush that was subsequently transplanted. Despite protests from women's groups, all of the Japanese cherry trees were still on the site pending removal. *Amy Waters Yarsinske*

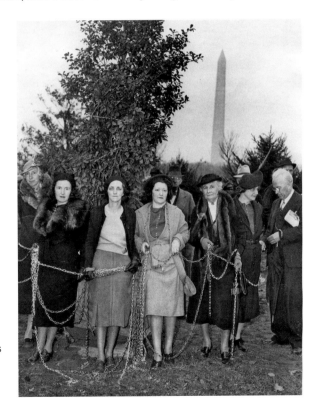

Some of Washington, D.C.'s most prominent women chained themselves in protest to Japanese cherry trees that were about to be removed to make way for the new memorial to Thomas Jefferson. The Washington Monument looms in the background. The picture was taken on November 18, 1938. *Amy Waters Yarsinske*

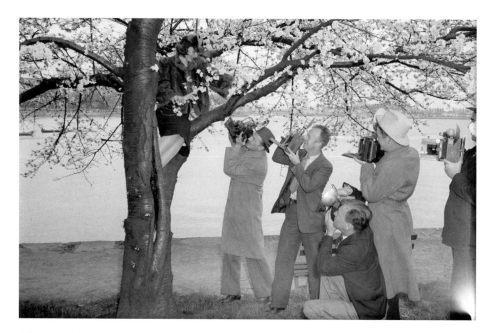

A Harris and Ewing cameraman took this picture of Peggy Townsend, of Washington, D.C., who was set to be crowned queen of the cherry blossom festival, posed for photographers as she arrived at the venue on the Tidal Basin to preview the beautiful blooms in Potomac Park on March 28, 1939. *Library of Congress*

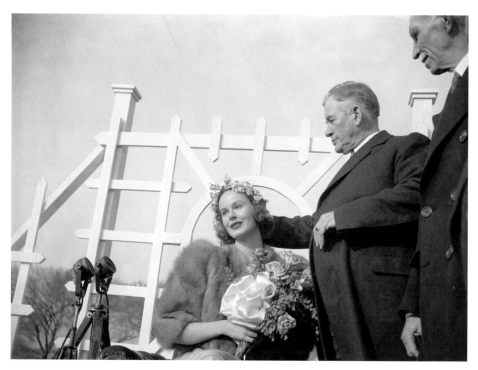

Climaxing the annual cherry blossom festival in Potomac Park, Senate Majority Leader Alben W. Barkley placed the crown on the head of Peggy Townsend, cherry blossom queen, on March 31, 1939. A Harris and Ewing photographer took the photograph shown here. *Library of Congress*

This little girl had climbed a Tidal Basin Japanese cherry tree during the 1939 festival when a Harris and Ewing photographer got this picture. *Library of Congress*

Secretary of Agriculture Henry A. Wallace (right) presented the Meyer Medal for distinguished services in plant introduction to David Fairchild, veteran plant explorer in the United States Department of Agriculture (USDA). Wallace made the award on July 24, 1939, on behalf of the American Genetic Association, the trustees of the medal. Following the presentation, Wallace outlined Fairchild's illustrious fifty-year-career with the USDA. Fairchild had introduced, up to that period, many hundreds of new plants to the United States. Others in the photograph included Fairchild's wife, the former Marian Hubbard Bell, and P. H. Dorsett, a retired plant explorer. *Library of Congress*

These two reverends attended the National Cherry Blossom Festival in May 1941. The picture was taken by Martha McMillan Roberts (1919–1992). *Library of Congress*

The title on this Martha McMillan Roberts picture from the May 1941 cherry blossom festival was "tired feet." *Library of Congress*

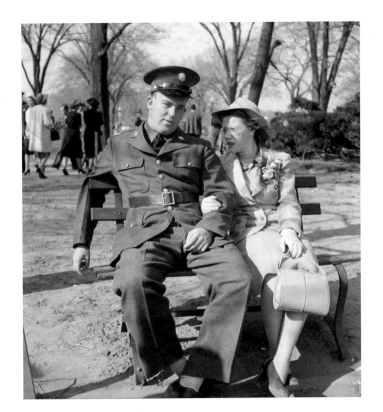

This soldier and his date looked like it had been a long day when Martha McMillan Roberts snapped their picture in May 1941 at the cherry blossom festival.
Library of Congress

"Steady, Dad, this is for the folks at home," was the title of this May 1941 picture taken by Martha McMillan Roberts at the annual cherry blossom festival on the Tidal Basin.
Library of Congress

This woman was watching the coronation of the National Cherry Blossom Festival queen in May 1941. Martha McMillan Roberts, who photographed the day's events, captured scenes that would not be visited on the banks of the Tidal Basin again until after World War II was over. *Library of Congress*

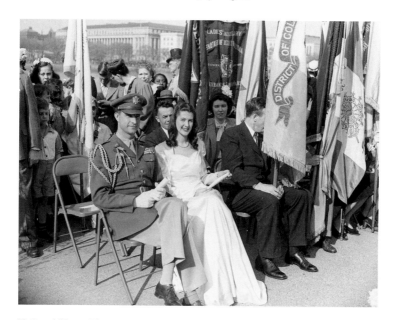

National Cherry Blossom Festival queen Nancy Anderson (seated center), daughter of President Harry Truman's secretary of agriculture, Clinton Presba Anderson, attended the commemoration of Thomas Jefferson's birthday, held on April 13, 1947, at the memorial. The picture was taken by Abbie Rowe. *Harry S. Truman Presidential Library and Museum*

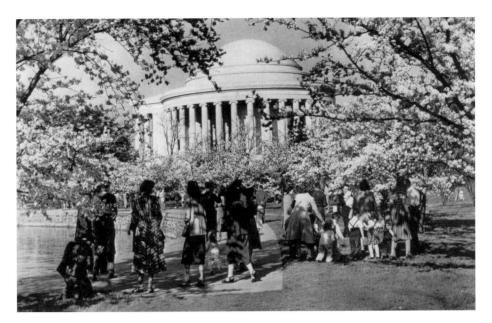

The cherry blossoms were in full bloom in Washington, D.C., when this picture was taken on March 29, 1949, by a Detroit Gravure Corporation photographer. Sightseers turned out in large number near the Jefferson Memorial to enjoy an unseasonably warm spring day. *Amy Waters Yarsinske*

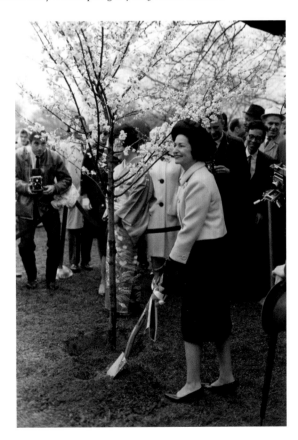

First lady Lady Bird Johnson planted a Japanese cherry tree during the annual festival at the Tidal Basin on April 6, 1965. *Lyndon Baines Johnson Presidential Library and Museum*

Above left: Tricia Nixon (front center), daughter of President Richard M. Nixon, posed with cherry blossom queen contestants on April 9, 1970. *Richard M. Nixon Presidential Library and Museum*

Above right: President Richard M. Nixon and first lady Thelma Catherine "Pat" Nixon were photographed strolling beneath the cherry blossoms at the Tidal Basin on April 14, 1969. *Richard Nixon Presidential Library and Museum*

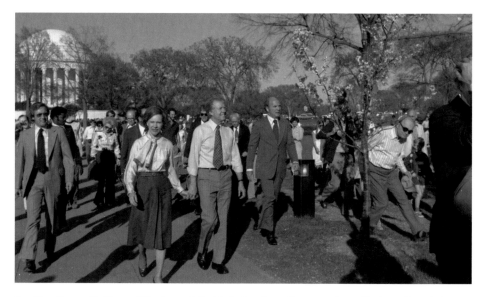

President James E. "Jimmy" Carter and first lady Rosalynn Carter took a walk along the Tidal Basin adjacent to the Jefferson Memorial on April 12, 1978. *Jimmy Carter Presidential Library and Museum*

III

Honoring America's Third President

After Congress created the Thomas Jefferson Memorial Commission in 1934, chaired by New York congressman John Joseph Boylan, that same year the Commission of Fine Arts was considering possible sites for the monument, which at that point was still intended to take the form of a statue. The Commission of Fine Arts,[40] established by Congress on May 17, 1910, as an independent federal agency charged with giving expert advice to the president of the United States, the Congress and the federal and District of Columbia governments on matters of design and aesthetics, as they affect the federal interest and preserve the dignity of the nation's capital, were concerned from the beginning of the Jefferson memorial site search. Nearly all of the major site proposals would have placed the statue along the Washington Monument—Capitol axis. Among the sites considered were the Lincoln Park, the terminus of East Capitol Street, and various locations along the National Mall. The site chosen, of course, was situated next to the Tidal Basin, at the intersection of the White House and Maryland Avenue axes. This location had been marked as the site of a great memorial by the McMillan Commission as early as 1901. The McMillan Commission had envisioned a grand structure on the scale of the White House, Washington Monument, and Lincoln Memorial, and either one large monument to a single individual or a Pantheon in which statues of various American heroes would be displayed. In the 1920s this site was suggested as the location of a monument to Theodore Roosevelt. Of note, the Theodore Roosevelt Memorial Committee went so far as to hold a design competition before the project faltered. Then, in 1937, the Thomas Jefferson Memorial Commission chose John Russell Pope as the architect of the memorial. In the spirit of the McMillan Plan of 1901/02, Pope's design called for a monolithic pantheon of large dimensions facing north toward the White House. The Tidal Basin was to be transformed into a series of reflecting pools flanked by rectangular terraces outlined with formal rows of trees.

The Commission of Fine Arts and the National Capital Parks and Planning Commission brought forth a number of objections to this scheme. First, the very grandeur of the structure and grounds would so dominate the vista that they would upset the balance of the capital's monumental core. Second, they argued, the remodeling of the Tidal Basin would

diminish its capacity to flush the Washington Channel. Third, the elaborate landscaping would necessitate fundamental changes in the street design, causing disruptions in the flow of traffic to Virginia. Finally, the landscaping plan required the destruction of eighty elms and each of the one thousand two hundred cherry trees that surrounded the Tidal Basin. As a result of these concerns, the Commission of Fine Arts and the National Capital Parks and Planning Commission called for alterations in the plan after their objections were lodged with Otto R. Eggers and Daniel P. Higgins, who assumed the memorial's design responsibilities after the untimely death of Pope in August 1937. Eggers and Higgins moved to mitigate the adverse effects in two ways. First, they planned to move the monument six hundred feet south of its original site and to decrease the size of the structure for compatibility with the other monuments. Second, they proposed to forgo Pope's designs for elaborate landscaping, thus leaving the Tidal Basin, the street plan, and the majority of the Japanese cherry trees largely intact. Although these changes went far in pacifying the opponents of the plan, many members of the Commission of Fine Arts still objected to the Pantheon design of the memorial, favoring instead an open peristyle design. This change, however, met the resistance of the Thomas Jefferson Memorial Commission, which took its case directly to President Franklin D. Roosevelt, who ordered the construction to begin, thus overriding the authority of the Commission of Fine Arts. Though the Commission of Fine Arts filed a vigorous appeal with Congress, it fell on deaf ears and on December 15, 1938, the groundbreaking took place. Hundreds of spectators watched as Thomas Jefferson Memorial Commission member Stuart G. Gibboney turned the first spadeful of dirt with the same shovel used to break ground at the Tomb of the Unknown Soldier and at the Lincoln Memorial. Construction began in earnest the following year with John McShain, Inc. of Philadelphia as the contractor. Frederick Law Olmsted Jr.[41] (1870–1957), of Olmsted Brothers, and a founding member of the American Institute of Landscape Architects, was chosen as the consulting landscape architect on October 18, 1938. Much of Olmsted's work on the memorial was actually prepared by the aforementioned Henry V. Hubbard, a landscape architect employed by Olmsted's firm.

Aside from his early work on the memorial commission, Olmsted, thirty-seven years previously, while serving on the McMillan Commission, had been involved in designing and planning the National Mall and the rest of the capital. He continued almost throughout his life as a consultant on various projects constructed on the Mall.

The general plan showing layout and massing of foliage from the Olmsted office is on plan number N.P.S. 76-402, PPJ 716, dated October 10, 1938, revised November 1938. In order for construction to begin on site, a number of cherry trees located near the edge of the Tidal Basin had to be removed. Such an act proved extremely controversial as discussed in the previous chapter, as this area of West Potomac Park had become famous for its much-loved trees.

Once the site for the Jefferson Memorial was chosen, there was never any question about its visual relationship with the White House—a direct line. President Roosevelt, in fact, ordered trees to be cut so that the view of the memorial from the White House would be enhanced. As the National Park Service manages most of the land in the viewshed from the

Jefferson Memorial to the White House, the commanding view from the memorial across the Tidal Basin to the Washington Monument and White House remains largely unchanged. Of interest, at the time of construction, much thought was also given to the relationship between the Lincoln and Jefferson Memorials. Additional tree pruning was completed to ensure a narrow view from one memorial to the other.

On April 3, 1939, the sculpture committee report to the memorial commission recommended that the first procedure toward selection of an artist to create the statue of Thomas Jefferson should be to invite the submission of photographs and records of executed work by anyone who wanted to be considered as sculptor for the project. A little over three months later, on July 25, 1939, sculpture committee chairman Fiske Kimball reported to the commission that a jury comprised of Henri Marceau, who served as chairman, and two sculptors, James Earle Fraser and Heinz Warneke, had met in Washington and spent three days going over 101 sets of photographs submitted by applicants. The jury chose six sculptors to compete in the second stage of competition, to include Rudulph Evans, Raoul Josset, Lee Lawrie, Maurice Sterne, Sidney Waugh, and Adolph A. Weinman. The sculpture committee and the jury headed by Marceau took more than a year to narrow the field further. At a meeting of the commission held on September 13, 1940, Lawrie, Evans and Weinman were invited to fashion revised models for the statue. The models were not reviewed by the commission until February 21, 1941, when Evans' was chosen as project sculptor.[42]

Meanwhile, on November 15, 1939, a ceremony was held in which President Roosevelt laid the cornerstone of the Jefferson Memorial. In it were placed copies of the Declaration of Independence, the Constitution, the 1939 Thomas Jefferson Memorial Commission report, the ten-volume *Writings of Thomas Jefferson* by Paul Leicester Ford, Jefferson's *The Life and Morals of Jesus of Nazareth* (also known as *The Jefferson Bible*),[43] and one edition each of four prominent Washington, D.C., newspapers.

Back to Olmsted. The Olmsted planting plan as originally installed during construction, was divided into two specific areas, the land inside the circular roadway, and the land outside the circular roadway. The plan for the area surrounding the Jefferson Memorial within the circular roadway, which was approved by the Commission of Fine Arts in October 1941, specified thirteen species of plants, most of which were evergreen. Once this area was planted in 1942, it was considered to be too thin, so twelve additional white pines were added, several holly trees were replaced and added, and some of the shrubs were rearranged. The scheme for the Jefferson Memorial grounds outside the circular roadway was limited to a few different trees, shrubs, and ground covers; the original plant palette for this area included cotoneasters, yews, thorn trees, Japanese hollies, dogwoods, crabapples, maples, American hollies, lindens, oaks, American elms, cherry trees, and periwinkle. All landscape changes were made before the April 13, 1943 dedication of the memorial.

Arguably, perhaps Olmsted's intention behind including such diversity of plants was to draw attention to those species which would have been featured in a garden at Jefferson's Monticello and possibly to celebrate Jefferson's skills as a botanist and plant collector. Yet Gilmore D. Clarke, chairman of the Commission of Fine Arts, wrote in a letter to National Park Service director Newton B. Drury, dated, March 4, 1941, of the design:

[...] the areas outside of the Memorial circular drive [plan number 758] contains, in the opinion of the writer, too many different varieties of plant material, which will result in a scheme too gardenesque, too detailed, and comprising plants too small in character to be in proper scale with the environs. The writer believes that all areas outside of the outer drive should be planted with trees and grass only, including major and minor trees, the latter being cherry trees in accordance with the express wishes of the President. Trees in this large-scale composition would serve to create a more permanent treatment, and one in better scale with the memorial. Limiting the planting of these areas as in the manner suggested would appear to create a [quieter] and more dignified planting composition, in character with the building and, quite incidentally, make for a much simpler problem of maintenance, an important consideration in a public park where great crowds gather.[44]

Clarke goes on to cite the road layout proposed to the south of the memorial as "inadequate, and in character inappropriate" suggesting further investigation is needed. He informed Drury:

In view of the contemplated changes with respect to the rearrangement of park drives, incident to the construction of the Fourteenth Street and Maine Avenue grade crossing separation structures, the Commission advises that further study be given to the problem of circulation in the vicinity of the Jefferson Memorial, outside of the circular drive, including the two diagonal roads connecting this drive with the present park road passing south of the memorial. The commission considers the proposed scheme inadequate and in character inappropriate. [...] The whole problem of parking automobiles in the vicinity of the Jefferson Memorial appears to require further study, and in this connection, the commission would be pleased to discuss this matter with your representatives at such time as may be appropriate in the circumstances.

While differences of opinion with regard to Olmsted's landscape plan persisted, the memorial commission report for the month of June 1941 stated that the project was 97.7 percent complete and listed activities concerning the landscape that had been carried out that month including the pouring of 4,500-square-feet of concrete pavement at the front of the memorial; installation of tile lines for lawn drains between the terrace and stylobate walls, and earth filling and grading."[45]

The park service cultural landscapes survey for the memorial indicates that in response to the criticism of the planting plan, in August 1941, the proposed layout of the lawn and road area to the south of the memorial was further changed by the Olmsted office. The converging roads, criticized previously by the Commission of Fine Arts through the words of Clarke as being "inappropriate," had been replaced by parallel roads. These were subsequently approved by Eggers and Higgins in their letter to Olmsted of August 21, 1941. They did not, however, approve of Olmsted's new proposal to extend the line of trees east and west of the "approach roads," across the line of Route 1, towards the shore of the Potomac River. Their opinion was that, in contrast to the Lincoln Memorial, the setting of the Jefferson Memorial should be informal without long rows of trees. Further, Eggers

and Higgins advised: "It is desirable to keep fairly narrow vistas of the Memorial in every case but the main one on the North."[46]

Olmsted's reasoning behind his inclusion of flanking trees was to link the southern axial space created by the trees, to the tree-flanked circular space surrounding the monument. In his letter of August 8, 1941, to Arthur Edward Demaray, acting director of the National Park Service, he had explained the tree plan:

> The previous studies for such a rectangular treatment have made the space unpleasantly short in proportion to its width, a difficulty in large part overcome in the present plan by extending the flanking tree masses straight across the future dual highway and returning them across its southern axis (through which opening it would be possible in the remote future, if the obstruction of the railroad bridge is ever removed, to obtain from the memorial a long, narrow, axial view down the Potomac River).

Historical record indicates that by October 1941, another planting plan concerning the area within the circular roadway was received from the Olmsted office and finally approved by the various commissions. This was a much simpler design than the previous gardenesque schemes, using only thirteen, mainly evergreen, species. This presumably satisfied the Commission of Fine Arts who had, as previously indicated, deemed the earlier plans over-elaborate and too difficult to maintain in a place where large crowds gather. The planting plan for the area outside the circular road differed from the previously rejected scheme in that Olmsted omitted the colorful shrubberies and restricted the planting to a limited choice of trees, shrubs and groundcover plants. This was apparently not a satisfactory solution, as far as he was concerned. In correspondence with the National Park Service, Olmsted wrote of the newly accepted planting plans:

> As to the use of shrubbery outside of the circular drive in view of the undoubted desirability of minimizing the amount of maintenance work required for keeping the surroundings of the memorial in first class condition, and in view of defensible differences in opinion as to the most desirable aesthetic effects, I have agreed with the Chairman of the Commission of Fine Arts on the expediency of omitting from the planting outside of the circle all except the trees, provided that the soil is so prepared that shrubs may later be added if, as, and when it shall later appear that the trees alone (within the areas in the previous plans called for shrubbery also) are in fact insufficient to produce a satisfactory effect.

The simple use of evergreens around classical structures set in the landscape had been widely practiced in Europe since the eighteenth century, and probably seemed more appropriate in this setting, appealing to the Commission of Fine Arts' classical tastes. Conifers had also been widely used throughout history in memorial plantings and cemeteries.[47]

The aforesaid "too thin" criticism came once the area surrounding the monument within the circular roadway was planted, garnering negative comment from the National Park Service, the Thomas Jefferson Memorial Commission, and Eggers and Higgins for being far

too sparse. Olmsted's frustration must have been boiling over at this point in the project. While his original plan had been rejected for being "too fussy," his final scheme was now rejected as "too thin." In a letter to the Olmsted Brothers from Otto Eggers dated July 14, 1942:

> The planting gives one the impression of having been spread pretty thin over a large area. I know that funds for this part of the work were particularly limited but it disturbs me that even what we were able to buy is thin and scrawny and evidently not doing well. My particular case in point are the hollies at either side of the steps on the upper stylobate. I wanted a good heavy mass in this location. Instead the pines at the edge of the water tend to accentuate the thinness of the foliage of the groups of hollies.

The plants had been provided by the New England Tree Expert Company, which successfully bid the contract for the area within the circular roadway. Olmsted did not agree to the awarding of the contract to the lowest bidder. While the plants seemed well suited for planting, they were not the best specimens. Despite the dissatisfaction of the aforementioned parties, and Olmsted's own concerns regarding the quality of the plants, he was still reluctant to "thicken up" the plantings to achieve denser mass. Instead, he apologized for the plantings looking so thin. Olmsted subsequently agreed to beef up the plantings and a rearrangement of the planting on the terrace was devised.[48]

National Park Service records document the various circulation issues around the memorial, in addition to those of vegetation, that arose regarding the construction of the nation's tribute to Jefferson. Drainage of the circular roadway was a primary concern. Olmsted was in favor of sloping the encircling roadway away from the monument, so there would only have to be catch basins on the outer edge of the circular roadway, but the Thomas Jefferson Memorial Commission had other ideas. Anticipating settlement problems, they thought it preferable to play it safe and shape the road asymmetrically in profile, incorporating drainage on both sides of the road. Thus, they would not be subsequently faced with the drainage problem if the initially higher inner side of the road settled below the level of the drains on the outside. This was particularly important in the area on the Tidal Basin side of the memorial as this was all new fill material. Settlement had been an important consideration since the start of the memorial's construction. The construction of the roadways and sidewalks to facilitate "jacking up"[49] is one indication of how this inevitable phenomenon was intended to be overcome.

This concern about settlement was documented in a letter to the Olmsted Brothers dated August 21, 1941, from Newton Drury, just then the director and executive officer of the memorial commission:

> Regarding the additional catch basins on the inside edge of the circular road and the asymmetrical crowning of this road as now proposed, it is the feeling of the National Park Service that this offers a more practical solution as we all are aware that the roadway pavement is bound to settle and as a matter of fact, is designed to anticipate jacking up when settlement would be sufficient to warrant re-jacking the roadway slabs. Additional catch basins will insure adequate drainage no matter which way the settlement occurs. If the roads were all drained

to the outside, as originally suggested by your office, in case greater settlement occurred at the inside curb, no means would be available for draining. This was felt to be particularly important in the 40-foot section of the roadway on the basin side of the Memorial.[50]

By May 1942, the majority of the building and landscape work had been completed. The sea wall, extending southwesterly to the inlet bridge, had to be realigned, both vertically and horizontally, by adding a course of stone and a six-inch high concrete coping to bring it to its design elevation. Following this, the asphalt walkway was built alongside it, leading to the inlet and outlet bridges. It was completed in September 1942.

History informs that in January of 1943 the vista between the Lincoln and Jefferson Memorials was discussed by the Commission of Fine Arts, the Thomas Jefferson Memorial Commission, and Eggers and Higgins. By the end of the month this vista was opened up through pruning of trees, enabling the visitor a narrow view from one memorial to the other. It was intended that this should be further opened up to improve the vista. As was true during construction, settlement remained a major problem. Research suggests that the main marble steps were first reset by the National Park Service the same year of the Memorial's dedication—the first in a series of repairs and reconstructions that have continued up to the present day.

Previously mentioned, a plaster replica of Rudulph Evans' statue of Thomas Jefferson served as placeholder until the Roman Bronze Works installed Evans' bronze sculpture of nation's third president on April 22, 1947. During the planning phase, it was determined that Jefferson's statue would be placed so that the Founding Father, third president and sage of Monticello looked out from the interior of the memorial toward the White House—or so it was believed. Others contend that Jefferson is looking just east of it, to the United States Treasury Building, in front of which stands a statue of Alexander Hamilton, a Jefferson rival, arguably perhaps the biggest. Maybe Hamilton is looking back at him. Hamilton's bronze was installed in 1923, and as historians have observed many times, he might as well have been staring at Theodore Roosevelt since the site was first set aside for his memorial, not Jefferson. National Park Service ranger Michael Kelly observed in the fall of 2015 that Hamilton and Jefferson were rivals who had fought vigorously over the direction of the country in the Republic's early period. "Both men served under George Washington. Both became leaders of different political parties," he continued. "George Washington hated the idea of factions and of political parties, warning everyone to recognize themselves as nothing other than Americans. Jefferson and Hamilton are those that are beginning to pull the administration apart and even pull the country apart into parties. Jefferson is looking at Hamilton, and Hamilton is looking back."[51] Kelly further pointed to the fact that across the Tidal Basin is Washington's towering obelisk. "Standing between them is the monument to President Washington, who tried to bridge their differences, who tried to unify them in common purpose, but failed. It's not a secret, but no one really connects it [the monument and statuary alignment]."

The Roman Bronze Works that cast, delivered and installed Evans' Thomas Jefferson statue, was first established in Brooklyn, New York, in 1897 by Riccardo Bertelli, a Genoese

chemist with intimate knowledge of European methods of bronze casting. Importantly, Roman Bronze Works was the first American bronze foundry to specialize in the lost-wax (*cire perdue*) casting method,[52] and was the United States' preeminent art foundry during the American Renaissance period that began with the kickoff of the Industrial Revolution and the nation's centennial in 1876 and ended in 1917. The company, even in its salad days, specialized in art sculpture and was a subcontractor to Louis Comfort Tiffany's Tiffany Studios. From 1898, Frederic Remington worked exclusively with Roman Bronze Works, as did Charles M. Russell. Remington bronzes were being cast by Roman Bronze Works as late as the 1980s. In 1927, it became a subsidiary of the General Bronze Corporation, and it was during this association that the company moved to the old Tiffany bronze studios in Long Island's Queens Borough, where it continued to cast art sculpture and many commercial pieces, including architectural elements for building interiors and exteriors. The company was the foundry of choice for a who's who of artists working in the United States and Canada during the first half of the twentieth century to include, of course, Evans.

Sculptor Rudulph Evans, born in Washington, D.C., on February 1, 1878, and who grew up in the nation's capital and Front Royal, Virginia, studied in France at the École des Beaux-Arts. Among Evans' fellow students were Auguste Rodin and Augustus Saint Gaudens. After Evans returned to the United States in 1900, he maintained a studio in New York City, and residency in Ossining, Westchester, New York, until a move to Manhattan to be nearer his studio. It was not until after World War II that Evans moved back to Washington, D.C. He died in Arlington, Virginia, on January 18, 1960, and is buried in Rock Creek Cemetery, located in the District of Columbia.

Changes have been made to the Jefferson Memorial and the monument's surrounding grounds. Starting with the landscape, the National Park Service has documented many changes to Olmsted's landscape plan. Much of what is planted on the grounds today is not what was originally specified or first planted. The plantings, in general, are now more architectural in style than Olmsted (and Hubbard) intended. The major change in the landscape in the immediate vicinity of the memorial occurred in the 1970s, when a mass of yews was planted on the stylobate mall. At the same time, a ring of fourteen Zelkova trees was planted in 1972 inside the circular roadway, where none originally existed. The planting design, although a departure from Olmsted's original scheme, still respected the original narrow vistas to the east and west. Over time, however, the yews grew to such an extent that they interfered with the openness of the original planting. The yews also hung over the edge of the stylobate wall, which caused staining and deterioration of the marble. Other more minor changes have also been made to the landscape over the years. In 1986, three mature, original white pine trees were removed and replaced with six-foot-high specimens of the same. Also, that year the holly hedge on the stylobate mall, comprised of 3,806 dwarf inkberry plants, which made up the hedge on the terrace mall, were replaced with an equal number of the Japanese holly cultivar Shamrock.[53] The new yews were removed in 1993, and several original yews, a holly, and a white pine were removed and replaced. A number of original species of flowering trees and shrubs, including dogwoods, cotoneasters, and glossy Abelia have been lost entirely. Olmsted preferred a more diverse

plant palette than exists today. The original periwinkle ground cover was replaced with grass soon after the memorial's completion.[54] Further changes were executed during 1993 and 2000 restorations, all of which have largely attempted to restore integrity to Olmsted's altered design and improve the form and function of the memorial structure.

A few structural alterations have also been made to the memorial since it was dedicated on the two hundredth anniversary of Jefferson's birth in the spring of 1943. The memorial's settlement problems persisted. Details of these findings are documented by Storch Engineers [of New Jersey], which compiled a comprehensive report dated March 31, 1965. Settlement of the adjacent roadway and sidewalks of up to three feet was the clarion call to action and led to the commissioning of the so-called Storch Report by the National Park Service which, due to the complexity of the problem, took five years to complete. The Storch Report identifies the following settlements, among many, as being significant in the relationship between the structure and the appearance of the landscape:

> By 1951, settlement of the fill adjacent to the NW corner of the main approach steps had caused severe cracking of the sidewalk between the roadway and the main Memorial approach steps. [...] Due to settlement of fill adjacent to the main steps and at the southerly approach to the terrace steps, wooden steps were placed on the settled ground [...] bituminous concrete was used to fill opened sidewalk joints. [...] The maintenance department made use of mud-jacking techniques in attempts to raise portions of the peripheral roadway, the adjacent sidewalk, the terrace walk and portions of the walk adjacent to the Tidal Basin.

Storch's recommendations for rehabilitation preceded the most significant departure from Olmsted's original landscape design intent in the landscape—the replacement of the roadway adjacent to the Tidal Basin with a plaza, in addition to a replanting scheme around the memorial. The memorial was closed in October 1969 in order to carry out the stabilization program which included installing concrete reinforcing struts to arrest the subsidence, the reconstruction of sidewalks, rebuilding the terrace walk, and substantial planting and grading. The peripheral roadway at the Tidal Basin and some of the curbs and sidewalks were replaced, using a lightweight, expanded slag sub-base in place of the previous one, to reduce subsequent compaction. Previously, a heavy sub-base had been used which had compacted the underlying silty clay. Steps at the north side, which had been steadily shifting since their construction, were reset back to their original position. Most prominently visible in this package of renovations was the replacement of the roadway on the Tidal Basin side of the memorial with a multicolored exposed aggregate and colored concrete plaza. The substructure was modified to stabilize the memorial and the newly designed plaza to the north was "floated" by means of a concrete slab. This slab was supported by a viaduct-like system of supporting and horizontal reinforced concrete beams. It was completed on December 16, 1970. The levels of this area were considerably altered in that the new plaza adjacent to the seawall has a higher finished grade than its predecessor. This alteration in levels between the old existing road and the new plaza meant that the remaining approach roads to the new plaza, shown in the plan, had to be

ramped upwards toward the plaza in order for them to meet. Obviously, this higher level makes for better drainage of the plaza as the runoff falls in the direction of the Tidal Basin and to the catch basins at the east and west of the plaza in the road. The smooth curve of the circular road around the memorial, however, was lost.

The construction of this plaza has changed the character of the original, single, continuous, circular roadway. The plaza is not linked to the memorial's historic landscape, nor does it relate to the memorial's shape and form. Additionally, according to National Park Service record, the plaza does not delineate the edge of the Tidal Basin as the roadway's sidewalk originally did. Several years after the plaza's construction, two phases of work were performed in preparation for the nation's bicentennial. Between 1974 to 1975, work was completed to repair minor structural defects in the memorial. To give visitors a better experience, over the period 1975 to 1976, visitor amenities were improved, to include elderly and handicapped access with the installation of an elevator and ramps. A small gift shop was also added. In 1987, the freestanding information booth located inside the memorial was replaced with a more sympathetic, integral one. In the early 1990s, a team led by Einhorn Yaffee Prescott, Architecture and Engineering, and Hartman-Cox Architects worked with the National Park Service on the first comprehensive repair effort at the memorial. "For the next three to five years, the Lincoln and Jefferson Memorials in Washington, those soaring marble arias to democracy and the inspiration for thousands of tourists each week, will be partly obscured by decidedly unpoetic girdles of scaffolding, fences and thick green nets, as workers struggle to shore up the crumbling monuments and restore a bit of their dimming grandeur," reported the January 14, 1992 *New York Times*.[55] "The monuments are suffering, not so much because they have been battered by grit, grime and acid rain or even because pigeons shamelessly roost on the heads of the presidential statues within, but because in the half-century since the monuments were built they have been kept so meticulously clean. To help assure the appearance of unsullied timelessness at the monuments, the National Park Service hoses down the entire structures twice a year and swabs off the Lincoln statue with detergent and water every other day." As a result of the constant washing, the marble had eroded so badly in particular areas that a chunk of one of the Jefferson Memorial's forty-two-foot columns crashed to the ground and other columns were found to be teetering dangerously. The debate over cleaning the monuments regularly or not raged on:

> Some argue that a building coated with dirt or graffiti or bird droppings is an offense and that a city of grimy buildings is a dark, unsavory place, bespeaking economic and social disintegration. They also say that pollution and filth are harmful to a building and that surely the expeditious removal of grime is in the building's best interest.
>
> Others insist that cleaning a building almost always does more harm than good, driving water deep into the capillaries of the stone, where it can expand if it freezes and crack the masonry. They say a spattering of grease and graffiti on the facade is far preferable to deep structural damage that can follow a cleaning, and they say cities are full of buildings that have been mangled by cleanings past.[56]

The *Times* article informed that the critics of cleaning echoed the nineteenth-century architect and neo-medievalist John Ruskin, who argued that there is something pleasing about "the sweetness of line the wind and rain have brought" to buildings that have been around long enough to qualify as landmarks. "They decry," observed the *Times*, "the desire to clean, clean, clean as evidence of America's restless obsession with novelty and youth." But a third camp, composed of preservationists with a strong background in engineering, chemistry and even geology, sits between the two extremes, saying the technology for cleaning and restoring buildings has progressed so far in just the last several years that even the most delicate of structures can sometimes benefit from a deft and carefully executed cleaning.[57] The use of methods like electron microscopy, infrared spectroscopy and gas chromatography has enabled preservationists to determine whether dirt on a building is merely smudging the stone on the outermost layer or has pervaded the pores like a sickness and thus threatens the whole structure. The preservationists say it is now possible to combine the best of both worlds, observed the *Times* article, removing deleterious dirt without compromising the craftsmanship and subtleties of a beloved landmark. "For most people, buildings seem indestructible, designed to withstand the abuses of the elements and certainly far more stoic than the mortals who create them. But conservationists compare their specialty to medicine, using the same terms to describe damage and decay in a building as might be applied to a patient. They talk about whether the building suffers from any 'pathology' and they ask whether or not its stone can breathe and sweat," wrote the *Times*' Natalie Angier. But then there are those like Nicolas F. Veloz, who worked just then on protecting and restoring monuments for the National Park Service, who told Angier: "The most important principle in medicine is, first do no harm. The same goes for buildings. You generally do the least amount of intervention possible."

Unfortunately, in the 1960s and 1970s, reported the *Times*, many buildings whose stones or bricks had merely begun to weather a little were sandblasted with an abrasive spray shot at the façade at a wilting pressure of about one hundred and fifty pounds per square inch to strip off dirt the quickest way possible. The practice was viewed as sanitizing a building, but the results were devastating. "When you sandblast, you lose most of the surface, and all the decorative details that give a building character," said Martin Weaver, director of the Center for Preservation Research and a professor of architecture at Columbia University in New York. "You strip the building down to something that looks like molten candy."[58] Another popular cleaning item was hydrofluoric acid, a compound so powerful it is used to etch glass. Masonry buildings, with their craggy surfaces, were thought to be able to withstand an acidic drizzle, and the treatment did have the seemingly miraculous effect of instantly lifting away filth without any immediate impact on the stone. But, according to Angier's *Times* article, many building materials, particularly those with a base of calcium or magnesium carbonate, like marble and limestone, were later shown to be able to dissolve in acid as sugar does in a cup of tea, and whenever these compounds were bathed in hydrofluoric acid, portions of the structure's skin gradually turned to dust and blew away. Thus, as became clear from what had happened to the nation's most treasured memorials, compulsive cleaning by their caretakers, guilty of trying anything, akin to scrubbing dirty

marble with a steel wire brush—just one example—the immediate brightening effect would eventually turn into what Angier dubbed "a horror show." What happened was subtle, to some degree. "A lot of marble statues were given measles," Weaver observed. "Invisible steel fibers were deposited below the surface, where they rusted. The statue would be white one day, and all of a sudden, these brown spots would appear everywhere."[59]

In Washington, just as the Jefferson Memorial problems were starting to be addressed, the National Park Service researchers became desperate to figure out how to keep the nation's treasured monuments presentable enough without resorting to regular scrubs, which were still part of the routine. Their investigations in this period revealed that at the Lincoln Memorial, what some described as a peculiar cross between technology and the food chain is to blame for some of the untidiness. "Each day at sunset, small insects called midges emerge *en masse* to mate. At the same time, flood lights are switched on to bathe the building in a noble aura, and the excited midges fly toward the lights, smashing against the wall and forming a great proteinous mess."[60] After that, the cycle of life gets a bit brutal—for the Lincoln Memorial. "Large spiders are attracted to the scent of decaying midge bodies, and they sully the structure with cobwebs and spider droppings. The spiders in turn beckon sparrows, which also defecate against the memorial." The resulting ecosystem train wreck does not harm the building as much as the process of trying to wash them off with water. The saturated stone absorbs particles from automobile exhaust, and the mixture infiltrates the marble.[61] As part of the early 1990s initiative, in 1993, restoration of the stylobate mall, which consists of the grassed elevated terrace that rings the base of the Jefferson Memorial, returned the planting in this area back to the original design as it was at the time the memorial first opened, as the first stage of landscape restoration.

Despite the top tier maintenance that enveloped the memorials of Washington, D.C., in the 1990s, the Jefferson Memorial included, there were other improvements made. In 1998, the lower level of the memorial was rehabilitated and an improved exhibit and staff space installed. The restrooms were enlarged to include a family restroom, and two shops were added. In an effort to restore the integrity of the historic landscape, plantings installed for the bicentennial celebration, primarily hollies, were removed. Dogwood and yew have been planted in keeping with the Olmsted plan. A restoration of the entrance steps and plaza, completed in 2000, focused on rehabilitating the surfaces of the memorial landscape. All marble stairs were reset and repaired. The circular road was raised and resurfaced with aggregate concrete colored to mimic the original asphalt. The north plaza was redone with the same material, and raised so that it is completely flush. Where there were once curbs, granite pavers were set in the surface. The 1970s planters were removed and safety lighting was installed along the seawall. The walkways and parking lot were resurfaced, and minor landscape changes implemented.[62]

Beyond the bluster of structure and landscape, form and function of the memorial, there is the meaning of the place itself, embodied in the man that it honors. General Colin L. Powell, then chairman of the Joint Chiefs of Staff, delivered an eloquent Memorial Day speech recorded in the June 11, 1991 *Congressional Record* that best informs the American people—and the world—of the importance of memorial to Thomas Jefferson and why it

remains so relevant today. Powell remarked that he had begun to realize [as Memorial Day approached] and he had just concluded a meeting with army general Mikhail Alexeyevich Moiseyev, appointed chief of the Soviet General Staff in December 1988, a post he held until August 22, 1991, making him Powell's Russian counterpart, that it was the first time he had seen Moiseyev since October 1990, when he took him around Washington, D.C., to see the monuments and memorials of city. While he wanted to take him to the wall of the Vietnam Veterans Memorial, Powell observed that Moiseyev was not ready for it. "I had to show him what America was really about, what we really stood for. I had him look into the very crucible where America's values were fired." So that fall, on what Powell described as a very beautiful morning, he took him first to the Jefferson Memorial:

I showed him Jefferson's words carved into the walls of that memorial. His nation-building words about our Constitution. His freedom-loving words about the abomination of slavery. His God-given words about religion. His ageless words from the Declaration of Independence. I showed General Moiseyev the extraordinary words at the end of the Declaration of Independence—words that have a special meaning for every man and every woman who has ever served in America's armed forces. Words that were to stir every patriot's heart. To these ends, Jefferson wrote, 'We mutually pledge our lives, our fortunes, and our sacred honour.' This is what every one of us in the military does. We pledge our lives. We pledge our fortunes. We pledge our sacred honor. We pledge them all to the preservation of America.

Then Powell told Moiseyev to look up, above the statue of Jefferson:

Look up to the words that encircle the monument's interior. Words written in letters two feet high. Words bigger than life. Words that distill the very essence of Thomas Jefferson and the very essence of America. Those words read: 'I have sworn upon the altar of God eternal hostility against every form of tyranny over the mind of man.'

"I told General Moiseyev that here are our roots. Captured in this memorial, in this man Jefferson, in these words, you see our beginnings [as a nation]," Powell iterated. "You see the foundation of America, a nation where 'We hold these truths to be self-evident, that all men are created equal, that they are endowed by their Creator with certain unalienable Rights, that among these are Life, Liberty, and the pursuit of Happiness.'"

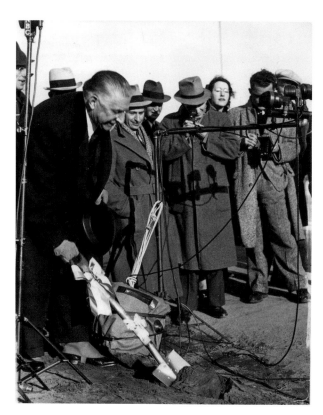

Stuart G. Gibboney, acting chairman of the Thomas Jefferson Memorial Commission, turned the first spadeful of dirt at the memorial site on the Tidal Basin on December 15, 1938. President Franklin D. Roosevelt was the speaker. *Amy Waters Yarsinske*

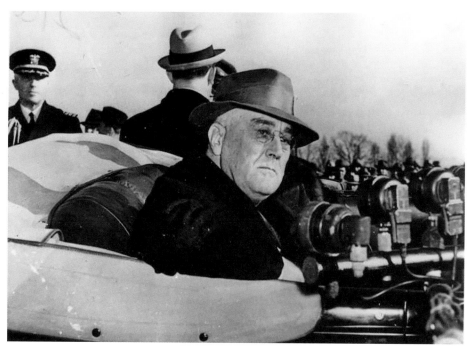

President Franklin D. Roosevelt attended the groundbreaking ceremony for the memorial on December 15, 1938. *Franklin D. Roosevelt Presidential Library and Museum*

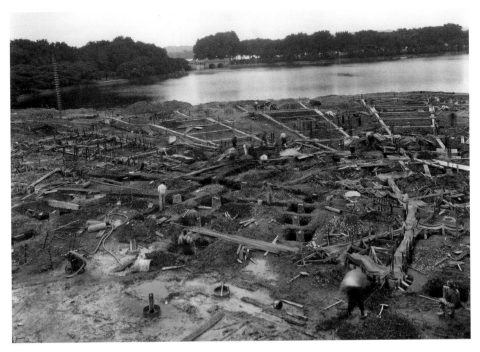

Work on the Thomas Jefferson Memorial's foundations was underway when this picture was taken on June 3, 1939. The view is facing west, showing the caps and tie beams in the southwest quadrum. The workers were employed by the Raymond Concrete Pile Company. *National Park Service*

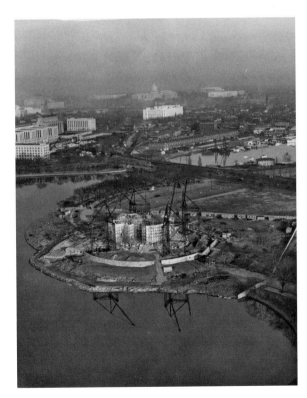

This aerial view of the Thomas Jefferson Memorial under construction was taken on December 31, 1939. *Amy Waters Yarsinske*

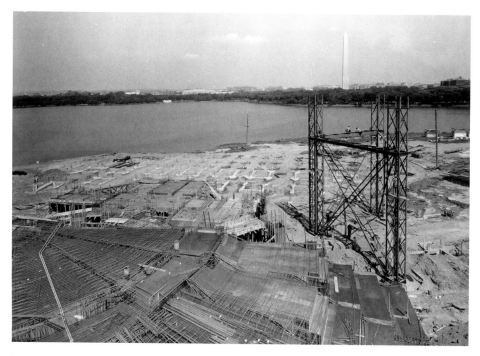

Construction work on the southeast edge of the stylobate steps, looking north, was photographed on September 1, 1939. *National Park Service*

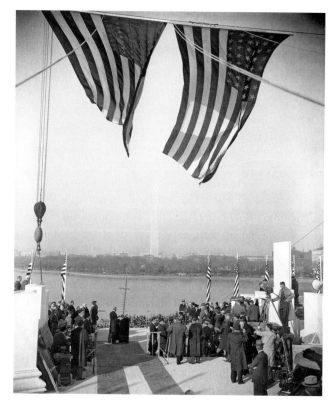

This dramatic Harris and Ewing photograph expands the view of President Franklin Roosevelt delivering his remarks at the November 15, 1939 cornerstone ceremony on the bank of the Tidal Basin. *Library of Congress*

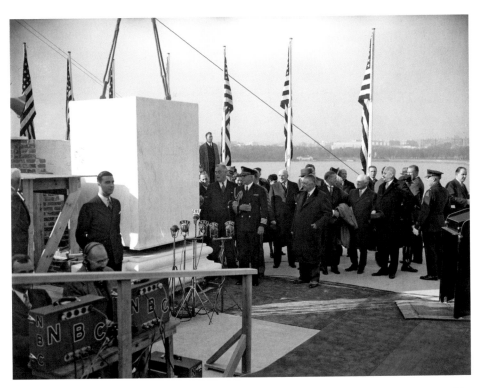

To the stonecutter who made the stone, it was better identified as simply "Number 208," but to all in attendance at the ceremony on November 15, 1939, it was the cornerstone of the Jefferson Memorial. Here, President Franklin D. Roosevelt wielded a trowel handed down through generations since George Washington. A Harris and Ewing photographer took the picture. *Library of Congress*

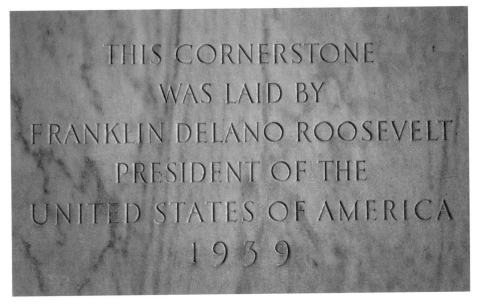

A close-up of the cornerstone of the memorial was photographed by Technical Sergeant Eric Miller of the New York Air National Guard on January 20, 2013. *United States Air Force*

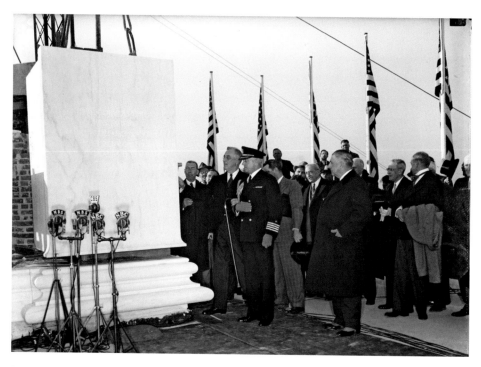

In another Harris and Ewing view of the memorial cornerstone laying, President Franklin Roosevelt, his hand on the stone, is braced by his White House naval aide, Captain Daniel Callaghan. *Library of Congress*

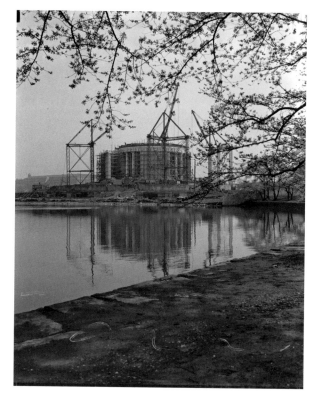

The memorial was under construction in the spring of 1940 when this picture was taken by a Harris and Ewing photographer. *Library of Congress*

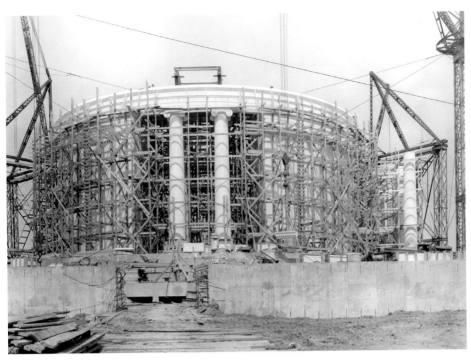

The memorial's superstructure was under construction when this photograph was taken on April 1, 1940. The view is the south face of the building looking north. *National Park Service*

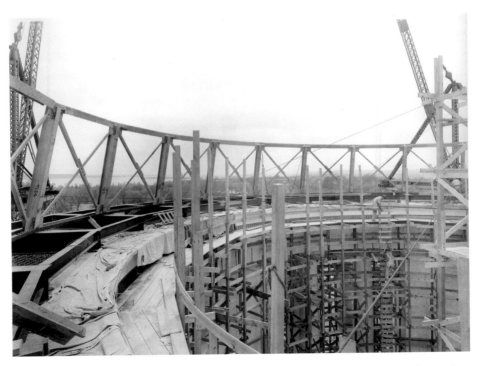

Looking south, this picture shows the structural steel for the dome base. The photograph was taken on May 1, 1940. *National Park Service*

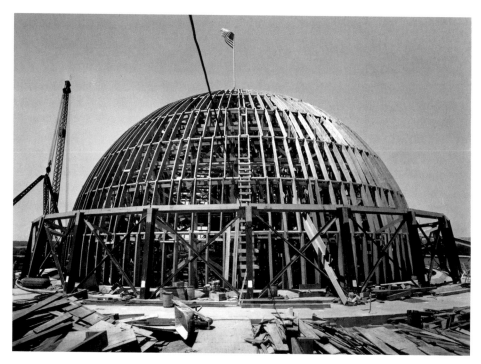

Temporary support was erected for the memorial's limestone interdome during construction. The picture was taken on August 1, 1940. *National Park Service*

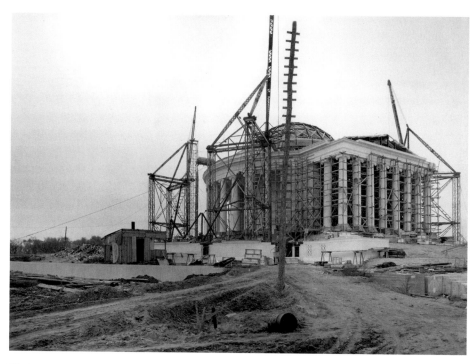

Work continued on the northeast quadrant of the memorial. The view, photographed on November 1, 1940, is looking southeast. *National Park Service*

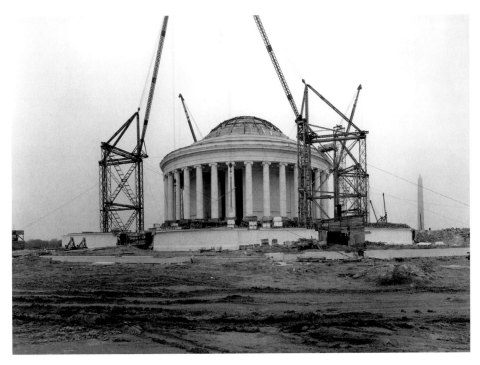

This is a central view of the southeast face, also taken on November 1, 1940. *National Park Service*

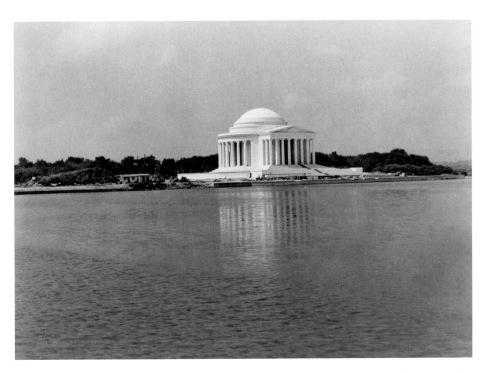

Photographer Martha McMillan Roberts took this picture of the Jefferson Memorial under construction in July 1941 from across the Tidal Basin. *Library of Congress*

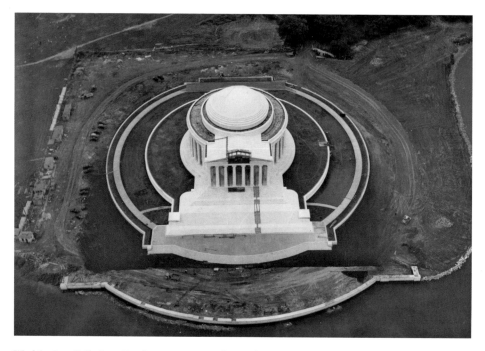

Washington, D.C., is a city of monuments and was about to add a new one as the Thomas Jefferson Memorial construction continued. The view here was taken from a Goodyear blimp on September 8, 1941. *Amy Waters Yarsinske*

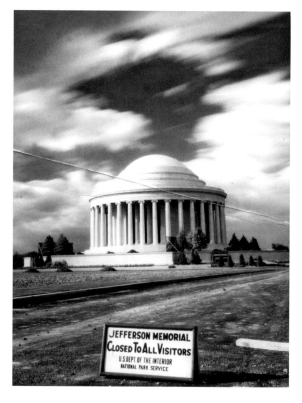

When the landscape work at the memorial was completed, the memorial was set to be opened to the public with appropriate ceremonies. Until then, it was closed to all but National Park Service employees. The picture was taken on March 7, 1942. *Amy Waters Yarsinske*

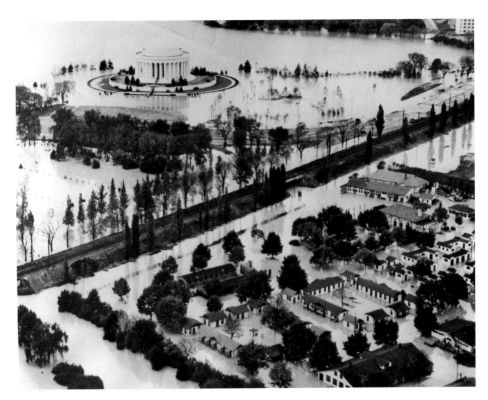

This photograph, taken on October 19, 1942, by the United States Army Air Force, shows what happened when the waters of the Potomac River rose to unusual levels. The Jefferson Memorial (in the background) and buildings in the foreground, used by the federal government and which were once a tourist camp (foreground) were overcome by floodwaters. *Amy Waters Yarsinske*

An original watercolor, artist unknown, depicts the memorial and new bridge under construction in March 1943. The million-dollar bridge was designed by architect Paul Phillipe Cret in 1941 to connect Independence Avenue with the Potomac River Highway above Fifteenth Street. Construction was completed by the engineering firm of Alexander and Repass of Des Moines, Iowa, in 1943. The bridge was subsequently named for Brigadier General Charles W. Kutz, a three-term commissioner of engineering for the District of Columbia, for whom it was dedicated in 1954.
Amy Waters Yarsinske

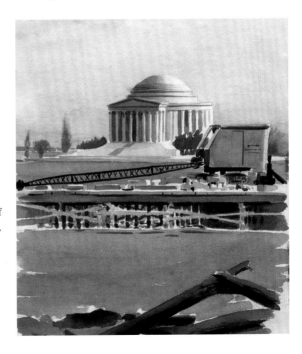

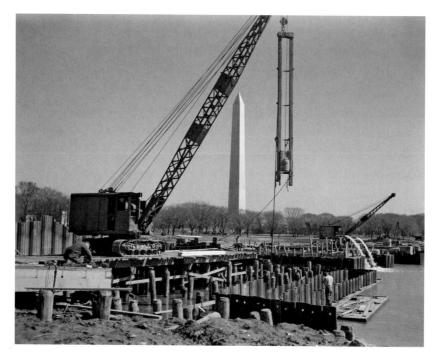

The famous cherry blossoms along the Tidal Basin would be viewed from a new angle after completion of the bridge over the basin was completed. Roger Smith, an Office of War Information photographer, took this picture in March 1943 of heavy machinery and piers used in the early stages of construction. Construction of the new bridge was on the fast track largely to provide better access to the Pentagon during World War II. Today, the Kutz Bridge is a major contributing feature of the West Potomac Park Historic Area. *Library of Congress*

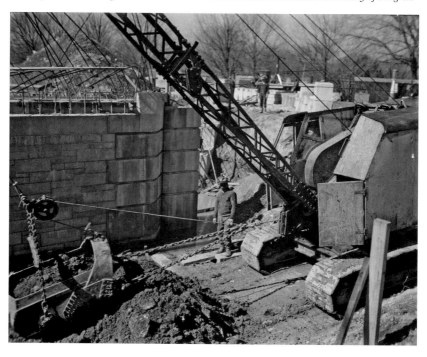

Archie A. Alexander, senior partner in the firm of Alexander and Repass of Des Moines, Iowa, contractors for the million-dollar bridge being built just then over the Tidal Basin (pictured here, March 1943), with his partner and crew, finished the project that year. Alexander and Maurice A. Repass were classmates at the University of Iowa School of Engineering and halfbacks on the varsity football team. At the time this picture was taken, they had been in business together for twenty-eight years. *Library of Congress*

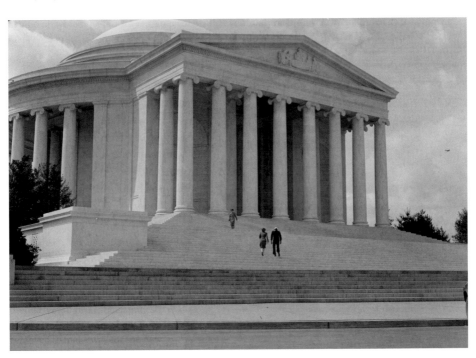

This was the exterior of the Jefferson Memorial as it looked on April 12, 1943, the day before it was dedicated on the bicentennial of Thomas Jefferson's birthday. The $3 million building was constructed of marble from Vermont, Missouri, Georgia and Tennessee. The picture was taken by Ann Rosener (1914–2012), an Office of War Information photographer. *Library of Congress*

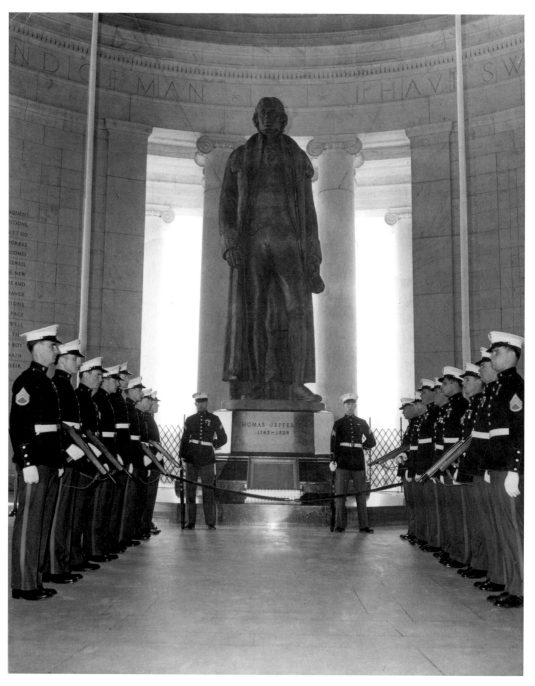

A special detachment of United States Marines stood guard over the original Declaration of Independence (center) that was removed from its secret wartime hiding place at Fort Knox, Kentucky, to be placed on exhibition beneath the plaster of Paris statue of Thomas Jefferson as a feature of the memorial dedication ceremonies (and Thomas Jefferson's birthday) on April 13, 1943, also the date of the picture. *Amy Waters Yarsinske*

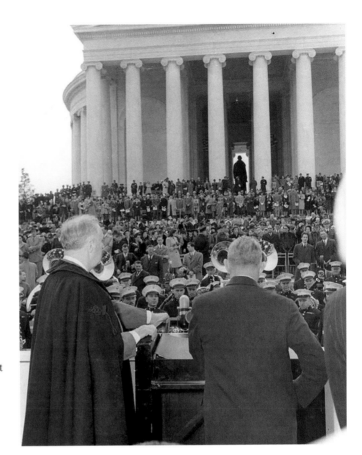

President Franklin D. Roosevelt returned to the Tidal Basin on April 13, 1943, to speak once again at the dedication of the memorial. *Franklin D. Roosevelt Presidential Library and Museum*

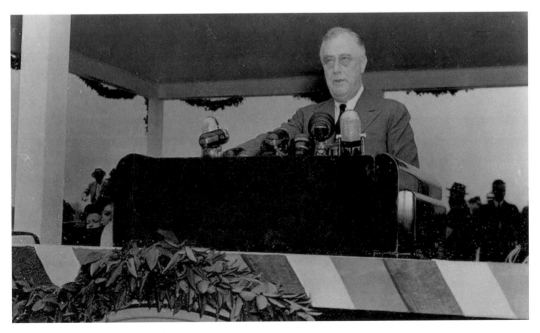

Roosevelt delivered his remarks at the dedication of the memorial. *Franklin D. Roosevelt Presidential Library and Museum*

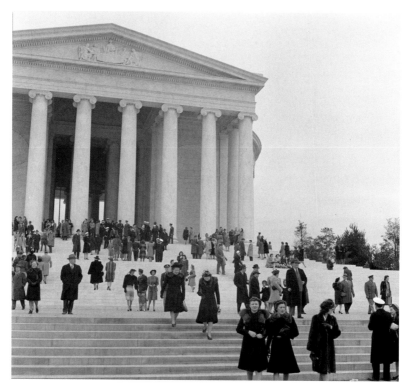

Crowds flocked to the Jefferson Memorial on April 13, 1943, to witness the dedication of the nation's newest and iconic national monument. Esther Bubley (1921–1998), an Office of War Information photographer who specialized in expressive photographs of ordinary people in everyday life, took these pictures. *Library of Congress*

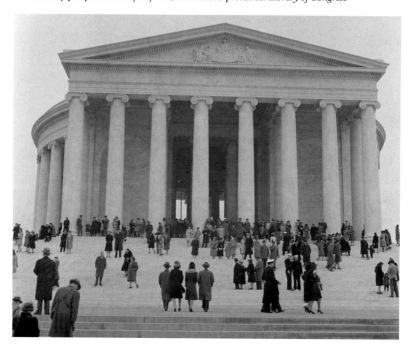

Esther Bubley was looking across the Tidal Basin from the steps on the newly opened Jefferson Memorial on April 13, 1943, when she took this photograph. *Library of Congress*

Photographed from an aircraft flying over the Virginia side of the Potomac River in June 1943, Memorial Bridge is lower left, with the Lincoln Memorial at its northern end. The Old Navy Hospital is at the extreme middle left. The Main Navy and Munitions Buildings, constructed in 1918 along Constitution Avenue (then known as B Street) on Washington, D.C.'s National Mall (also known as Potomac Park), are in the upper left center, with many World War II temporary buildings behind them on both sides of the Reflecting Pool. The Tidal Basin is in the upper right, with the Jefferson Memorial at the extreme right. *National Archives*

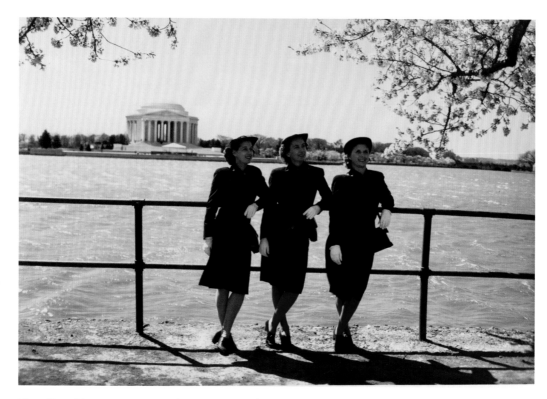

Three United States Naval Reserve (Women's Reserve), better known under the acronym WAVES for Women Accepted for Volunteer Emergency Service, stood by the north side of the Tidal Basin during the spring cherry blossom season between 1943 and 1945. The Jefferson Memorial is in the distance. *National Archives*

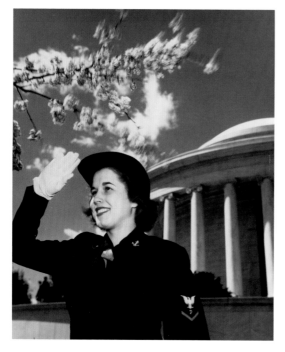

Saluting as she stands among the spring cherry blossoms near the Jefferson Memorial during World War II, this navy WAVES third class petty officer wears a specialist rating badge "P" for photographer. *National Archives*

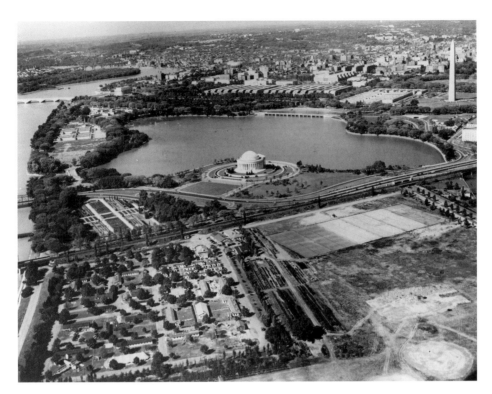

An aerial view of Washington, D.C., taken on January 1, 1945, from a United States Navy aircraft, shows the Jefferson Memorial (center) on the Tidal Basin. Other presidential monuments shown in this picture include the Lincoln Memorial (upper left) and the Washington Monument (far right). The Potomac River is far left. *Amy Waters Yarsinske*

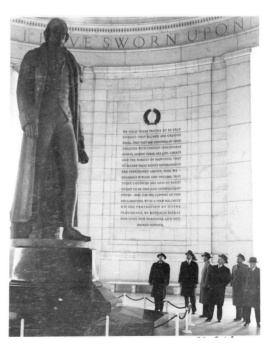

Harry S. Truman (third from right) with Secretary of the Interior Harold Ickes and others were photographed by Abbie Rowe (1905–1967), a photographer of the National Capital Parks of the National Park Service, on January 14, 1946, taking a look at the plaster of Paris statue of Thomas Jefferson, which was just months from being replaced with the Rudulph Evans bronze. *Harry S. Truman Presidential Library and Museum*

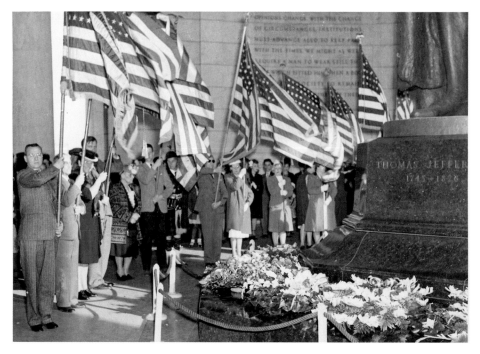

A ceremony held at the Jefferson Memorial to mark the two hundred and fourth anniversary of the birth of Thomas Jefferson was held on April 13, 1947. Abbie Rowe took the photograph. *Harry S. Truman Presidential Library and Museum*

Flag bearers, dignitaries and spectators gathered on the steps of the Jefferson Memorial to continue the commemoration of Thomas Jefferson's birthday on April 13, 1947. *Harry S. Truman Presidential Library and Museum*

The large crowd gathered at the memorial for a ceremony marking Thomas Jefferson's birthday, with the Tidal Basin and Washington Monument in the background, on April 13, 1947, was also photographed by Abbie Rowe. *Harry S. Truman Presidential Library and Museum*

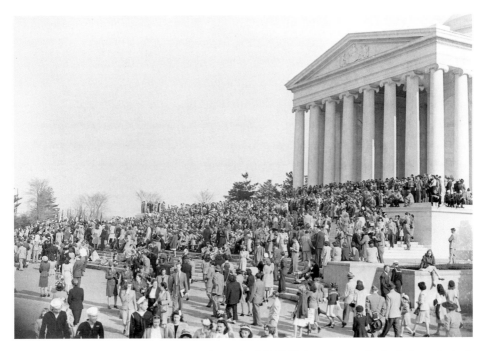

The celebration of Thomas Jefferson's birthday on April 13, 1947, drew thousands of onlookers who took advantage of a beautiful spring day on the Tidal Basin to help the nation remember one of the nation's Founding Fathers. Abbie Rowe took the photograph. *Harry S. Truman Presidential Library and Museum*

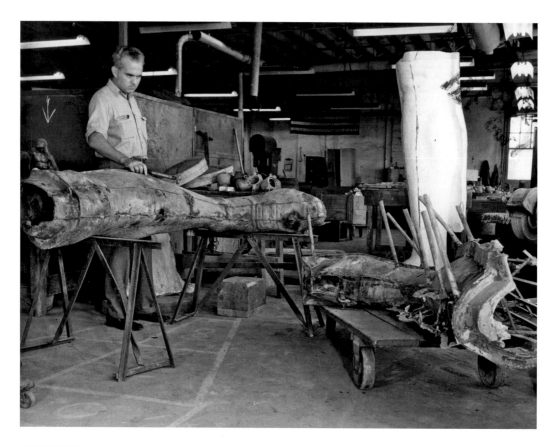

Plaster casts for sculptor Rudulph Evans' bronze statue of Thomas Jefferson was created in the studio of the Roman Bronze Works, a foundry in Corona, New York, located in the Long Island borough of Queens, in 1946. *National Park Service*

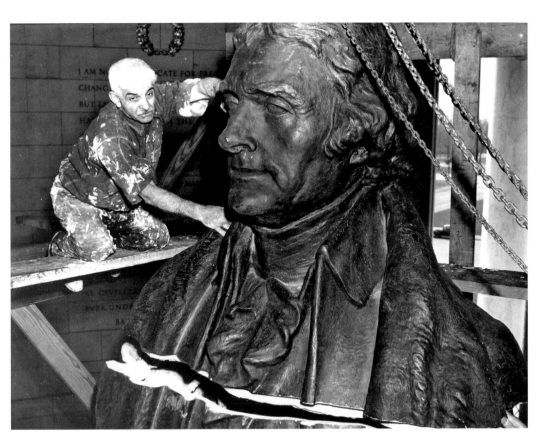

The temporary plaster of Paris statue of Thomas Jefferson was disassembled in mid-April 1947 prior to the permanent bronze statue being installed. *National Park Service*

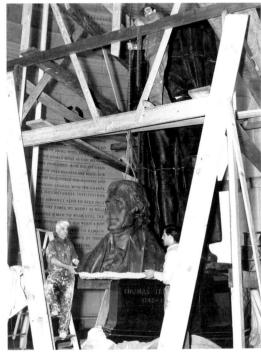

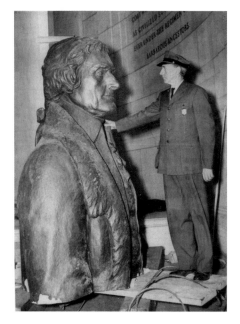

Samuel Ivan Gill, a guard at the Jefferson Memorial, was photographed on April 18, 1947, looking over the huge plaster figure of the nation's third president, taken down to make way for the new five-ton bronze replacement. A bronze shortage during World War II necessitated the use of plaster of Paris until the war was over and the bronze could be procured for the new statue. *Amy Waters Yarsinske*

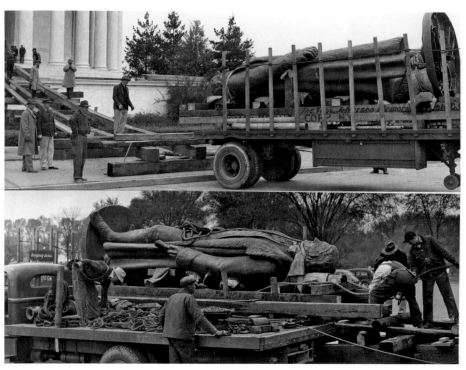

A new bronze statue of Thomas Jefferson, valued just then at $25,000 and weighing five tons, arrived at the memorial on April 22, 1947 (shown here). The new statue replaced a temporary plaster of Paris figure that had occupied the memorial for four years. The huge statue is shown here on the back of the Roman Bronze Works truck and in other photographs being hauled up a ramp to the memorial. The job took three to four days to complete and proved the most challenging for workers when it came time to mounting the heavy bronze onto its black marble pedestal. *National Park Service*

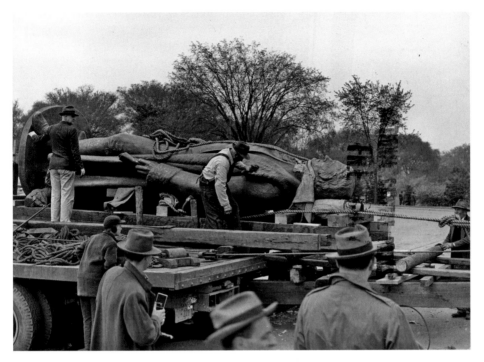

The bronze statue was offloaded from the Roman Bronze Works truck onto a ramp. *National Park Service*

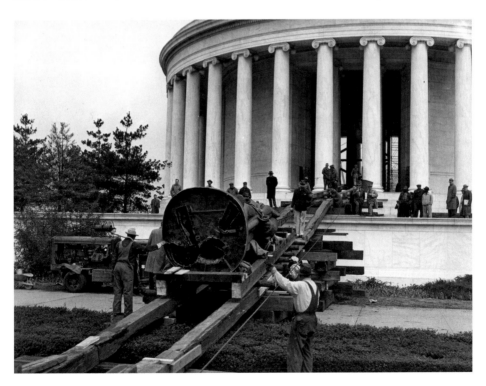

The bronze statue of Jefferson was rolled into the memorial from the south side. This picture and others in the National Park Service sequence from this event were taken on April 22, 1947. *National Park Service*

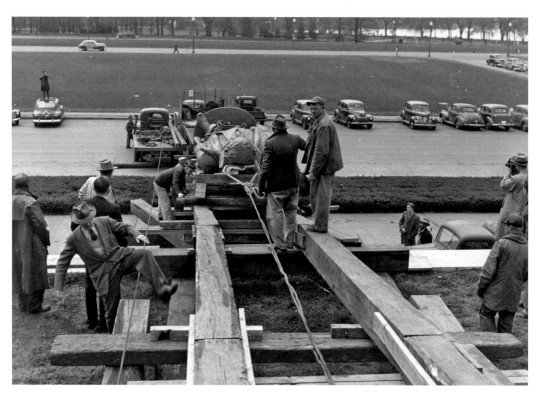

This is a view to the south as the statue of Jefferson was rolled into the memorial. *National Park Service*

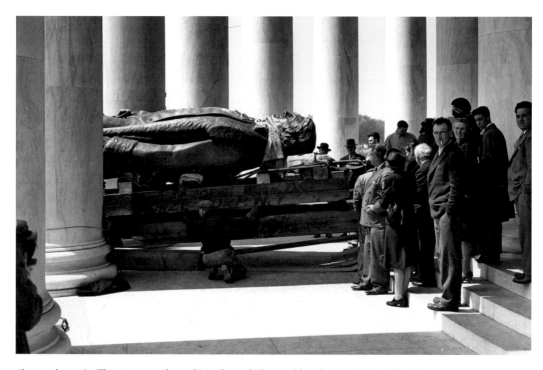

Above and opposite: The statue was brought in through the marble columns. *National Park Service*

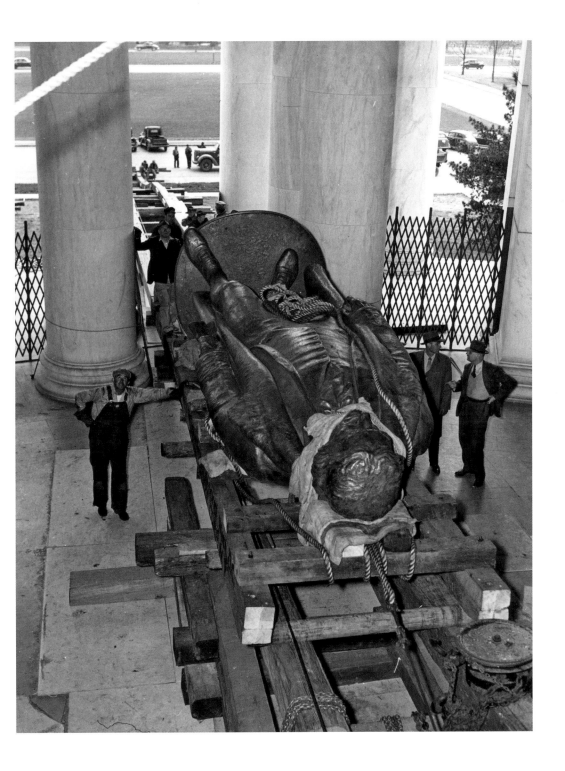

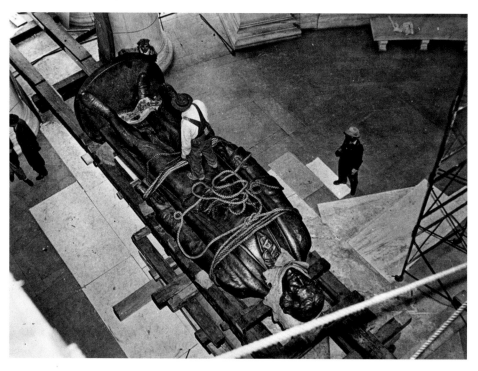

The rigging and padding was put into place to lift the statue into position. *National Park Service*

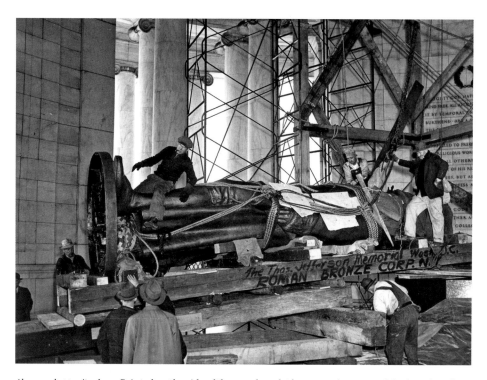

Above and opposite above: Painted on the side of the wooden platform was the name of the foundry where the bronze statue was cast—it read "Roman Bronze Corp. N.Y." *National Park Service*

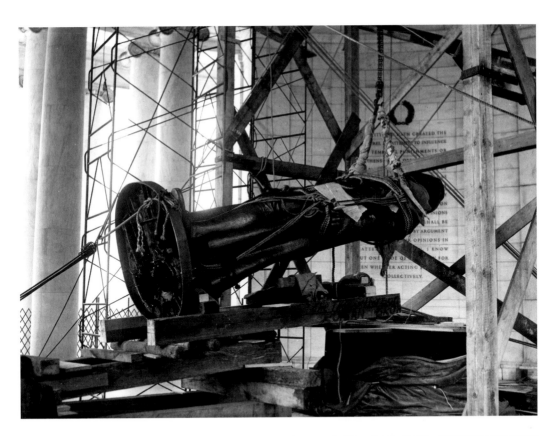

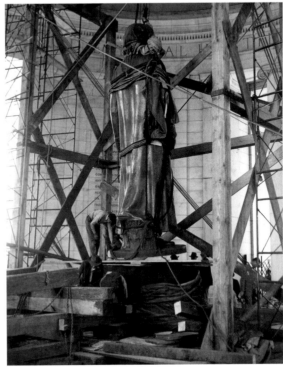

The Rudulph Evans bronze statue of Thomas Jefferson was lowered onto the pedestal in the chamber of the memorial.
National Park Service

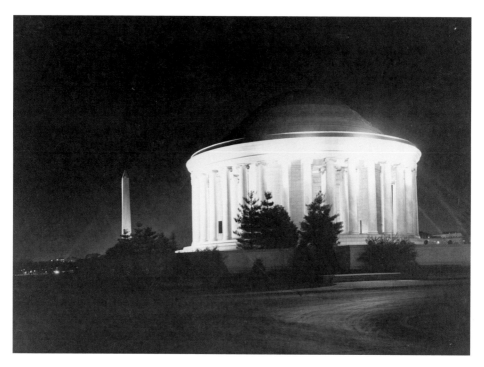

The Jefferson Memorial, with the Washington Monument in the background, was illuminated at night during President Harry S. Truman's inaugural celebration. The picture was taken by Abbie Rowe on January 20, 1949. *Harry S. Truman Presidential Library and Museum*

A fashion model posed in an evening gown on the steps of the Jefferson Memorial in June 1949, with the Tidal Basin and Washington Monument in the background. The picture was taken by Toni Frissell (1907–1988). *Library of Congress*

This graphic of a 1951 Packard Patrician 400—one of nine all-new models from the automaker that year—parked in front of the Jefferson Memorial first appeared as part of a larger advertisement in the March 31, 1951 *Saturday Evening Post*. *Amy Waters Yarsinske*

President Harry S. Truman (center) and other dignitaries arrived at the Jefferson Memorial for a wreath-laying ceremony honoring Thomas Jefferson on the anniversary of his birthday on April 13, 1952. Abbie Rowe took the photograph. *Harry S. Truman Presidential Library and Museum*

The Baltimore and Ohio Railroad featured Paul Burns' watercolor of the Jefferson Memorial on its dining car service menu. The menu dates to 1952. Of note, martinis were fifty cents, a shrimp cocktail was eighty cents, grilled halibut steak, New England style, just $1.90, and a mixed London grill with fresh mushrooms $2.25. *Amy Waters Yarsinske*

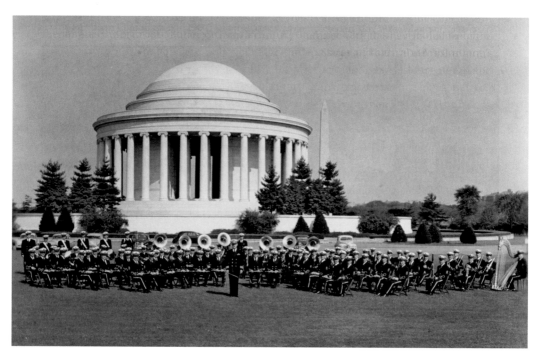

The United States Navy Band (shown here) played at the Jefferson Memorial at an unknown date between 1950 and 1959. *Naval History and Heritage Command*

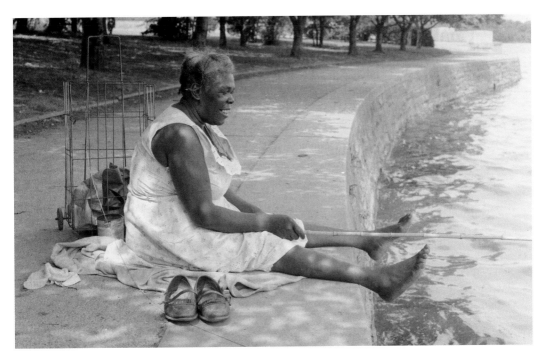

Toni Frissell took this picture of a woman fishing at the Tidal Basin in September 1957. *Library of Congress*

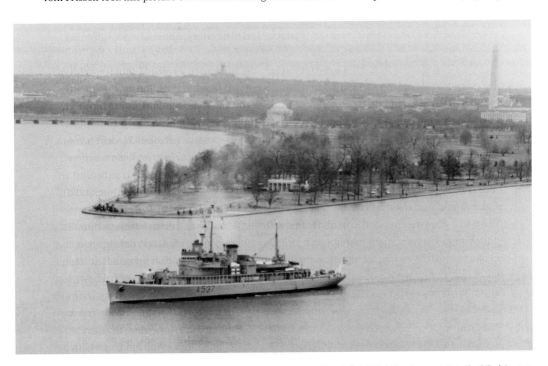

The Norwegian training ship *Haakon* VII passed Hains Point on March 9, 1970, following a visit to the Washington Navy Yard. Monuments and landmarks visible in the background include the National Cathedral (on the ridgeline, distant center), the Jefferson Memorial (center) and the Washington Monument (far right). *Naval History and Heritage Command*

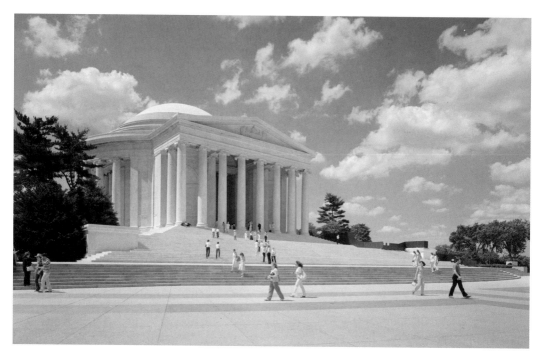

This view of the Thomas Jefferson Memorial shows the north front from the northeast as it appeared in 1976. *Library of Congress*

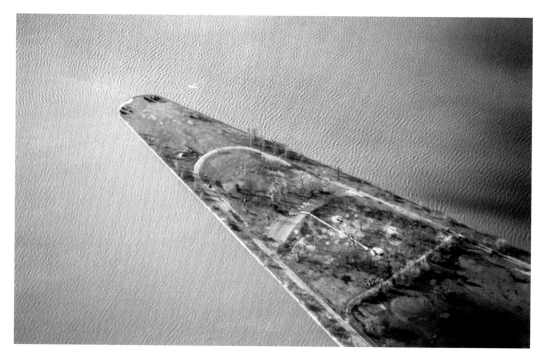

An aerial view of Hains Point and East Potomac Park, taken in March 1, 1991, provides a unique view of the low-lying peninsula that begins the divide between the Potomac River (right) and Washington Channel (left). *National Archives*

The United States Air Force band—Airmen of Note—was photographed against the backdrop of the Jefferson Memorial on May 22, 1981. *National Archives*

The United States Air Force Honor Guard drill team posed on the steps of the Jefferson Memorial on June 5, 1981. *National Archives*

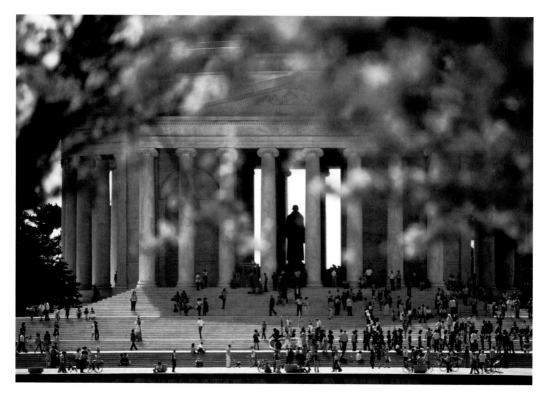

This view of the memorial through the cherry blossoms was taken in the spring of 1982. *National Archives*

President Ronald W. Reagan delivered remarks on his Economic Bill of Rights during the Star-Spangled Salute to America at the Jefferson Memorial on July 3, 1987. *Ronald Reagan Presidential Library and Museum*

This air-to-air port side view of United States Air Force 1402nd Military Airlift Squadron aircraft over the memorial was taken on November 1, 1989, and shows a Beechcraft C-12 Huron (top) and the Learjet C-21 (bottom). *National Archives*

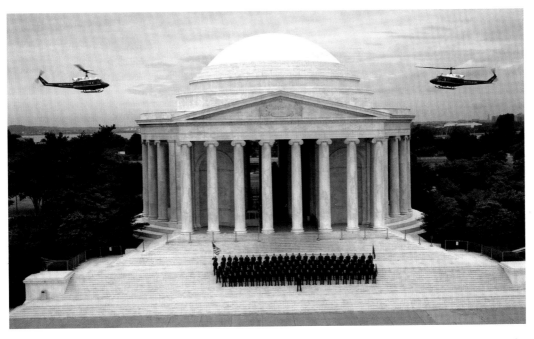

Two United States Air Force UH-1N Iroquois helicopters from the First Helicopter Squadron hover above the Jefferson Memorial on June 21, 1991, as squadron members gathered on the monument's steps to celebrate their record of 150,000 accident-free flight hours. The squadron is quartered at Andrews Air Force Base, Maryland. *National Archives*

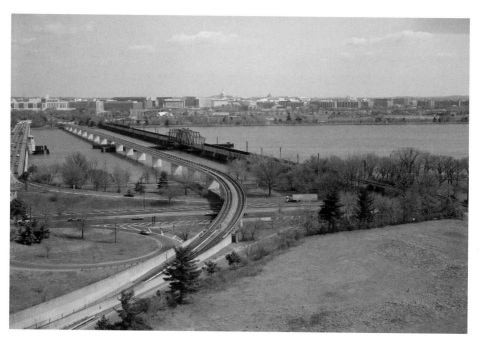

This aerial view is looking southeast towards Washington, D.C., near the Jefferson Memorial. Landmarks spanning the Potomac River include the Long Bridge (far right), Metrorail Bridge (center), and the Arland D. Williams Jr. Memorial Bridge (left). Jack E. Boucher took the picture in 1992 as part of an Historic American Engineering Record Survey. *Library of Congress*

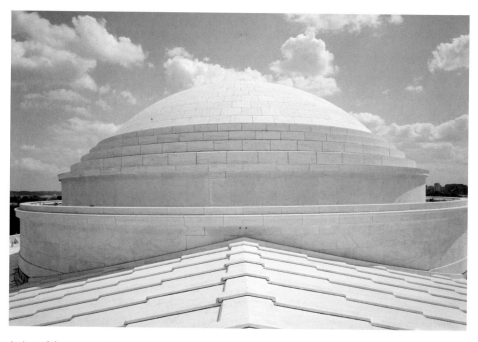

A view of the memorial dome from the north was photographed on June 4, 1991, by Jet Lowe as part of an extensive National Park Service documentation project, done in advance of restoration work that would follow. *Library of Congress*

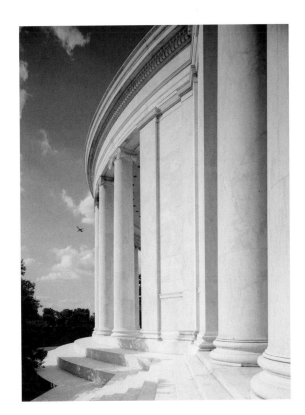

Taken on June 4, 1991, also by Jet Lowe was this picture of the colonnade at the northwest inside corner. *Library of Congress*

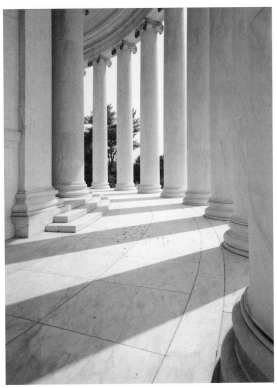

This is the ambulatory colonnade, photographed by Jet Lowe on May 23, 1991. *Library of Congress*

John McWilliams took this view looking west from Banneker Circle (Reservation Number 719) to the dome of the Jefferson Memorial in West Potomac Park in 1992 as part of an Historic American Buildings Survey (HABS) of the L'Enfant-McMillan Plan of Washington, D.C. The historic plan of Washington, designed by Pierre L'Enfant in 1791 as the site of the federal city, represents the sole American example of a comprehensive baroque city plan with a coordinated system of radiating avenues, parks and vistas laid over an orthogonal system. Influenced by the designs of several European cities and eighteenth century gardens such as France's Palace of Versailles, the plan was symbolic and innovative for the new nation. The foremost manipulation of L'Enfant's plan began in the late nineteenth century, and was codified in 1901 with the McMillan Commission, which directed urban improvements that resulted in the most elegant example of City Beautiful tenets in the nation. L'Enfant's plan was magnified and expanded during the early decades of the twentieth century with the reclamation of land for waterfront parks, parkways, and improved National Mall, and new monuments and vistas. Now more than two hundred years since its design, the integrity of the plan is largely unimpaired—boasting a legally enforced height restriction, landscaped parks, wide avenues, and open space allowing intended vistas. *Library of Congress*

Opposite page:

Above: Jack Boucher took this aerial photograph of the memorial from the north over the Tidal Basin in February 1992 in an effort to document the structure and surrounding grounds ahead of planned restoration work. *Library of Congress*

Below: In this aerial view, also taken by Jack Boucher in February 1992, the perspective is from the northeast. *Library of Congress*

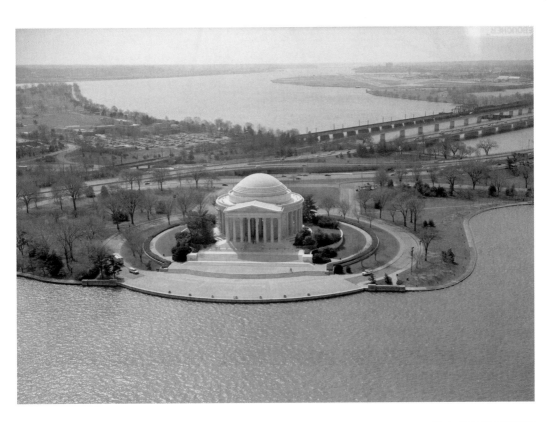

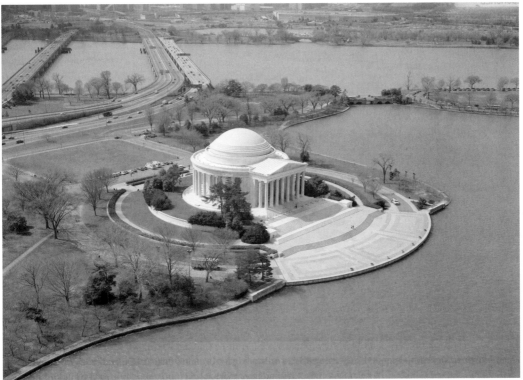

153

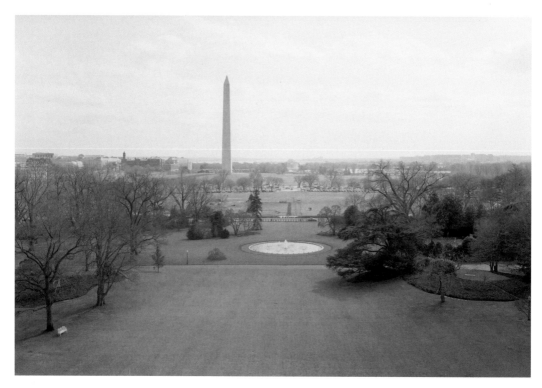

Intended at one time to mark a new world meridian, the axis of Sixteenth Street runs through the front and back doors of the White House. Wider than most of the orthogonal streets, in breadth and ceremony it is akin to the city's grand avenues. Around the turn of the twentieth century, wealthy Washington widow Mary Henderson attempted to develop the street as the "Avenue of the Presidents" through congressional pressure and speculative building. Although dozens of historic structures along the street were razed between the 1920s through the 1970s, those that remain have earned the contributing buildings between N Street and Florida Avenue distinction as the National Register's Sixteenth Street Historic District. This view looking south on the Sixteenth Street axis was taken by John McWilliams from the White House roof to the Jefferson Memorial in 1992. One bright spot in the twentieth century development of the street was the erection of the Jefferson Memorial. Although the memorial is not actually located on Sixteenth Street, it terminates its axis, due south of the White House. *Library of Congress*

Opposite above: Located in the statuary chamber of the memorial are four walls, each photographed by Jet Lowe on April 14, 1992, and that contain quotations from multiple sources of Jefferson's writings, including "A Summary View of the Rights of British America," "Notes on the State of Virginia," "The Autobiography," and two letters, the first to George Wythe in 1790 and an earlier letter to George Washington in 1786: "God who gave us life gave us liberty. Can the liberties of a nation be secure when we have removed a conviction that these liberties are the gift of God? Indeed, I tremble for my country when I reflect that God is just, that His justice cannot sleep forever. Commerce between master and slave is despotism. Nothing is more certainly written in the book of fate than that these people are to be free. Establish the law for educating the common people. This it is the business of the state to effect and on a general plan." *Library of Congress*

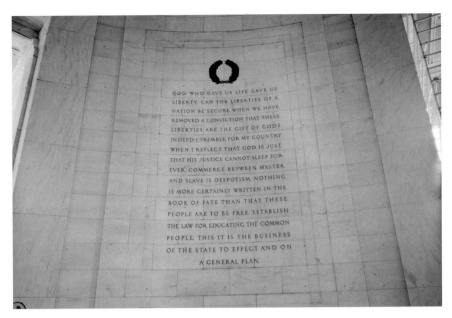

Below: The northwest wall (shown here) is inscribed with a combination of Jefferson's writings, including excerpts from "A Bill for Establishing Religious Freedom," drafted in 1777, and first introduced in the Virginia General Assembly in 1779, after he had become governor. The bill passed by the assembly in 1786, while Jefferson was serving as minister to France. The last sentence is excerpted from a letter to James Madison dated August 28, 1789, as he was returning to America to assume his position as secretary of state: "Almighty God hath created the mind free. All attempts to influence it by temporal punishments or burthens ... are a departure from the plan of the holy Author of our religion ... No man shall be compelled to frequent or support religious worship or ministry or shall otherwise suffer on account of his religious opinions or belief, but all men shall be free to profess and by argument to maintain, their opinions in matters of religion. I know but one code of morality for men whether acting singly or collectively." *Library of Congress*

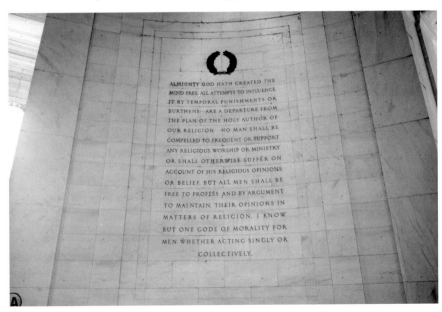

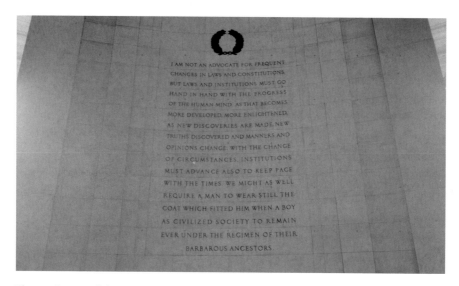

The southeast wall features a statement on the evolution of law and the Constitution, which was taken from a letter Jefferson had written to Samuel Kercheval on July 12, 1816: "I am not an advocate for frequent changes in laws and constitutions, but laws and institutions must go hand in hand with the progress of the human mind. As that becomes more developed, more enlightened, as new discoveries are made, new truths discovered and manners and opinions change, with the change of circumstances, institutions must advance also to keep pace with the times. We might as well require a man to wear still the coat which fitted him when a boy as a civilized society to remain ever under the regimen of their barbarous ancestors." *Library of Congress*

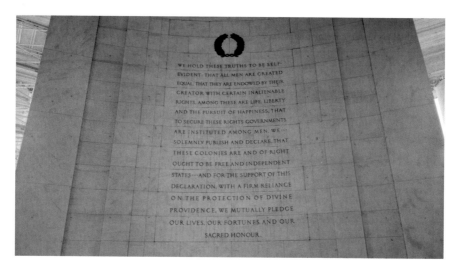

An excerpt from the Declaration of Independence, the document for which Jefferson is best known, is located on the southwest wall: "We hold these truths to be self-evident, that all men are created equal, that they are endowed by their Creator with certain inalienable rights, among these are life, liberty, and the pursuit of happiness, that to secure these rights governments are instituted among men. We ... solemnly publish and declare, that these colonies are and of a right ought to be free and independent states ... and for the support of this declaration, with a firm reliance on the protection of divine providence, we mutually pledge our lives, our fortunes, and our sacred honour." *Library of Congress*

One of the gems recovered during restoration was a model of the memorial found in the substructure of the building. Carol M. Highsmith took this undated photograph of that find. *Library of Congress*

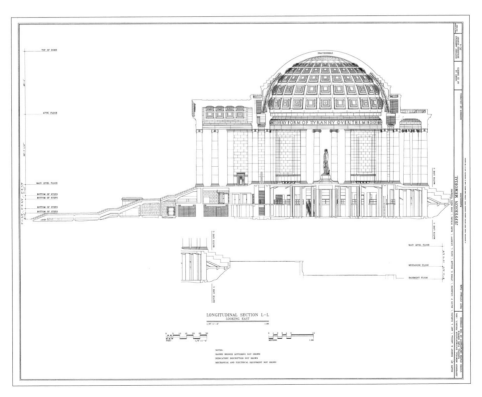

Looking east, this longitudinal section of the Thomas Jefferson Memorial in West Potomac Park was drawn as part of the National Park Service's documentation project in 1994. *Library of Congress*

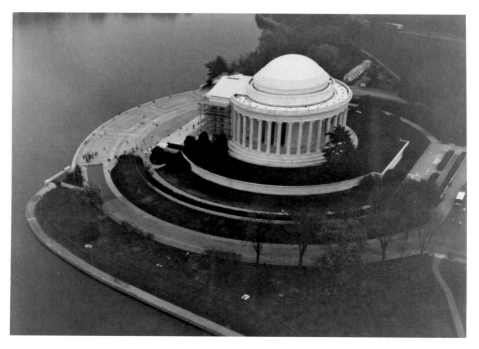

An undated aerial view of the Thomas Jefferson Memorial, shot by Carol Highsmith, shows restoration well underway but the building still open to visitors. *Library of Congress*

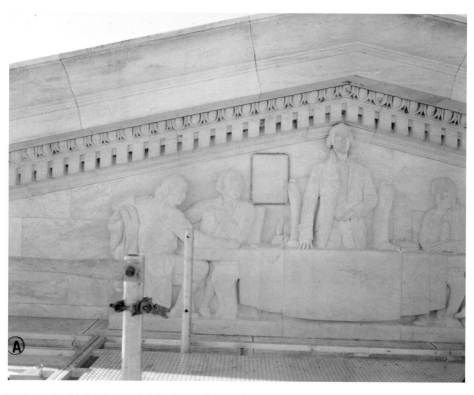

Photographer Mark Schara took this picture of the pediment sculpture on April 8, 1994. *Library of Congress*

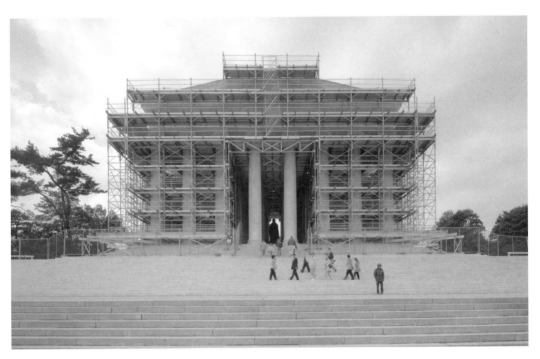

Back at ground level, Carol Highsmith captured this view of the portico on the north face of the memorial covered in scaffolding, which is also visible in aerial perspectives she photographed for the National Park Service in May 1994. *Library of Congress*

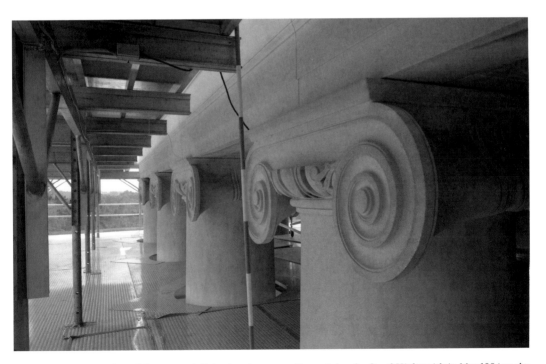

This close-up view of the memorial's ionic column scrolls was taken by Carol Highsmith in May 1994 as she documented the restoration's progress. *Library of Congress*

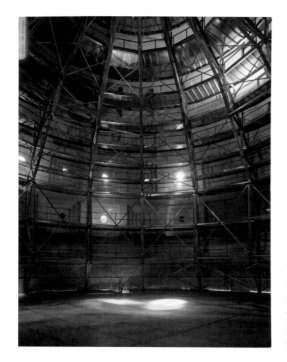

In this broader view of the scaffolding around the inner dome of the rotunda, the complexity and the challenges of working on the structure were captured in this Carol Highsmith photograph, also taken in May 1994. *Library of Congress*

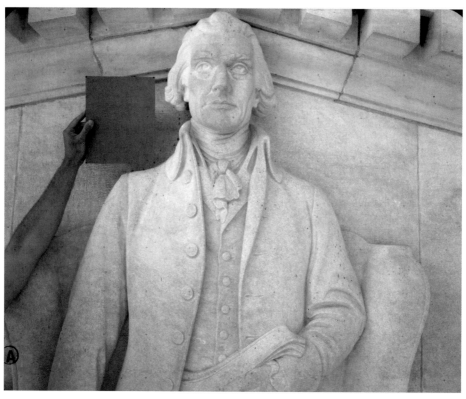

Jose Raul Vazquez took this close-up photograph of the figure of Thomas Jefferson in the pediment sculpture on June 22, 1994. *Library of Congress*

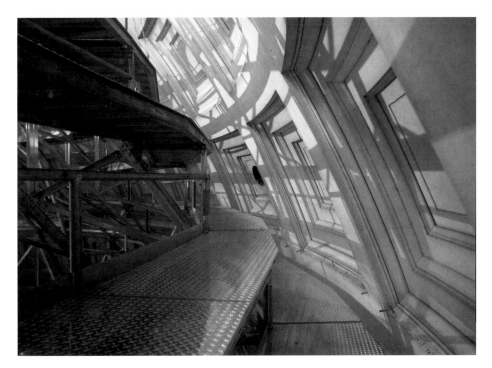

Rarely seen is this view of the inner dome of the memorial and fitted with scaffolding during the restoration. The picture was taken by Carol Highsmith in June 1994. *Library of Congress*

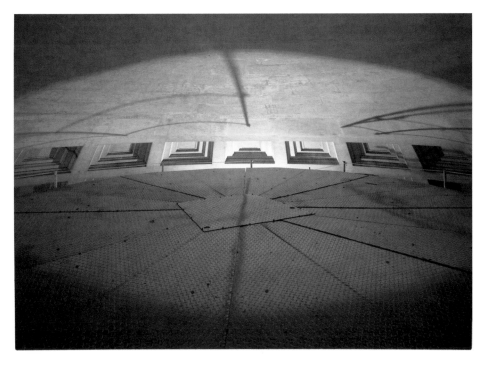

This view of the rotunda interior was taken from the top of the scaffolding in June 1994 by Carol Highsmith. *Library of Congress*

The memorial's east side stylobate mall, installed just then with white pine on the left and yew on right adjacent to the ramp was photographed by Carol M. Highsmith on September 21, 1994. *Library of Congress*

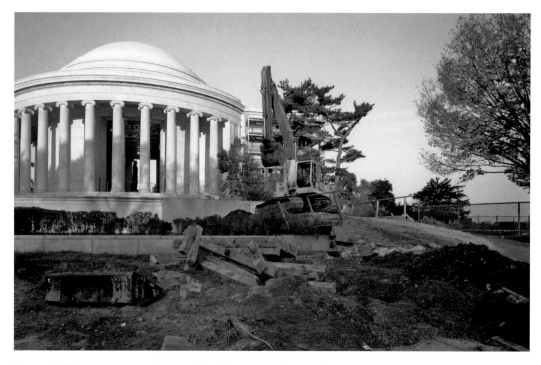

Removal of the access ramp on the east side of the memorial was underway when Carol Highsmith took this picture on November 4, 1994. *Library of Congress*

Repointing of the memorial's ridge took place as part of the restoration. In this photograph taken on November 9, 1994, Carol M. Highsmith documented the open, raked joint on the left with new mortar in the joint on the right. *Library of Congress*

Here, a Williamsport mason repoints a head joint in the entablature of the inner dome on the west side. Note the water absorption of the stone and the curve of the tuck pointer. The picture was taken by Carol Highsmith on November 30, 1994. *Library of Congress*

Customized tuck-pointing trowels were used for the repointing work done by Williamsport masons on the memorial. The curved trowel was used for overhead pointing of projections. Both types of trowels were ground to fit the joint size. Carol Highsmith photographed the masons' tools on November 30, 1994. *Library of Congress*

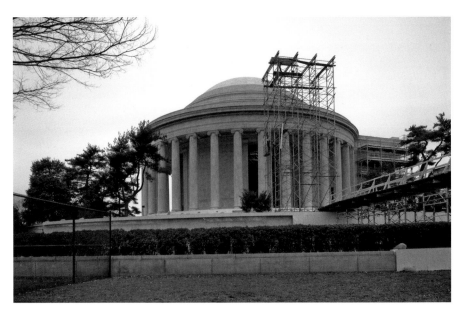

When Carol Highsmith took this picture on February 1, 1995, from the access road looking west, construction of the roof access tower on the east stylobate mall was a work in progress. Note the elevator on the left side. *Library of Congress*

To offer a different perspective, Carol Highsmith took this picture, also on February 1, 1995, of the roof access tower construction from the east colonnade looking to the east out over the staging area. Note the stacked concrete materials on the access road. *Library of Congress*

This is a view of the southeast staging area on the lower roof during restoration. The photograph was taken by Carol M. Highsmith on March 2, 1995. *Library of Congress*

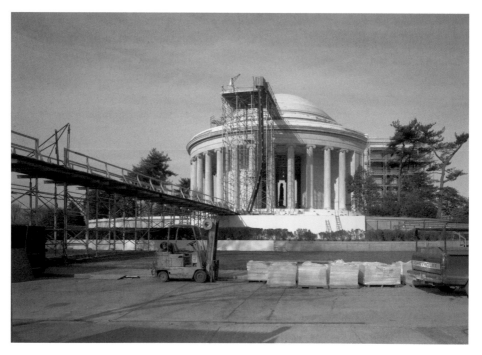

To replace the roof, workers built an elaborate system of scaffolding and ramp access, to include a tower to hoist up replacement materials, here shown on the east side. The picture was taken by Carol Highsmith on March 10, 1995. *Library of Congress*

Foreground in this March 15, 1995 Carol Highsmith photograph of ongoing work on the south side lower roof is an asphalt melter. In the background, roof demolition continued. *Library of Congress*

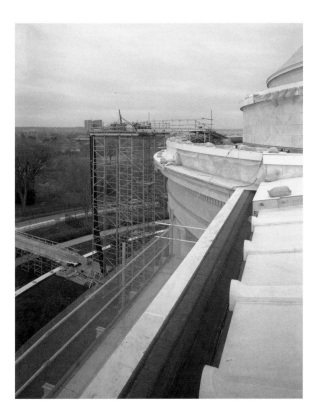

Carol Highsmith photographed ongoing work on the memorial, here looking southeast of the construction access for the reproofing projection from the portico roof on March 30, 1995. *Library of Congress*

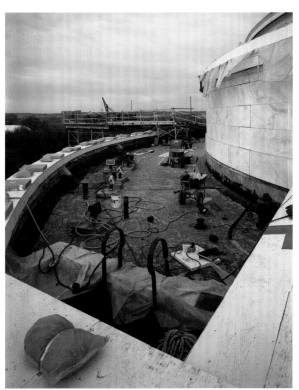

Another view of roof preservation work, shot by Carol Highsmith also on March 30, 1995, is shown here. *Library of Congress*

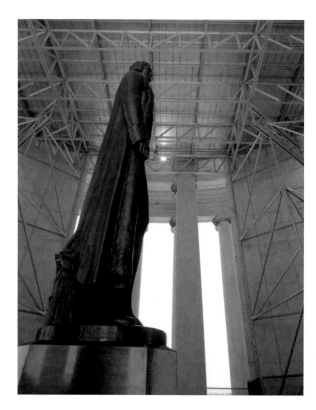

During the restoration, the Thomas Jefferson statue was protected by surrounding interior scaffolding. This undated photograph was also taken by Carol Highsmith. *Library of Congress*

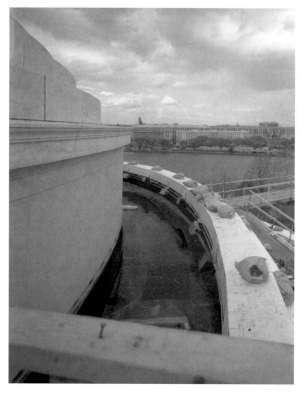

A view of the east section of the new upper roof of the memorial is shown during a flood test in this April 4, 1995 Carol Highsmith photograph. Neoprene flashing was installed and fluid applied. *Library of Congress*

Workers are shown installing neoprene counter flashing on the drum wall on the east side of the lower roof in this April 19, 1995 picture, taken by Carol Highsmith. Note the roof paver cutting booth in the background. *Library of Congress*

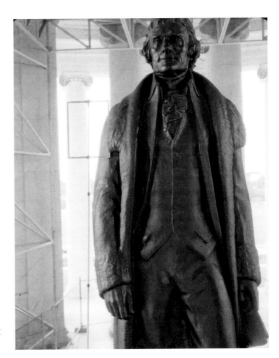

This north view, detail photograph of the Thomas Jefferson statue was taken by Mark Schara on August 9, 1995. *Library of Congress*

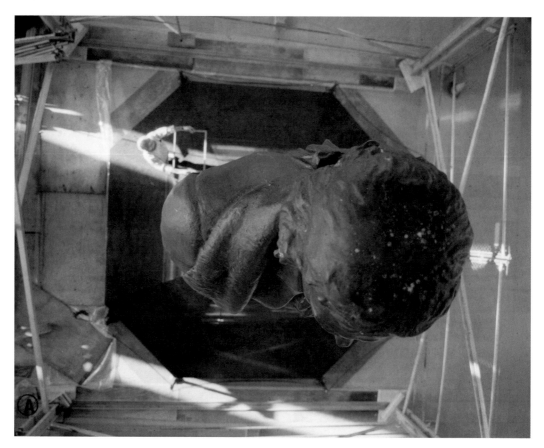

Photographer Mark Schara took this view of the Jefferson statue from above on September 28, 1995. Note the scaffolding cradling the bronze. *Library of Congress*

IV

THE MEMORIAL TODAY

Seven decades after the Jefferson Memorial made its debut on the Tidal Basin, settlement at the north seawall, located in the Tidal Basin, threatened the memorial's stability. The structure's original builders did not sink the seawall's pilings into bedrock, causing the wall to begin sliding into the basin. Pilings and pipes for the memorial structure were driven into an artificial mud flat. But at least one support for the monument, according to the National Park Service, was sunk one hundred and thirty-eight feet to the bedrock. As for the seawall, it had sunk nearly a foot in places since the memorial was first built, and the rate of increase had only acclerated in the new millennia. Noticeably, the north plaza and seawall had experienced increased rates of separation of seawall from the plaza, joint separation in the east and west walkways next to the plaza, and cracking and joint separation on the surface of the plaza, as a result of differential settlement and lateral soil movement beneath the site. The condition of these structures directly related to the integrity of the site and the ability to enjoy it. To assess what needed to be done, the National Park Service commissioned a study to repair and control settlement of the monument's seawall, north plaza, and transition areas in April 2009. The document revealed that soil movement beneath the plaza has continued to cause separation between the exposed aggregate concrete that makes up the plaza. "Until a long-term solution is implemented," read the report, "the National Park Service has maintained patching of separated pavement. Based on the rate of soil movement, new patching is necessary every three to four months. This not only requires constant attention by [National Park Service] staff in patching the walkway, but it also does not provide a long-term solution to protecting and preserving the plaza. As a result, there is a need to develop a long-term solution to protect the plaza from lateral soil movement."[63] The horizontal and vertical movement of the seawall had increased in the months leading up to the study. Unlike the plaza, there was no short-term fix for the problem. Along with the Jefferson Memorial, the plantings and materials used to construct the plaza and seawall contribute to the site's significance. While the majority of the site's plantings remain unaffected by the soil movement, the condition of the pavement and stones that cover the plaza and seawall were concluded to adversely impact the

significance of the site. In some cases, the existing materials were not directly related to the significance of the Jefferson Memorial. For example, the exposed aggregate concrete that covers the plaza is a surface layer of recent construction; however, the capstones and facing stones used on the seawall date to its original construction and are critical to the historic nature of the site. Therefore, the park service determined just then that it was important to recognize the historic nature of materials on the site and reuse them wherever possible to maintain the significance of the site.

Several National Park Service plans and studies related to the memorial's structural problems had informed and led to the development of alternatives for repairing and controlling settlement at the Jefferson Memorial seawall, north plaza, and transition areas. These included the *Revised Thomas Jefferson Memorial Cultural Landscapes Inventory* [NPS 2001] and the *Investigation of Settlement and Upheaval at the Jefferson Memorial* [HNTB 2008a]. The *Revised Thomas Jefferson Memorial Cultural Landscapes Inventory* [NPS 2001] was done to reevaluate the Jefferson Memorial's landscape after restoration efforts had been completed on the north plaza and entrance steps. The cultural landscapes inventory evaluated the condition of the historic landscape and the elements that contribute to this landscape. These elements include the aggregate used to surface the north plaza and the stones used to cap and face the seawall that were of concern as plans began to attack the settlement of the monument. The condition and importance of these elements was taken into consideration as the park service studied the alternatives to fixing the 32,000-ton memorial's plaza and seawall problem. Though the park service preferred the alternative that called for replacement of the entire seawall wrapping the memorial, it settled on a fix that reinforced the wall with pilings driven through the mud flats and anchored in the bedrock far below.

Shortly after the study was published in the spring of 2009, the park service bid the project, choosing Clark Construction Group, a building and civil construction firm American owned and operated since 1906, and headquartered in Bethesda, Maryland, to design and execute the seawall repair project. The design consisted of thirty-nine forty-eight-inch-diameter drilled shafts installed to depths of up to one hundred and twenty feet below work trestle elevation. In order to access the face of the seawall, Clark installed a sheet pile cofferdam and dewatered an area within the Tidal Basin along the length of the seawall. "In a bit of engineering detective work, experts have discovered," reported the June 2, 2010 *Washington Post*, "that the wall had been slipping away from the memorial's north plaza because the timber pilings that were used to support the wall were probably not *long* enough to reach bedrock when the memorial was built in the 1930s and 1940s."[64] The existing timber piles that had supported the seawall for decades were abandoned in place, and the structural load was transferred to thirty-nine load bearing cast-in-place concrete caissons. Due to the limited work area on the project site, the caisson rebar cages were partially assembled offsite and shipped to the job for final assembly over drilled caisson holes. Simultaneous to the replacement of the seawall, Clark demolished and repaired existing grade beams, or grillage, as necessary, under the plaza area. This portion of the construction required extremely accurate sequencing in order to maintain access to the seawall. All work occurred on the memorial's north plaza. The project cost $14 million and was the cheapest actionable option but it was by no means the best long-term fix.

PEW Charitable Trusts, in an article published March 27, 2017,[65] raised the issue of the Potomac River, which runs adjacent to many of the Japanese cherry trees from the Tidal Basin to Hains Point [this takes in West and East Potomac Parks], running over failing seawalls almost daily and threatening to rot the trees' roots. "The flooding has become so bad that the National Park Service, which manages the cherry trees, the surrounding land, and the seawalls, built a temporary path by the Jefferson Memorial to help visitors stay dry," according the PEW report. "But the trees still feel the impact." To repair the seawalls in the area in question would cost $512.3 million, a daunting price tag for an agency strapped with a $12 billion backlog of deferred maintenance across all 417 national park sites, projects that range from crumbling roads, rotting historic buildings, and blocked trails to deteriorating memorials and outdated water, sewer, and electrical systems.[66]

Among the deteriorating memorials that would make the PEW list: the Jefferson Memorial. In April 2014, a five-foot-long, three-foot-wide chunk of limestone fell out of the ceiling of the memorial, according to National Park Service spokesman Mike Litterst. "It was the early morning hours. That would suggest there probably wasn't anyone around, or if there was, there probably weren't very many people,"[67] Litterst opined. As in the case of the sea-wall, water was also the culprit in the ceiling collapse. The slab came loose because water infiltrated the roof of the portico, the front porch-like part of the memorial, corroding the supporting steel. The water got in, explained Litterst, because of malfunctioning gutters on the roof of the memorial, which the park service will fix before replacing the limestone. Additional repairs to the portico may be necessary depending on the extent of the water damage.[68] The ceiling was stabilized, and netting was installed in case anything else came loose. A full repair has not yet been done.

On August 10, 2016, the *Washington Post* reported about the biofilm—a microbial invasion of unknown origin that has begrimed the stone surface of the Jefferson Memorial. Part algae, part bacteria, part fungi, the biofilm won't eat your flesh, like the gooey Blob in the 1958 horror film, as a National Park Service spokesman remarked.[69] While the park service has not yet determined if it is actually eating the stone, what it does know is that it cannot be killed—and it is growing. The park service has experimented with various cleaning solutions that work without causing harm to the Vermont marble. "No damaging scrub brushes can be used, although some of the cleaning products leave a temporary orange tint. Officials have also discussed cleaning with lasers." The film is not limited to the Jefferson Memorial. It is also on the memorial amphitheater at Arlington National Cemetery, the Washington Monument, and the Lincoln Memorial, according to the National Park Service. Of note, it was also on the District of Columbia War Memorial on the National Mall, the city's tribute to its World War I dead, before the monument was refurbished in 2011—but it was already suspected of coming back there as well. The park service describes the biofilm akin to dental plaque. "We can remove a good amount of it," observed Judy Jacob, senior conservator with the park service's Historic Architecture, Conservation, and Engineering Center in New York, "But it doesn't mean we kill it. We can't do that [...] And it doesn't mean that it won't come back."[70] The biofilm is actually what is described as a multicultural community of organisms living in the relatively harsh environment of the sun-blasted stone, according to Federica

Villa, a Milan-based microbiologist who has studied the Jefferson Memorial surface.[71] The black pigment is produced by the organisms to protect themselves from solar radiation. Villa and others studying the problem do not know if the organisms are damaging the stone. "If you read the scientific literature, most of the scientists correlate the presence of the biofilm with deterioration." But, she offered, her experiments have demonstrated that the biofilm may have a protective impact on the stone. "It's funny because in some cases you are using microorganisms to help clean an artwork, and in some cases, you are working to remove the microorganisms,"[72] Villa explained. The biofilm first became noticeable in 2006. The National Park Service has postulated that the reason may be that air pollution, which can inhibit the growth of the organisms, has actually decreased. But then it might just have something to do with a microclimate near the memorial, reported the *Post*.

Of note, there is a small weather station on top of the Jefferson Memorial, and data is collected monthly, according to Catherine Dewey, chief of resource management for the National Mall and Memorial Parks. "Because we have this huge body of water," she said, referring to the Tidal Basin, "is that tiny little bit of extra humidity—a factor?" Then, she added, "We have some photographs from 2009 where there's very, very little growth [of the biofilm]," she said. "In 2012, you see a little bit more. In 2014, it's even worse. It's grown immensely over the last few years."[73] Whatever is going on, it affected the Jefferson Memorial more so than any of the other monumental core sites. "It's really deep into the stone, so it will take some time," Dewey told the *Post*. "What we're finding is it may not be clean immediately. But give it six months, and it will be much lighter."

While the study of the relationship of biofilms on buildings and the effects of cleaning them is still young, according to the National Park Service, one of the common factors in the existence of many biofilms is the presence of nutrients and a place to grow, like stone. At the Jefferson Memorial, perhaps the most significant factor in its development is the erosion of the marble through natural weathering. The marble blocks that make up the Jefferson Memorial were smooth when they were originally hoisted into position, but over the years, rain has slowly eroded the marble, turning its once smooth surfaces into pitted surfaces—the perfect environment for a biofilm. "Treatment of biofilm is difficult, as there is no known permanent method for removing it, and we have to ensure that any treatment must not do further damage to the soft marble of the memorial nor encourage further growth," said Catherine Dewey. "We are testing a variety of treatment techniques to find the option that is least damaging to the stone, safe for the environment and visitors, and cost effective." National Park Service officials recently began testing ten different chemical biocides in small patches affected by biofilm at the base of the Jefferson Memorial and will monitor how effective each one is going forward. They will also experiment with more non-traditional treatment options, including ozonated water and irradiation with lasers.[74]

Despite the pressing issues that face the nation's most revered landmarks, the Thomas Jefferson Memorial stands as a symbol of liberty and endures as a site for reflection and inspiration for all visitors. As the home to one of America's most influential Founding Fathers, the Jefferson Memorial has gained further renown for the cherry blossom trees that surround it and the Tidal Basin that the memorial overlooks. "Many will say that the

best time to view the Jefferson Memorial is either at sunrise, or dusk, when sunlight forms a rainbow-like prism as it beams through the monument's twenty-six pillars (symbolizing the number of states at the time of Jefferson's death), according to another source. "This makes Easter Sunrise services one of the most popular annual events in the nation's capital."[75] Today, the site receives over two million visitors a year who come to learn about Thomas Jefferson or take part in other activities around the Tidal Basin.

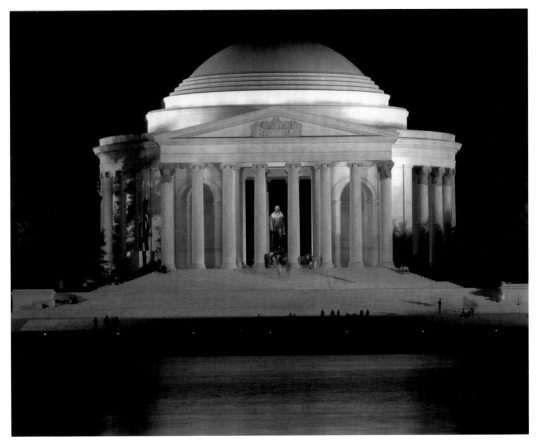

Taken on July 9, 2004, by Photographer's Mate Second Class Daniel J. McLain, this nighttime picture of the memorial includes the monument's reflection in the Tidal Basin. *United States Navy*

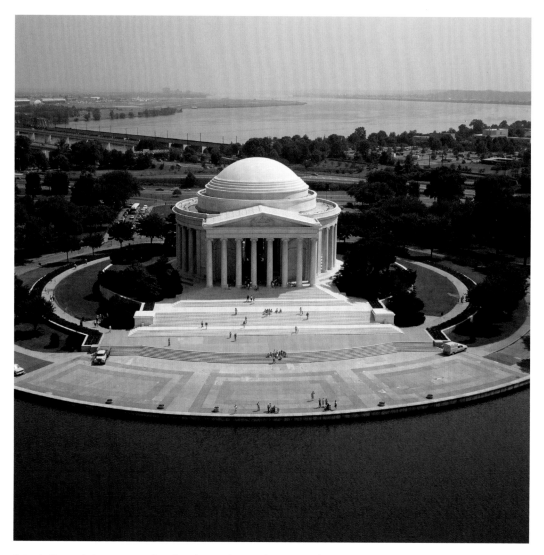

Prior to the work that was completed on the north plaza (shown here), funded by the American Recovery and Reinvestment Act of 2009, the Jefferson Memorial and its stone-faced (ashlar) seawall were sinking eight inches per year. Engineers working on the project discovered that the timber pilings originally constructed in the 1930s to support the seawall were slipping away from the memorial. The memorial, which weighs 32,000 tons and sits on an eighteen-acre site, had shifted significantly since its initial construction began in 1938. This aerial photograph of the Jefferson memorial and the seawall was taken on April 5, 2005, prior to restoration. According to Clark Construction, which did the work, thirty-nine forty-eight-inch-diameter drilled shafts were installed to depths of up to 120 feet below the work trestle elevation. In order to access the face of the seawall, Clark's team installed a sheet-pile cofferdam and dewatered an area within the Tidal Basin along the length of the seawall. The existing timber piles were abandoned in place, and the structural load transferred to thirty-nine load bearing cast-in-place concrete caissons. *National Archives*

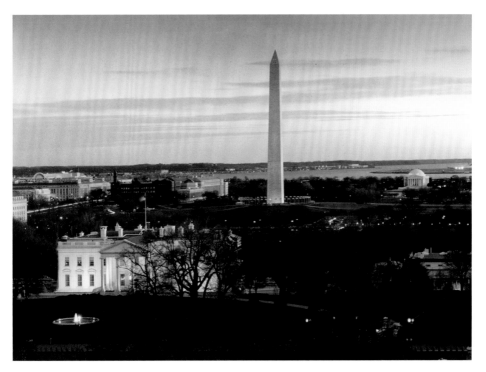

On August 23, 2005, Carol Highsmith took this dawn photograph of the alignment of the White House, Washington Monument and Jefferson Memorial. *Library of Congress*

Andrew Bossi took this photograph of the cherry blossoms in full bloom on April 1, 2006. *Andrew Bossi*[76]

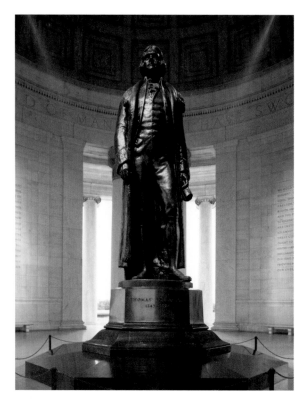

Rudulph Evans' bronze statue of Thomas Jefferson was mounted to its black marble base four years after the memorial opened. Carol M. Highsmith took this photograph of the imposing sculpture of America's third president on August 4, 2011. *Library of Congress*

Carol M. Highsmith took this contemporary photograph of this Japanese pagoda on the southwest bank of the Tidal Basin during spring cherry blossom season. Located on the southern end of the Franklin D. Roosevelt Memorial next to the waterline, right amongst the trees, the pagoda dates back to about 1600 and was gifted to Washington, D.C., by the mayor of Yokohama on April 18, 1957, to commemorate 100 years of United States–Japanese relations, and dedicated the following year on the same date. The pagoda, made of granite, weighs 3,800 pounds and was shipped to the United States in five crates. In gifting the pagoda, the Yokohama mayor iterated that it was intended to "symbolize the spirit of friendship between the United States of America manifested in the Treaty of Peace, Amity and Commerce signed at Yokohama on March 31, 1854…" *Library of Congress*

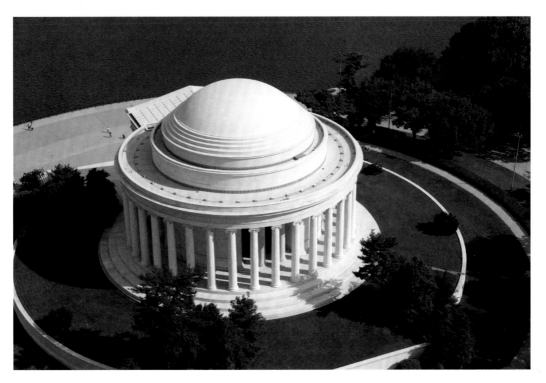

This aerial view of the Jefferson Memorial was taken on September 20, 2006, by Carol M. Highsmith. *Library of Congress*

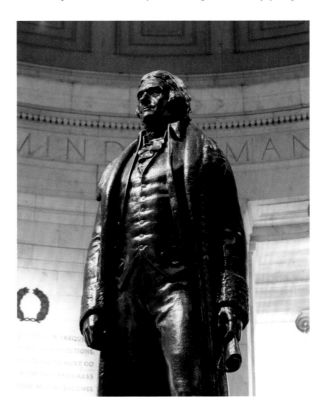

A contemporary close-up of Rudulph Evans' bronze statue of Thomas Jefferson inside the memorial was taken by Carol M. Highsmith on August 6, 2005. *Library of Congress*

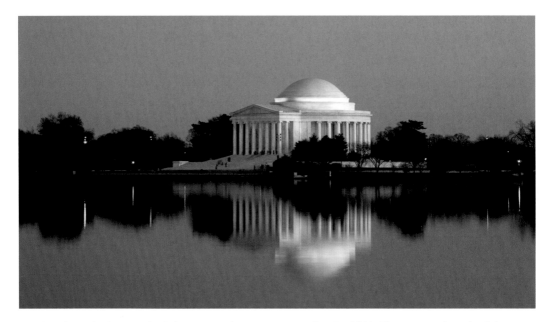

Carol Highsmith photographed the memorial again on November 25, 2006. The memorial was built by Philadelphia contractor John McShain. *Library of Congress*

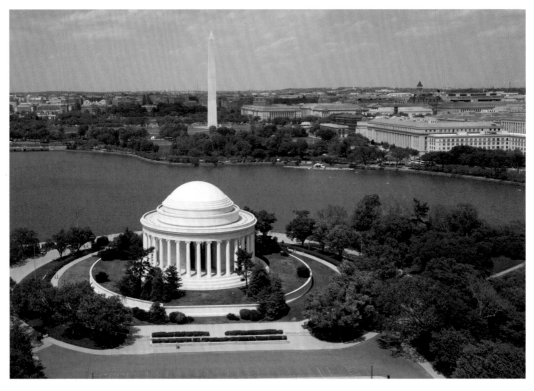

When this aerial view was taken by Carol Highsmith on April 30, 2007, it provided a modern-day perspective of the iconic Washington Monument and Jefferson Memorial. The view is looking toward through West Potomac Park to the Washington, D.C. skyline. *Library of Congress*

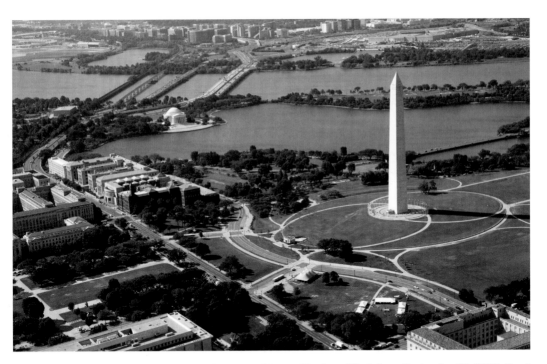

Looking out over the Tidal Basin and Potomac River to Northern Virginia on September 20, 2006, Carol Highsmith documented West Potomac Park, the Washington Monument, the Jefferson Memorial and several key roadways and bridges. *Library of Congress*

In this August 12, 2011 Carol Highsmith photograph, the Washington Monument, sheathed in scaffolding during a renovation, looms over the White House. In the distance is the Jefferson Memorial. *Library of Congress*

Challenger, a bald eagle, takes flight during the bald eagle recovery and final delisting ceremony held at the Jefferson Memorial on June 28, 2007, as Secretary of the Interior Dirk Kempthorne (right) stands with his hand over his heart. The picture was taken by navy petty officer second class Molly A. Burgess. *National Archives*

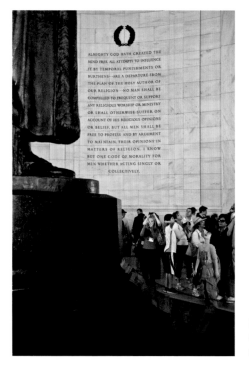

Large crowds visit the memorial every year, to include this one, photographed on April 2, 2010, in the statuary vista. *National Archives*

Eric Vance, chief photographer of the United States Environmental Protection Agency (EPA), caught the crowds enjoying the cherry blossoms on the Tidal Basin near the Jefferson Memorial (in the background) on April 2, 2010. *National Archives*

Taken for a series focused on people interacting with nature, the EPA's chief photographer Eric Vance took this picture of two children interacting with a female mallard duck directly across the Tidal Basin from the Memorial, visible in the background, on April 8, 2010. *National Archives*

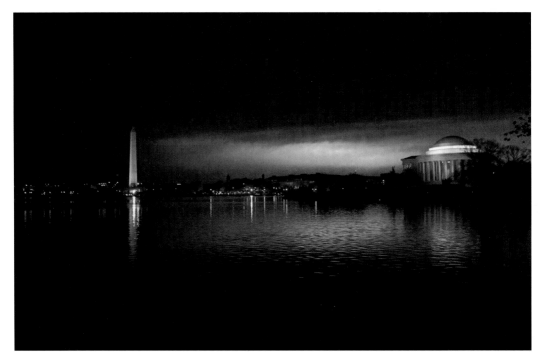

Lightning in the clouds over the nation's capital on the night of April 3, 2011, backlit the Washington Monument and the Jefferson Memorial. *Forest Wander*[77]

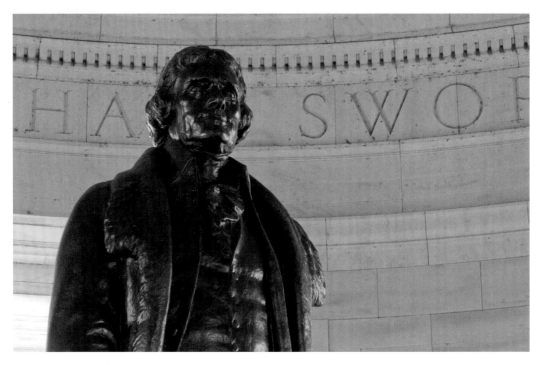

This contemporary close-up of the Rudulph Evans bronze statue of Thomas Jefferson was photographed by Carlos Delgado on July 27, 2012. *Carlos Delgado*[78]

The cherry blossom got its "close-up" with the Jefferson Memorial in the background on April 16, 2013. *Corwinhee*[79]

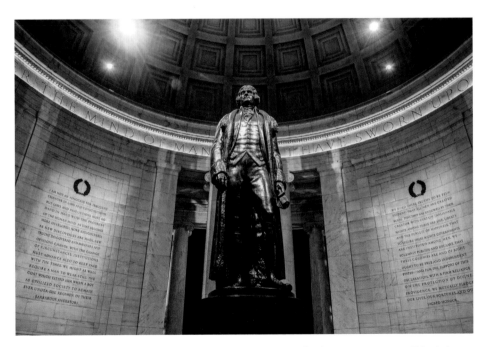

The statue of Thomas Jefferson, flanked by the southeast wall (left) and southwest wall (right), was photographed illuminated on the evening of September 13, 2013. In addition to Jefferson's writings featured on the walls, a fifth quote is engraved on the frieze encircling the memorial's interior. This quote "I have sworn upon the altar of God eternal hostility against every form of tyranny over the mind of man," is taken from a September 23, 1800 letter from Jefferson to Dr. Benjamin Rush. *Graysick*[80]

The United States Air Force Honor Guard drill team competed during the fourth annual joint service drill exhibition on April 14, 2012, at the Jefferson Memorial. Drill teams from all four branches of the armed services competed at the event. The air force team won the coveted title of "best of the best" that year. The picture was taken by Senior Airman Perry Aston. *United States Air Force*

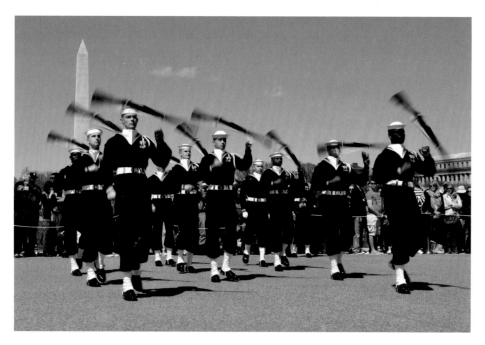

Sailors assigned to the United States Navy Ceremonial Guard drill team performed during the annual armed forces drill competition at the Jefferson Memorial during the National Cherry Blossom Festival. The picture was taken by Mass Communications Specialist First Class Pedro A. Rodriguez on April 11, 2015. *United States Navy*

This spring 2011 photograph of a granite Japanese lantern was taken by Carol M. Highsmith. Located on the northern side of the Tidal Basin between the Martin Luther King Memorial and Kutz Bridge (across from Jefferson Memorial), it dates to about 1651 and was installed in 1954 after originally being on view for almost 300 years on the grounds of a Tokyo temple. The lantern was gifted to the United States by the governor of Tokyo to mark the centenary of United States–Japanese trade relations. Since 1954, the lighting of this lantern has been an important part of the National Cherry Blossom Festival. The lighting is performed by the Japanese embassy's cherry blossom princesses, typically the daughter of a diplomat assigned to Washington, D.C. *Library of Congress*

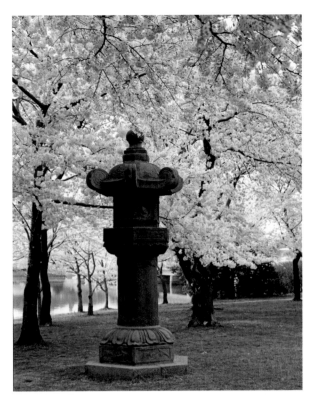

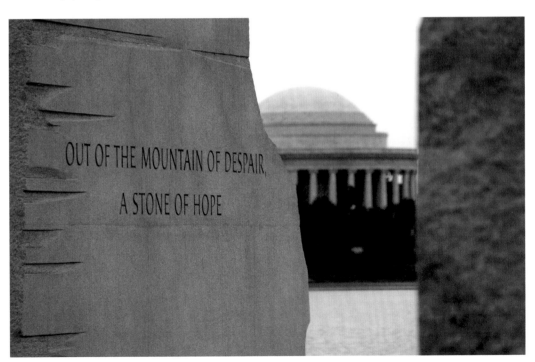

The Jefferson Memorial was photographed from the Martin Luther King Monument across the Tidal Basin on August 11, 2015. *National Park Service*

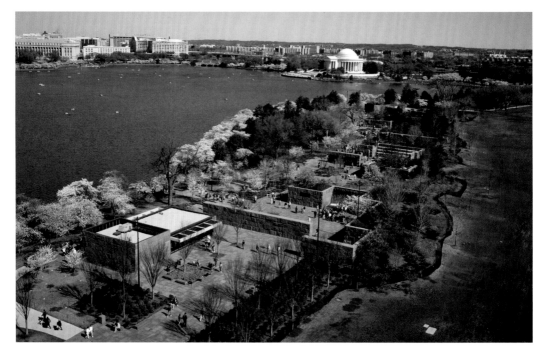

This spring 2011 aerial view shows the Franklin D. Roosevelt Memorial in the foreground during cherry blossom festival time, with the Tidal Basin (left) and Jefferson Memorial in sight. The picture was taken by Carol M. Highsmith. *Library of Congress*

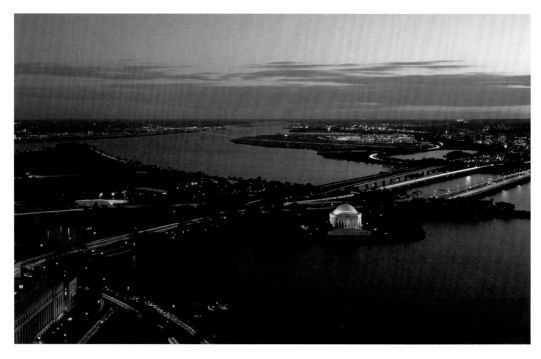

Carol Highsmith took this aerial dusk shot over Washington, D.C., on August 5, 2011, featuring the Jefferson Memorial. *Library of Congress*

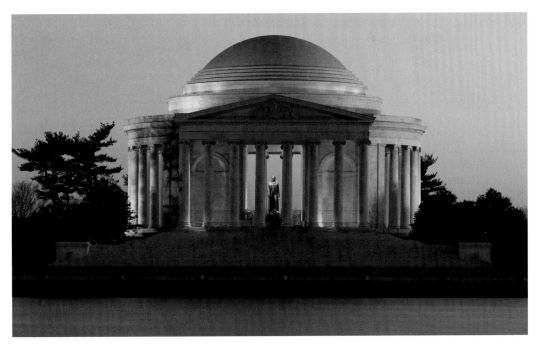

Taken on July 30, 2011, as the evening sun set over the nation's capital, this remarkable photograph was taken by Carol Highsmith looking across the Tidal Basin at the Jefferson Memorial. *Library of Congress*

The date March 27, 2012 marked 100 years since first lady Helen Herron Taft and Viscountess Iwa Chinda planted the first two cherry trees. To mark this significant milestone, first lady Michelle Obama re-enacted the first planting of the trees in a ceremony held on the Tidal Basin, shoveling dirt over a five-year-old cherry tree sapling. *National Archives*

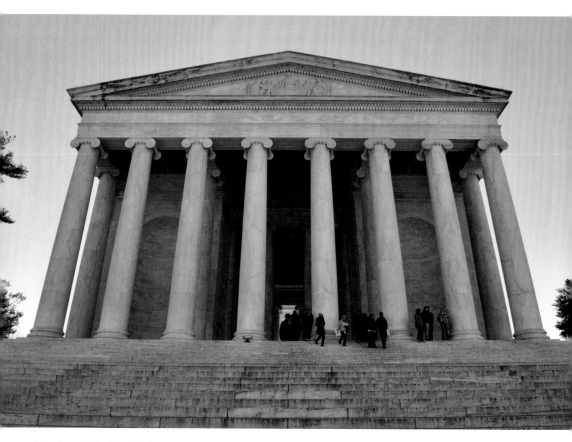

Members of the New York Air National Guard, 106th Rescue Wing, gathered on the steps of the Jefferson Memorial on January 19, 2013. The guardsmen were in Washington, D.C., to support the fifty-seventh presidential inauguration. The picture was taken by Technical Sergeant Eric Miller. *United States Air Force*

Opposite page:

Above: This photograph of the memorial at night, shot from the edge of the Tidal Basin, was taken on January 29, 2013. *Graysick*[81]

Below: Michael Silva took this picture of memorial on April 2, 2013. *Michael Silva*[82]

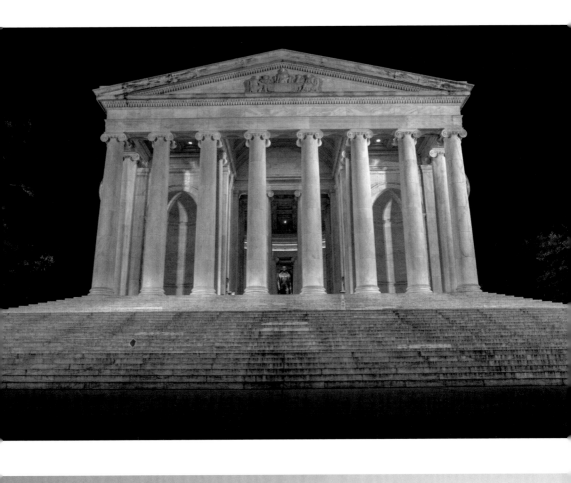

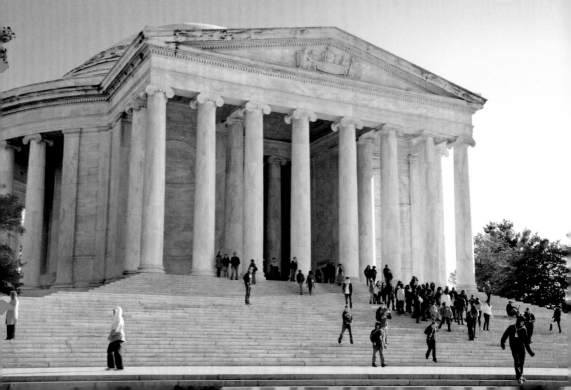

The Marine Corps Silent Drill Platoon marched in front of the Thomas Jefferson Memorial on their way to perform for the National Cherry Blossom Festival on April 12, 2014. Sergeant Bryan Nygaard took the picture. *United States Marine Corps*

Thousands of attendees at the twelfth annual Southwest Waterfront Fireworks Festival watched the fireworks display over the Gangplank Marina on April 4, 2015, where 103 years of cherry blossoms were celebrated. The picture was taken by Damien Salas of Joint Base [Fort] Myer-Henderson Hall Public Affairs Office. *United States Army*

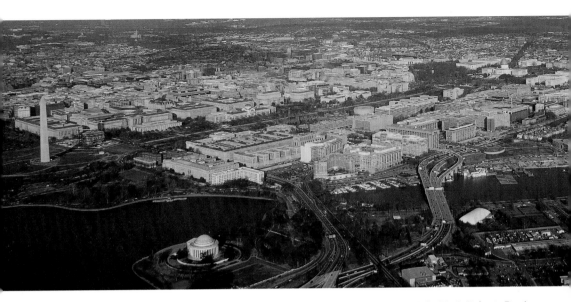

This aerial view of the eastern part of the National Mall, taken on December 18, 2014, by Mario Roberto Durán Ortiz, shows the Washington Monument (left), the United Sates Capitol (upper right), and the Jefferson Memorial (bottom left). *Mario Roberto Durán Orti*[83]

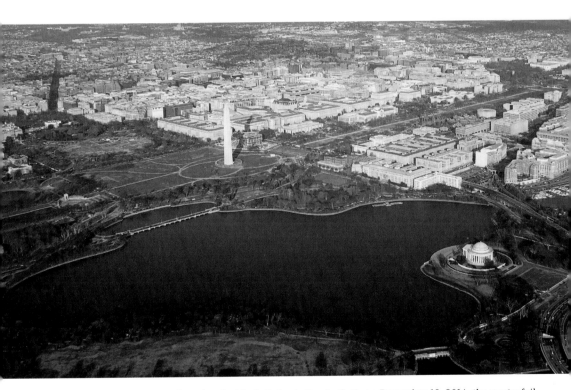

In this aerial perspective, also taken by Mario Roberto Durán Ortiz on December 18, 2014, the quatrefoil shaped Tidal Basin is framed by the Washington Monument and Jefferson Memorial. The White House, with an unobstructed view to the Jefferson Memorial across the basin, is shown upper left. *Mario Roberto Durán Ortiz*[84]

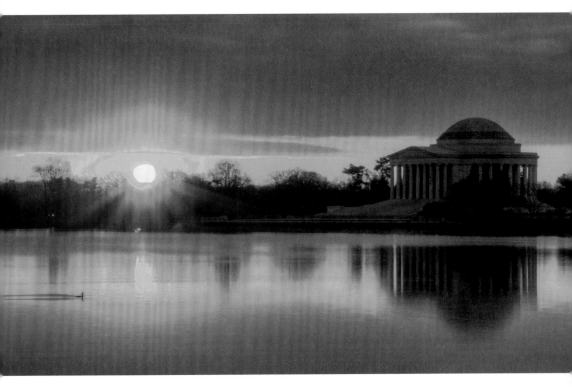

The Jefferson Memorial at sunrise was photographed by Mark Dignen on December 16, 2015. *Mark Dignen*[86]

OPPOSITE PAGE:

Above: The view shown here, dated May 25, 2014, and taken by Timothy Evanson, is looking south across Independence Avenue Southwest (foreground) at the Kutz Memorial Bridge, which carries the road over the northern bay of the Tidal Basin. The Jefferson Memorial can be seen in the distance, on the far side of the basin. The bridge was completed in 1943. *Timothy Evanson*[85]

Below: Sam Droege, of the United States Geological Survey, took this photograph, generated on August 9, 2015, of a very small stalactite that grows in the Jefferson Memorial. Calcite from the Salem limestone and marble have weathered and made stalactites and stalagmites grow in the basement of the memorial along cracks in the concrete floor. *United States Geological Survey*

The nation's third president and founding father Thomas Jefferson was honored on the occasion of his two hundred and seventy-third birthday with an armed forces full honors wreath ceremony at the Thomas Jefferson Memorial on April 13, 2016. Major General Bradley A. Becker (center right), Joint Force Headquarters, National Capital Region, and the United States Army Military District of Washington commanding general, and Paul Ollig, chief of interpretation and education for the National Mall and Memorial Parks (center left), participated in the ceremony. *United States Army*

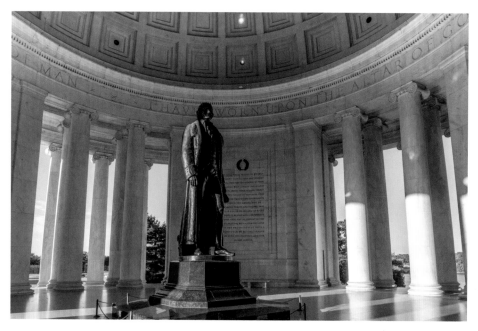

This photograph from inside the Jefferson Memorial, taken by Erik Cox on September 12, 2016, shows the southwest wall in the statuary chamber. *Erik Cox*[87]

Endnotes

1 National Park Service Cultural Landscapes Inventory (Part 2b) (2001): Jefferson Memorial https://www.nps.gov/thje/learn/management/upload/Jefferson%20Memorial%20CLI%20Part%20 2b%20-%20History.pdf

2 Note the change of name: National Capital Park Commission (1924), National Capital Park and Planning Commission (1926), and National Capital Planning Commission (1952).

3 National Park Service: Thomas Jefferson Memorial https://www.nps.gov/nr/travel/presidents/ thomas_jefferson_memorial.html

4 Hains attained the rank of major general before his retirement.

5 The land on which East Potomac Park is located is sometimes described as a peninsula but is actually an island: the Washington Channel connects with the Tidal Basin north of the park and the Jefferson Memorial. The island is, of course, artificial, built up from Potomac dredging material over the decade that followed the 1882 congressional authorization. In some descriptions, the Jefferson Memorial is described as "northwest on the island."

6 Under legislation enacted in March 1849, the United States Department of the Interior was created and responsibility for Washington's city parks was given to this agency. The Office of Public Buildings and Grounds continued as a subsidiary unit of the Department of the Interior. In July 1851, President Millard Fillmore appointed Andrew Jackson Downing (1815–1852) the city's "rural architect," and charged him with turning many of the undeveloped reservations into public parks. Downing is considered to be a founder of American landscape architecture. Federal legislation enacted in March 1867 abolished the Office of Public Buildings and Grounds and transferred authority over city parks to the United States Army Corps of Engineers. The army corps of engineers' Office of Public Buildings and Grounds became an independent office within the executive branch under legislation adopted in February 1925. The new office, known as the Director of Public Buildings and Public Parks of the National Capital, reported directly to the President of the United States. Under Executive Order 6166 dated June 10, 1933, President Franklin D. Roosevelt placed the independent office into the new Office of National Parks, Buildings and Reservations in the United States Department of the Interior. The name of the new office was changed to the National Park Service by an Act of Congress in March 1934.

7 Bingham served as superintendent of the Office of Public Buildings and Grounds in the nation's capital from 1897 to 1901 with the rank of colonel. He then went to work at the White House as the military aide to President Theodore Roosevelt. He was later transferred to Buffalo, New York, on an engineering assignment where he suffered an accident that resulted in the loss of a leg, forcing his retirement from active service in the army in 1904 at the rank of brigadier general. Bingham served as police commissioner of New York City from January 1, 1905, to July 1, 1909. In 1911, he served for a few months as chief engineer of the New York State Department of Highways and from 1911 to 1915 was a consulting engineer with the Department of Bridges for the same. In 1917, after the United States entered the First World War, he was recalled to active service in the army, in command of the Second Engineering District, New York City. He was discharged from active service and returned to retirement on June 10, 1919.

8 KressCox Associates, P.C. [for National Park Service]. Historic Structures Report: Tidal Basin Inlet Bridge, Washington, D.C., May 2, 1986. https://web.archive.org/web/20150223072356/http://www.cr.nps.gov/history/online_books/ncr/tidal_basin_hsr.pdf

9 National Park Service, Department of the Interior. West Potomac Park Historic American Building Survey (HABS DC-693), 1992.

10 Ibid.

11 Ibid.

12 The Tidal Basin outlet bridge is a low-level bridge that is sandwiched today between two other bridges, the George Mason Memorial [Fourteenth Street] Bridge crossing the outlet, and the Fifteenth Street Bridge connecting with the Hains Point exit ramp. Constructed in 1889, the total length of the stone masonry structure is ninety-four feet, two inches; the height is twenty feet, seven inches from the river bottom level of the reservoir. It is one of the earliest constructed elements in the reclamation plan that eliminated Potomac Flats.

13 Hains, Peter C., "Reclamation of Potomac Flats at Washington, D.C., *American Society of Civil Engineers (ASCE) Transactions*, January 1894.

14 Wyeth is best known for designing the West Wing of the White House, creating the first Oval Office. He designed a large number of structures in Washington, D.C., including the Francis Scott Key Bridge over the Potomac River, the USS Maine Mast Memorial, the District of Columbia Armory, the Tidal Basin inlet bridge, many structures that comprise Judiciary Square, and numerous private homes—many of which now serve as embassies. He also co-designed the Cannon House Office Building, the Russell Senate Office Building, the Longworth House Office Building, and an addition to the Russell Senate Office Building.

15 "Report of pollution of the Tidal Basin," *Washington Evening Star*, December 11, 1915.

16 "Bathing at the Tidal Basin," *Washington Evening Star*, July 20, 1916.

17 Goff, Jenna, "Cooling off in the Tidal Basin," Boundary Stones—WETA's local history blog, July 21, 2015. http://blogs.weta.org/boundarystones/2015/07/21/cooling-tidal-basin

18 KressCox Associates, ibid. As an additional note: A request was made in July 1921 to establish a beach for black Washingtonians and visitors, who continued to swim on the north shore of the Tidal Basin and in other reaches of the Potomac. An appropriation for this new beach was approved. The *Afro-American* of December 13, 1924, reported that work was to start on this beach and accompanying facilities. But shortly thereafter, the February 19, 1925 *Washington Post*

informed the public that the United States Senate had declared there would be no more bathing in the Tidal Basin and ordered it permanently closed. By the time summer came that year, the Tidal Basin beach that had drawn tens of thousands and had remained one of the city's greatest attractions while it was in use, was resigned to history.

19 "Tug of war is big feature," *Washington Herald*, August 25, 1918.

20 "20,000 at Tidal Basin: attendance records shattered at improved bathing beach," *Washington Post*, June 14, 1920.

21 West Potomac Park is today used extensively for a variety of recreational and sporting uses by local residents, including polo matches at the Polo Grounds and jogging and bicycling throughout the park.

22 The retaining walls are also called seawalls.

23 Peele, Elbert, "Original plan of Washington," *House and Garden*, July 1940; National Park Service, Department of the Interior. East and West Potomac Parks Historic District, Revised National Register of Historic Places Nomination, National Capital Region, July 16, 1999, reference hereafter NPS (1999). As one of the many areas reserved for public uses in Washington, West Potomac Park is referred to as Reservation 322 in Washington's system of legal property description.

24 NPS (1999).

25 White House Historical Association: Colonel Theodore Bingham. https://www.whitehousehistory.org/photos/colonel-theodore-bingham

26 By Rob Ketcherside from Seattle, USA (Future Jefferson Memorial Site, DC, 1908) [CC BY 2.0 (http://creativecommons.org/licenses/by/2.0)], via Wikimedia Commons

27 By Jamieadams99 (Own work) [CC BY-SA 3.0 (http://creativecommons.org/licenses/by-sa/3.0) or GFDL (http://www.gnu.org/copyleft/fdl.html)], via Wikimedia Commons

28 National Cherry Blossom Festival: http://www.nationalcherryblossomfestival.org/about/history/

29 Pulvers, Roger, "Jokichi Takamine: a man with fire in his belly whatever the odds," *Japan Times*, June 28, 2009.

30 National Park Service: History of the Cherry Trees https://www.nps.gov/subjects/cherryblossom/history-of-the-cherry-trees.htm

31 Ibid.

32 Three years after World War II, in 1948, cherry blossom princesses were chosen from each state as well as from each federal territory. From the princesses, a queen was chosen to reign during the annual cherry blossom festival.

33 National Park Service Cultural Landscapes Inventory (Part 2b): Jefferson Memorial, ibid.

34 Ibid.

35 Ibid.

36 Ibid.

37 National Agricultural Library, United States Department of Agriculture. United States National Arboretum Collection Cherry Tree Files. https://specialcollections.nal.usda.gov/guide-collections/united-states-national-arboretum-collection-cherry-tree-files

38 Ibid.

39 "Hiroshi Saito, 51, ex-ambassador, dead in capital," *Chicago Daily Tribune*, February 27, 1939. http://archives.chicagotribune.com/1939/02/27/page/12/article/hiroshi-saito-51-ex-ambassador-dead-in-capital/

40 The Commission of Fine Arts is composed of seven presidentially appointed experts in relevant disciplines including art, architecture, landscape architecture, and urban design. The Commission reviews designs proposed for memorials, coins, medals, and new or renovated government buildings, as well as privately owned properties in certain areas of Washington under the Shipstead-Luce and Old Georgetown Acts. In addition, the Commission supports a variety of arts institutions in Washington, D.C., through the National Capital Arts and Cultural Affairs (NCACA) program. Through its unique work as the only federal commission dedicated to design review and aesthetic excellence, the Commission of Fine Arts serves the American people, international visitors, and those who live and work in the nation's capital, contributing to the beauty and dignity of this international symbol of American democracy.

41 A partial listing of Olmsted design projects in the nation's capital reads like a guide to National Park Service-managed sites, to include the National Mall, Jefferson Memorial, White House grounds, and Rock Creek Park. Olmsted also prepared the plan for Boston's metropolitan park system and a master plan for Cornell University, and was involved in the planning of Forest Hills Gardens, Queens, and Roland Park, Baltimore. He was a founding member of the American Society of Landscape Architects and actively involved in numerous planning and design organizations and commissions, including the United States Commission of Fine Arts, the National Capital Park and Planning Commission, the Baltimore Park Commission, the National Park Service Board of Advisers for Yosemite, the National Conference on City Planning, the American City Planning Institute, the National Institute of Arts and Letters, and the American Academy in Rome. Olmsted received many awards and honors during his long career, among them the American Academy Gold Medal (1949) and the United States Department of the Interior Conservation Award (1956).

42 Thomas Jefferson Encyclopedia: Jefferson Memorial Statue https://www.monticello.org/site/research-and-collections/jefferson-memorial-statue

43 In the foreword to the Wilfred Funk 1941 printing of Jefferson's book, editor Douglas E. Lurton wrote: "The most exquisite story ever written is simply told in about 25,000 words. These words extracted textually from the Gospels by Thomas Jefferson, form a beautifully moving story of the life and morals of Jesus. Within this brief and sublime story are the authentic words of Christ which give life to the Bible. They are its essence. During his first term in the White House, the Father of American Democracy," Lurton continued, "revealed his dream of separating the sayings which were indisputably the words of Jesus from what he considered to be extraneous matter in the Holy Library of 66 volumes, 1,189 chapters, 773,000 words."

44 National Park Service Cultural Landscapes Inventory (Part 2b): Jefferson Memorial, ibid.

45 Ibid.

46 Ibid.

47 Ibid.

48 Ibid.

49 "Jacking up" is a method of combating settlement problems by raising the level of the pavement or roadway, by injecting grout under pressure beneath it. It is limited in its application to raising in relatively small elevation increments. There must be lateral confinement underneath the surface to contain the semi-liquid material used in order for this operation to prove successful.

50 National Park Service Cultural Landscapes Inventory (Part 2b): Jefferson Memorial, ibid.

51 Moody, Chris, "Myths and secrets of presidential monuments," *CNN Politics*, September 18, 2015. http://www.cnn.com/2015/02/16/politics/presidents-day-myths-and-facts/

52 Metropolitan Museum of Art: American bronze casting http://www.metmuseum.org/toah/hd/abrc/hd_abrc.htm

53 National Park Service Cultural Landscapes Inventory (Part 2b): Jefferson Memorial, ibid.

54 NPS (1999).

55 Angier, Natalie, "Debate on buildings: to scrub or not," *New York Times*, January 14, 1992. http://www.nytimes.com/1992/01/14/science/debate-on-buildings-to-scrub-or-not.html?pagewanted=all

56 Ibid.

57 Ibid.

58 Ibid.

59 Ibid.

60 Ibid.

61 Ibid.

62 National Park Service Cultural Landscapes Inventory (Part 2b): Jefferson Memorial, ibid.

63 National Park Service, United States Department of the Interior. Repair and Control Settlement at Thomas Jefferson Memorial Seawall, North Plaza, and Transition Areas [NAMA 128232]. National Mall and Memorial Parks, Washington, D.C., April 2009.

64 Ruane, Michael E., "Workers try to repair the sinking seawall at the Jefferson Memorial," *Washington Post*, June 2, 2010. http://www.washingtonpost.com/wp-dyn/content/article/2010/06/01/AR2010060101735.html

65 Argust, Marcia, "Cherry blossoms face a threat worse than wild weather," The PEW Charitable Trusts, March 27, 2017. http://www.pewtrusts.org/en/research-and-analysis/blogs/compass-points/2017/03/27/cherry-blossoms-face-a-threat-worse-than-wild-weather

66 Ibid.

67 Dingfelder, Sadie, "Did you know a 5-foot chunk of stone dropped from the Jefferson Memorial in April? *Washington Post*, October 8, 2014. https://www.washingtonpost.com/express/wp/2014/10/08/did-you-know-a-5-foot-chunk-of-stone-dropped-from-the-jefferson-memorial-in-april/?utm_term=.9174e95641e6

68 Ibid.

69 Ruane, Michael E., "A grimy, black biofilm is starting to cover the Jefferson Memorial, and it can't be killed," *Washington Post*, August 10, 2016. https://www.washingtonpost.com/local/the-grimy-black-biofilm-thats-creeping-over-the-jefferson-memorial/2016/08/09/33be9040-5d70-11e6-9d2f-b1a3564181a1_story.html?utm_term=.90ef81d2d2ec

70 Ibid.

71 Ibid.

72 Callaghan, Meaghan L., "The Jefferson Memorial is slowly being covered in slime," *Popular Science*, August 11, 2016. http://www.popsci.com/jefferson-memorial-is-slowly-being-covered-in-slime

73 Ibid.

74 "National Park Service studies biofilm blackening the Thomas Jefferson Memorial," National Park Service Press Release, August 10, 2016. https://www.nps.gov/nama/learn/news/jefferson-memorial-biofilm.htm

75 Jefferson Memorial: http://www.memorials.net/Jefferson-Memorial-information.php

76 By Andrew Bossi (Own work) [GFDL (http://www.gnu.org/copyleft/fdl.html), CC-BY-SA-3.0 (http://creativecommons.org/licenses/by-sa/3.0/) or CC BY-SA 2.5-2.0-1.0 (http://creativecommons.org/licenses/by-sa/2.5-2.0-1.0)], via Wikimedia Commons

77 By Forest Wander (Flickr: Lightning in the clouds over Washington DC) [CC BY-SA 2.0 (http://creativecommons.org/licenses/by-sa/2.0)], via Wikimedia Commons and http://www.forest-wander.com

78 Carlos Delgado [CC BY-SA 3.0 (http://creativecommons.org/licenses/by-sa/3.0) or Public domain], via Wikimedia Commons

79 By Corwinhee (Own work) [CC BY-SA 4.0 (http://creativecommons.org/licenses/by-sa/4.0)], via Wikimedia Commons

80 By Graysick (Own work) [CC BY-SA 3.0 (http://creativecommons.org/licenses/by-sa/3.0)], via Wikimedia Commons

81 By Graysick (Own work) [CC BY-SA 4.0 (http://creativecommons.org/licenses/by-sa/4.0)], via Wikimedia Commons

82 By Michael Silva (http://www.flickr.com/photos/sully-m/9565610219) [CC BY-SA 2.0 (http://creativecommons.org/licenses/by-sa/2.0)], via Wikimedia Commons

83 By Mariordo (Mario Roberto Durán Ortiz) (Own work) [CC BY-SA 4.0 (http://creativecommons.org/licenses/by-sa/4.0)], via Wikimedia Commons

84 By Mariordo (Mario Roberto Durán Ortiz) (Own work) [CC BY-SA 4.0 (http://creativecommons.org/licenses/by-sa/4.0)], via Wikimedia Commons

85 By Tim Evanson [CC BY-SA 2.0 (http://creativecommons.org/licenses/by-sa/2.0)], via Wikimedia Commons

86 By Mark Dignen (Own work) [CC BY-SA 4.0 (http://creativecommons.org/licenses/by-sa/4.0)], via Wikimedia Commons

87 By Erik Cox (Own work) [CC BY-SA 4.0 (http://creativecommons.org/licenses/by-sa/4.0)], via Wikimedia Commons

Select Bibliography

Government Documents

District of Columbia. Inventory of Historic Sites. September 30, 2009.

Jefferson, Roland M., United States National Arboretum, and Alan E. Fusonie, National Agricultural Library. *The Japanese Flowering Cherry Trees of Washington, D.C.—A Living Symbol of Friendship*. National Arboretum, Agricultural Research Service, United States Department of Agriculture, Washington, D.C., December 1977 [monograph].

KressCox Associates, P.C. [for National Park Service]. Historic Structures Report: Tidal Basin Inlet Bridge, Washington, D.C., May 2, 1986. https://web.archive.org/web/20150223072356/http://www.cr.nps.gov/history/online_books/ncr/tidal_basin_hsr.pdf

National Agricultural Library, United States Department of Agriculture. United States National Arboretum Collection Cherry Tree Files. https://specialcollections.nal.usda.gov/guide-collections/united-states-national-arboretum-collection-cherry-tree-files

National Park Service, Department of the Interior. Repair and Control Settlement at Thomas Jefferson Memorial Seawall, North Plaza, and Transition Areas [NAMA 128232]. National Mall and Memorial Parks, Washington, D.C., April 2009

–. Theodore Roosevelt Island (Analostan Island) (Mason's Island), George Washington Memorial Parkway, Potomac River, Washington, D.C. Historic American Landscapes Survey (HALS), DC-12, 2007.

–. East and West Potomac Parks Historic District, Revised National Register of Historic Places Nomination, National Capital Region, July 16, 1999.

–. L'Enfant-McMillan Plan of Washington, D.C. Historic American Buildings Survey (HABS), DC-668, 1993.

–. West Potomac Park Historic American Building Survey (HABS DC-693), 1992.

–. National Register of Historic Places Inventory Nomination Form, Thomas Jefferson Memorial, National Capital Region, January 12, 1981.

–. National Register of Historic Places Inventory Nomination Form, East and West Potomac Parks, Potomac Flats, National Capital Region, November 30, 1973.

ARTICLES, PAMPHLETS AND PAPERS

Angier, Natalie, "Debate on buildings: to scrub or not," *New York Times*, January 14, 1992. http://www.
nytimes.com/1992/01/14/science/debate-on-buildings-to-scrub-or-not.html

Argust, Marcia, "Cherry blossoms face a threat worse than wild weather," The PEW Charitable
Trusts, March 27, 2017. http://www.pewtrusts.org/en/research-and-analysis/blogs/compass-
points/2017/03/27/cherry-blossoms-face-a-threat-worse-than-wild-weather.

Burkhardt, Daniel, "USAF honor guard drill team considered 'best of the best,'" Joint Base Andrews,
11th Wing Public Affairs, April 17, 2012. http://www.jba.af.mil/News/Article-Display/Article/335166/
usaf-honor-guard-drill-team-considered-best-of-the-best

Dingfelder, Sadie, "Did you know a 5-foot chunk of stone dropped from the Jefferson Memorial in
April? *Washington Post*, October 8, 2014. https://www.washingtonpost.com/express/wp/2014/10/08/
did-you-know-a-5-foot-chunk-of-stone-dropped-from-the-jefferson-memorial-in-april/?utm_
term=.9174e95641e6

Moody, Chris, "Myths and secrets of presidential monuments," *CNN Politics*, September 18, 2015.
http://www.cnn.com/2015/02/16/politics/presidents-day-myths-and-facts/

Pulvers, Roger, "Jokichi Takamine: a man with fire in his belly whatever the odds," *Japan Times*, June
28, 2009.

Ruane, Michael E., "A grimy, black biofilm is starting to cover the Jefferson Memorial, and it can't
be killed," *Washington Post*, August 10, 2016. https://www.washingtonpost.com/local/the-grimy-
black-biofilm-thats-creeping-over-the-jefferson-memorial/2016/08/09/33be9040-5d70-11e6-
9d2f-b1a3564181a1_story.html?utm_term=.7276b9c5c93e

– . Workers try to repair the sinking seawall at the Jefferson Memorial," *Washington Post*, June 2, 2010.
http://www.washingtonpost.com/wp-dyn/content/article/2010/06/01/AR2010060101735.html

– . "D.C.'s cherry blossoms and the sad story of a Japanese family," *Washington Post*, March 26, 2010.
http://www.washingtonpost.com/wp-dyn/content/article/2010/03/24/AR2010032401725.html

WEBSITES

Girl Scout History Project: https://gshistory.com/
National Cherry Blossom Festival: http://www.nationalcherryblossomfestival.org/
National Park Service: https://www.nps.gov/

ABOUT THE AUTHOR

AMY WATERS YARSINSKE is the author of several best-selling, award-winning nonfiction books, including *An American in the Basement: The Betrayal of Captain Scott Speicher and the Cover-up of His Death* (Trine Day, 2013), which won the Next Generation Indie Book Award for General Non-fiction in 2014. To those who know this prolific author, it's no surprise that this Renaissance woman became a writer. Amy's drive to document and investigate history-shaping stories and people has already led to publication of over 75 nonfiction books, most of them spotlighting current affairs, the military, history, biography and the environment. Amy graduated from Randolph-Macon Woman's College in Lynchburg, Virginia, where she earned her Bachelor of Arts in English and Economics, and the University of Virginia School of Architecture, where she earned her Master of Planning and was a DuPont Fellow and Lawn/Range resident. She also holds numerous graduate certificates, including those earned from the CIVIC Leadership Institute and the Joint Forces Staff College, both headquartered in Norfolk, Virginia. Amy serves on the national board of directors of Honor-Release-Return, Inc. and the National Vietnam and Gulf War Veterans Coalition, where she is also the chairman of the Gulf War Illness Committee. She is a member of the American Society of Journalists and Authors (ASJA), Investigative Reporters and Editors (IRE), Authors Guild and the North Carolina Literary and Historical Association (NCLHA), among her many professional and civic memberships and activities.

If you want to know more about Amy and her books, go to www.amywatersyarsinske.com.